Käthe Kollwitz

KÄTHE KOLLWITZ

Otto Nagel

New York Graphic Society Ltd.
Greenwich, Connecticut

Translated by Stella Humphries
International Standard Book No. 8212-0401-7
Library of Congress Catalog Card No. 79-137655

Original German edition © 1963 by VEB Verlag der Kunst Dresden,
edited by Deutsche Akademie der Künste zu Berlin.
English language edition © 1971 by Studio Vista Ltd.
English language edition first published
in the United States of America by
New York Graphic Society Ltd., 1971
Printed and bound in Germany by Interdruck, Leipzig

List of Contents

It was late afternoon on 24 April 1945. A short funeral cortege made its way slowly from the chapel of the Moritzburg cemetery towards an open grave by the wall. The six elderly pall-bearers were shabbily dressed, and the only adornment to the plain pine coffin they carried was a simple garland of leaves, placed there by loving hands. Hardly a dozen people were present. The monotonous tolling of the chapel bell mingled with the noise of battle, for each day the front line was advancing closer.

The war had entered its final phase. The sound of fighting could be heard even in the usually quiet town of Moritzburg, not far from Dresden. It was here that an old woman who loved peace above all else, had fled when Berlin was being attacked daily by British and American bombers. She had grown very weary in recent years, and only a few days before she had written to her family who were still living in distant Berlin: 'The war goes with me to the end.'[1]

Against the cemetery wall nearby, stood a group of country women, refugees from the war zone. Tired as they were, they followed the proceedings with interest. 'She was an artist,' they had been told. Only two of the mourners had known the dead woman really well, the daughters of her 'first-born', the son for whom she yearned unceasingly in her last days. 'I dream of you every night... My dear boy, if only I could see you once again...'[2]

The motherly love she had so lavished on the world in the course of her lifetime, was a source of painful suffering to her during this grim period. A few days before she shut her eyes for ever, she expressed it for the last time: 'And then, I should fold you in my arms, rejoicing.'[3] But Death came swifter with his embrace, Death whom she did not think of as her enemy, with whom indeed she had conversed on friendly terms throughout her life, but whom nevertheless she feared.

The chapel bell in the Moritzburg cemetery fell silent. From the Meissen area, the noise of bursting grenades and exploding bombs could be heard, heralding the imminent end of the war the dead artist had hated so passionately. The peace she had waited for and hoped for in vain arrived too late for her.

The war was over, the weeks passed. Throughout Germany, the survivors worked side by side with the liberators, to bring order out of chaos, to provide an indispensable minimum of food, to give the homeless some kind of shelter, and to improvise the restoration of transport and of communications.

On 8 July — it would have been the artist's seventy-eighth birthday, — the newspapers carried articles in her honour, for the public still knew

nothing of her death. Not until 17 July, was this announced in the papers.

Today there is hardly a town in the Republic which has failed to pay its respects to the memory of Käthe Kollwitz in one way or another. There are many streets, schools, homes for mothers and for children, bearing the name of this eminent artist, in grateful tribute to her and to her work.

I shall try to give the reader an idea of Käthe Kollwitz's life and aims, and to convey something of her greatness as an artist. I approach this task quite simply as a fellow artist, whose style was close to hers, and also as a friend to whom she wrote shortly before her death 'in exile' in Moritzburg: 'My thoughts keep returning to so many, many things, those we laughed about together and those that saddened us too.'[4]

Writing now, if I wish to describe Käthe Kollwitz and her work, there are certain considerations I must take into account. Her participation as an artist in society, and what she had to say about that society, were conditioned by the times in which she lived. Often when she created this work or that, there was some outside event or experience to explain her treatment of the subject. People today, who live in a wholly different environment, can hardly be expected to appreciate either her intentions or her utter originality as an artist.

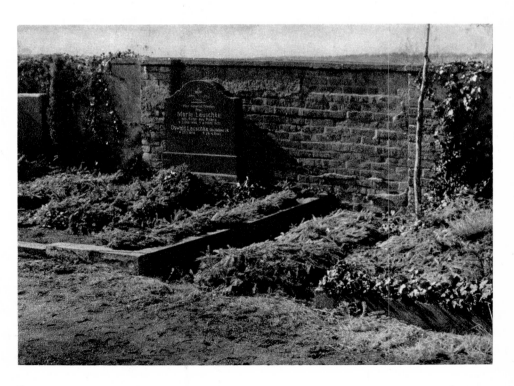

The Moritzburg cemetery

But how did Käthe Kollwitz and her work come to have such a wide influence, particularly on the younger generation of her day? It seems to me to be important to answer this question at the outset.

Now that I am in my late sixties, I can look back on that epoch, which, although it was once for me too the actual present, seems already to have receded into the distant past. In 1927, when I was still a young man, I wrote an essay for the *Sozialistische Monatshefte (Socialist Monthly Notebooks)* on the occasion of her sixtieth birthday. It was called 'Käthe Kollwitz and the Younger Generation', and I should like to bring the most important sections of that essay to the reader's attention. It will be seen that many of my arguments and the judgments I made—with Käthe Kollwitz as my starting point—are still valid today. This applies particularly to discussions about art, but it is also relevant to the opinions of the youth of today. Here is part of that article:

Young people who are interested in art, always tend to think of themselves as revolutionaries. They view with the greatest suspicion the older generation, particularly those who have made their way in the world, who hold ranks and office, and who enjoy a high reputation. The young are readily inclined to despise the achievements of the old because the latter fight shy of positive, progressive action, because they fail to come to grips with present day reality and its immediate problems. This argument applies not only from a politically revolutionary point of view, but particularly from an aesthetic standpoint. Nowadays, youth takes it for granted that art has a positive meaning in everyday life, that 'art for art's sake' is futile, that it is not a mere pastime for dilettantes nor simply a career for professional artists.

Käthe Kollwitz is sixty years old, and yet she stands nearer to the youth of today than any other artist. What is it about her that forges such a close bond?

She discovered a new style for her art, a new rhythm which enabled her to explore still further the path that Gerhart Hauptmann trod, with ever deepening intensity. She identified passionately with working-class life, and when she finally accepted the revolutionary tradition, this created an exceptional position for her. The basic direction in which her work developed was determined by her revolutionary aims, and these were bound up with her intense sympathy for those involved in the working class struggle, and for all suffering humanity.

Käthe Kollwitz drew her inspiration from life itself. This is what gives her work its tremendous power and penetration. She had no need

Käthe aged eight

to search for a direction in which to develop her art. She discovered for herself the simplest form in which she could make a positive statement, and what is more to make it in such a way that it can be understood by everyone form the worker in the slums to the bourgeoisie. This is the great secret of her art: her 'language' is so universally comprehensible and so powerful in expression that it captures the imagination of everyone who is sincere—all those who are young in mind and heart. The things in her work that grip us, shake and shatter us, are human destinies and human emotions. They are war and hatred, struggle and love, poverty and death. Käthe Kollwitz does not portray motives, her figures are not imitations, puppets or phantoms, she depicts life in all its actuality. There is not a line of her work which fails to make its comment, which does not cry aloud and indict, which does not expose the shabbiness of the petty laws of society. Every picture she draws deals with burning issues for you and for me, for us all. Every face she fashions cries aloud to us: 'It will be your turn tomorrow, comrade!'

Real life is the source of Käthe Kollwitz's immense strength, and it is once more the inspiration for some of the work of young artists today. After Dada-ism and Expressionism, one cannot fail to observe that there is a strong urge towards the representation of a new actuality. As in Käthe Kollwitz's case the artist must have something to say, and must say it in such a way that it can be universally understood. But in contrast to Käthe Kollwitz, the work of many young people today is much too cramped by slogans and a limited outlook. The outpouring of the human soul, so evident in her work, often becomes merely sensationalism and affectation, or even degeneracy, among the painters of the 'new realism'.

Käthe Kollwitz's art is active and alive in its relationship to the present day. It carries within itself the drive, the whole aim and all the longing of youth. There is another factor, too, which brings this artist close to the present generation, and that is the strength of her all-embracing mother love. It hovers about her work like a symbol of goodness, it gives us hope that we shall find a refuge. But it is also an exhortation and a faith in a new and better future.

'I was delighted with your husband's essay about me,'[5] wrote Käthe Kollwitz about that time in a letter to my wife, showing that she was in agreement with my comments.

I should like to quote one more example of her personal influence during the twenties. Some years ago I received a delightful letter from

an elderly lady teacher who lived in Oberweissbach, Thuringia, and here is an extract from it:

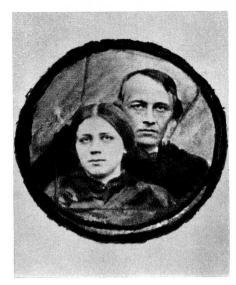

Her parents

> Käthe Kollwitz! I still have a postcard in her handwriting, asking us to ring her when we were next in Berlin. And so we did. I have an odd recollection of our visit to her. Berlin is such a huge city and Weissenburger Strasse where she lived was a long way from the district where we were staying with friends. We were both young teachers at the time and very hard up, and I had to give no end of private lessons before we could take a holiday. In Berlin we telephoned Käthe Kollwitz and she asked us to come and see her in an hour's time. It would have taken us hours to walk and we did not wish to keep her waiting . . .
>
> 'Let's take a taxi,' I exclaimed. 'Have you enough money?' replied my friend. 'Of course, we'll do without lunch, that's all.' 'Splendid idea!' was her answer.
>
> In the taxi we went on talking like this as we drove to Mrs Kollwitz's house, and as we passed a florist's I asked the driver to stop. 'Look at those lovely carnations. Aren't they huge! I'll buy a few for Mrs Kollwitz.' The same question as before — 'Have you the money?' I laughed cheerfully. 'Of course. Only we shan't be able to afford any supper.' 'Oh, good! I'm so glad you thought of it.' I placed the flowers on my lap and thought only of the dear person to whom I was going to give them.
>
> She opened the door for us herself. At first I could hardly make out anything at all in the room, for it was rather gloomy, and terribly austere. The gorgeous lush carnations I had bought were left lying on a little side table, still wrapped in their tissue paper. Käthe Kollwitz was so like her pictures, serious, almost ascetic. I had a great affection for her, and whenever we visited Berlin, we used to go to the Print Room and sit there all morning, looking at her portfolios.[6]

In 1927 when I published the above article, and which was probably the same year that the two young teachers paid the visit just described, we had no inkling of what was to come. We did not suspect that in a few years' time a regime of inhumanity would come to power in Germany, that this would lead to the cruellest war in history, and inflict on the world an incalculable amount of misery and suffering. How powerful Käthe Kollwitz's work was is shown not only in the way it survived such a holocaust, but also by the influence it continues to exert under very different conditions.

Käthe Kollwitz, was born on 8 July 1867, the fifth child of Karl Schmidt and his wife Katharina, the daughter of Julius Rupp. 'At that time we lived at 9 Weidendamm in Königsberg,'[7] she writes in her memoirs. She had only a dim recollection of the living room where she used to sit at a table, painting, but she remembered clearly the gardens and courtyards in the neighbourhood, especially one large garden that sloped down to the flowing waters of the Pregel, where flat barges laden with bricks were moored to the river bank. The child watched, fascinated by the labourers dragging their heavy loads to the builders' yard which her father owned, where the bricks were heaped in tall stacks.

Although she was not yet nine at the time she remembered, too, an old man who made plaster casts, busy in the long straggling shed where he lived. 'I often used to stand and watch him at his work. I can still smell the clammy odour of the damp plaster...'[8] The horses and carts her father used to transport the bricks from the yard to the various building sites intrigued her too. She also recalled the driver, Gudovius, in his blue cloth jacket, and the laden brick carts, rumbling in single file through the town, 'dusty, creaking, dragging their way along the streets, drawn by wretched nags.'[9]

When she was older they moved into a new house built by her father. 'In this house, my mother, with great pain, gave birth to her last-born dearly beloved child, who was named Benjamin in accordance with my father's wishes. This brother lived only a year and like the eldest child he died of meningitis.

'The memory of that period is deeply stamped on my mind. It must have been just before the baby died that we were sitting at the dining table with Mother ladling out the soup, when the old nurse burst into the room crying: "He's vomiting again, he's vomiting again!" Mother made no move but went on serving the soup. That she did not get upset and cry in front of us touched me very much, for she was suffering, I felt it most clearly.'[10] It is interesting that this incident from her childhood left such a lingering impression on Käthe Kollwitz's mind, and was one which lasted until well on into her old age.

The prevailing atmosphere in her parents' house must have exerted a strong influence on the girl. Her father, Karl Schmidt, was certainly an exceptional person. In spite of the claims of his work he concerned himself personally with his children's development and encouraged whatever talents they showed. He was indeed a remarkable man for his time, for although he had taken a degree in law he preferred to become a housebuilder, finding it impossible to reconcile his conscience with the requirements demanded of a judge in the Prussia of those days. He

Her father, Karl Schmidt

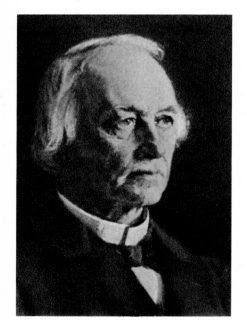

recognized with delight his daughter's gift for drawing when she was still very young, and he wished to help her to become an artist. 'As he saw it, since I was not pretty, there would not be much risk of love-affairs getting in the way of my career, so he was probably disappointed that I became engaged to Karl when I was only seventeen.'[11]

This young medical student, Karl Kollwitz, who later became her husband, his friends and Käthe's brother Konrad, were all imbued with socialist ideas. Contact with these young men was bound to have had an effect on the girl, whose mind had already been moulded by the liberal opinions of her parents.

Their evenings at home must have been delightful, when the father read aloud to the whole family. Käthe remembers how struck she was when she first heard Freiligrath's poem 'The Dead—to the Living'. 'This poem made an indelible impression on me. I used to daydream about deeds of heroism, with Father and Konrad fighting behind the barricades, and I beside them loading their rifles.'[12] Perhaps she was even more impressed by Freiligrath's translation of Thomas Hood's 'Song of the Shirt'. She remembered that her father was so moved by it that he could not finish reading it:

With fingers weary and worn,
 With eyelids heavy and red,
A woman sat, in unwomanly rags,
 Plying her needle and thread—
 Stitch! stitch! stitch!
In poverty, hunger, and dirt,
And still with a voice of dolorous pitch
She sang the 'Song of the Shirt!'

 Work—work—work
Till the brain begins to swim,
 Work—work—work
Till the eyes are heavy and dim!
Seam, and gusset, and band,
 Band, and gusset, and seam,
Till over the buttons I fall asleep
 And sew them on in a dream!

As a girl, Käthe failed to establish a really intimate relationship with her mother, and even in her old age spoke of the 'aloofness of the Madonna'[13], although she loved her mother more than anyone else. She

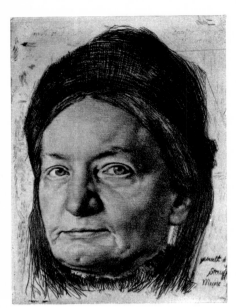

K. Stauffer-Bern:
My mother, 1890

was, however, more in sympathy with her grandfather, Julius Rupp, who influenced her profoundly and of whose undoubted courage she used to speak with pride. He must have been an outstanding personality, whose bearing left its mark on a whole generation. He had studied theology, history and philosophy, and he made his mark while still a young teacher, by achieving qualifications which enabled him to teach throughout the Gymnasium (Grammar School). At thirty-three he became a preacher and soon developed into a celebrated pulpit orator.

Rupp's progressive thinking and frank expression of his ideas attracted attention, for he actually dared to contrast his conception of a liberal state with the reactionary regime that then existed under Friedrich Wilhelm IV. For this he was first cautioned, then subjected to disciplinary action, before being finally dismissed from office. Soon afterwards he founded the first community of free-thinkers, who called themselves 'The Friends of Light'. This group survived for a time in spite of continual obstruction and persecution by the police for the community had no religious creed and was therefore declared to be a political party. Reactionary jurists demanded that the state must prohibit this 'revolutionary' body for its own good. Fines followed and Rupp was sent to prison. Eventually the association was banned altogether on account of its political activities. This man of high principles who was respected by every progressive-minded person obviously had a profound effect on the thinking of the Schmidt family, and a deep friendship grew up between Karl Schmidt and his father-in-law. Anyone concerned with the development of Käthe's character during her early life is bound to include her grandfather's name as a considerable source of influence. In 1884, when Käthe was seventeen, Julius Rupp died. He was almost blind and could hardly speak, but he was tirelessly active until the last.

At about this time Käthe had her first drawing lesson. Her teacher was a copper engraver named Rudolf Mauer, for whom she copied heads from plaster models and reproductions. In her spare time she spent hours wandering through the town, accompanied by her beloved sister Lise. It was not the main streets with their big shops that attracted the two sisters, but the neighbourhoods outside the city gates and particularly the port.

She described these expeditions in her memoirs:

We went back again to watch the loading and unloading of the cargoes... We knew the dock where the flat-bottomed grain ships tied up. They were manned by 'Jimkes' dressed in sheepskins, their feet bound in cloth rags. They were good-natured Russians or

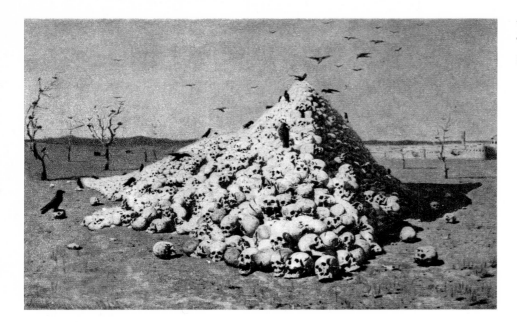

Lithuanians, and in the evenings they used to play the accordion and dance on deck. These apparently aimless wanderings round the town definitely helped my artistic development. Later on, there was a whole period when my work was focused entirely on the world of the working classes: the foundations were laid in those meanderings through the narrow streets of Königsberg, teeming with working class life.[14]

When she was sixteen Käthe illustrated Freiligrath's poem, 'The Emigrants'. The poem, written as early as 1832, impressed the girl considerably:

I cannot turn my eyes away,
I must linger near and stare
As your hurried hands pass all you own
To the sailors standing there.

Although this drawing no longer exists, one can well imagine that it contained something of her later manner. At any rate, when she was about to start lessons a year later with the Swiss painter, Stauffer-Bern,

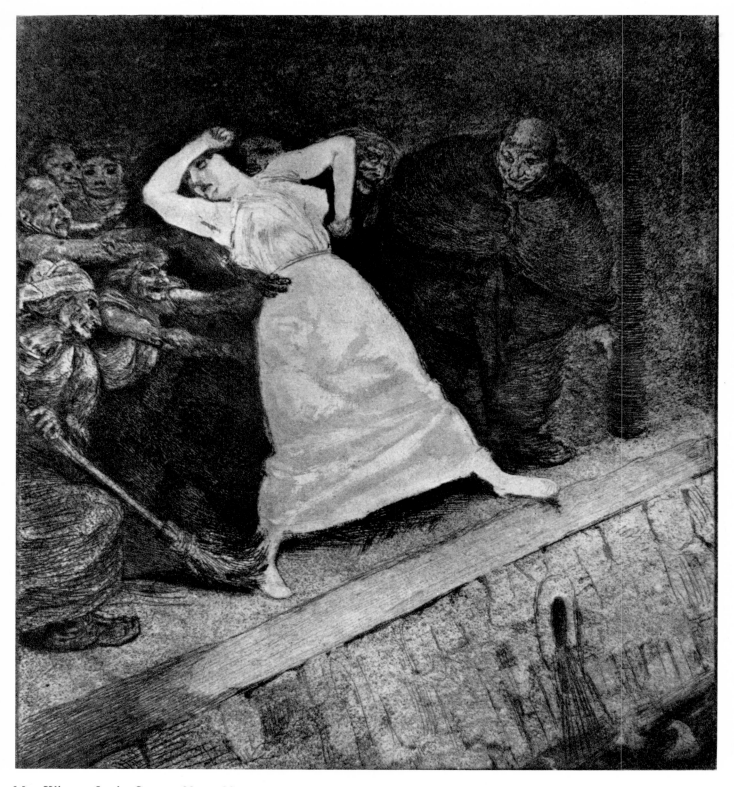

Max Klinger: In the Gutter 1881 — 1884

it was useful as evidence of her artistic talents, for it prompted that usually laconic artist to exclaim: 'But this is just like a Klinger!' It was about this time too that the influence of her brother Konrad reached its peak. Very early on he became aware of his sister's enthusiasm for literature, and he guided her reading towards Goethe, Tolstoi, Freiligrath and Heine. Reproductions of the engravings of Hogarth, the English painter and social critic, also made a deep impression on the girl.

In 1885 Käthe Schmidt left Königsberg to study in Berlin. Her brother Konrad was waiting for her at the station. He had been a student there for some years and he was eager to show Käthe the capital with its population of one and a half million. It was 18 March and he considered it his first duty to take her to see the graves of the victims of the revolution of March 1848 at the Friedrichshain cemetery. How profoundly this visit moved her can be seen in her lithograph of 1913, *The Graves of the Victims of the 1848 Revolution (The 'March' cemetery)*.

In 1885 the atmosphere in Berlin was extremely tense. At the Reichstag elections two years previously, Bismarck had received the people's answer to his so-called 'Socialist Decree' which was directed against the progressive trade unions; with two million votes the Social Democrats had emerged as the strongest single party. Germany, which had been unified politically in 1870, had enjoyed a period of apparent prosperity after defeating France in the war of 1870/71. But now the country was in the depths of a great depression and general distress could be seen everywhere. In the slum areas near the Oranienburg, Prenzlau and Schönhaus Gates, ugly tenement blocks sprang up everywhere, the work of land speculators and dishonest jerry-builders. Their more elegant counterparts were the fashionable houses near the Zoo. The famous avenue, the Kurfürstendamm, was extended westwards to become the showpiece of the city. Beyond it, Halensee and Grunewald were developed, while Westend, Friedenau and Südende became suburbs of detached houses. A similar contrast could be found in the intellectual and the artistic world. The Academy had chosen as its President the tedious Anton von Werner, who specialized in enormous battlefield pieces. This contradictory situation is reflected in the letters of Karl Stauffer-Bern, who was the most important influence on Käthe Schmidt at the time. He wrote to an friend in 1881:

There is a general conspiracy here to give me a swelled head. They say that in the kingdom of the blind the one-eyed man is king and that, to be sure, is why I have had such enormous success. I should

like to be occupied all the time but I can't do it. My work all but disgusts me. I idle away whole days, and most of the time I feel aggressive, as if I should like to challenge the whole world to a fight. I think this mood of mine is due to the fact that among Berlin's one and a half million inhabitants, there isn't anyone of my own age who I feel is a kindred spirit in the world of art, so here I am, with no one to turn to for companionship, it's the very devil... I am resigned to the inevitable superficiality of my work. Just imagine — I wear a top hat these days. Seriousness and pure inspiration, honest endeavour and effort are all going by the board. I often think how nice it would be to keep pigs on some remote farm at home in Switzerland...[15]

Also attracting attention at this time was the Russian artist Vereshchagin.[16] Like Leo Tolstoi he had taken part in the military campaign against the Turks and his pictures were a powerful indictment of the war. Also, a young lithographer named Heinrich Zille[17] was working at the Photographic Society in Berlin. He proudly described himself as a socialist and he spent all his free time drawing, trying to capture the likenesses of ordinary men and women and their surroundings. The exhibition by the Russian painter was held in a marquee at Kroll's, and it made a deep impression on Zille and also on Hans Baluschek,[18] whose parents had moved to Berlin only a few years before. As he himself said later, this exhibition influenced him for the rest of his life.

Through Stauffer-Bern Käthe Schmidt made her first acquaintance with the work of Max Klinger. She found his series, 'A Life', most exciting and although she would have liked to paint, Stauffer-Bern referred her to the work of his friend Klinger, and decided to concentrate on drawing.

The year in Berlin passed quickly and Käthe returned home having made many new acquaintances, and enriched by numerous experiences and impressions. Her original intention had been to return to Stauffer-Bern in Berlin quite soon but this was never fulfilled. He died insane in Italy a year later. For the moment Käthe remained at home and took lessons from Emil Neide,[19] who had studied at the Wilhelm-Dietz School in Munich. Two years earlier, Neide had created a sensation with his painting *Tired of Life*, shown at an exhibition at Berlin's Lehrter Station. Although he painted other pictures with similarly sentimental-cum-criminal themes he was not really an important artist in his own right. However, the fact that he was influenced by the naturalism of the French painter Courbet had fruitful consequences for his young

pupil. Neide was a follower rather than an innovator, but he was certainly effective as an interpreter. There is no doubt that it was he who roused in Käthe a desire to go to Munich which, as a centre of advanced thought, attracted artists from all over world. Munich eagerly absorbed everything that was new in the world of culture and art, and the young people working there had their heads full of Tolstoi, Ibsen, and above all, Emile Zola.

Käthe remained at home for another two years, until her father decided to send her away for a second spell, this time to Munich, to attend the Women's Art School. There she studied under the painter Ludwig Herterich [20]. 'He (Herterich) did not insist on keeping me at my drawing as Stauffer-Bern had done, but allowed me to join his painting class.'

The young girl found a life of freedom in Munich both 'exciting and enjoyable'.[21] She recalls the evenings when she and the girls in her class had animated discussions with young artists:

> A topic was set for these evenings, so I decided on 'Struggle' for mine. I chose the scene from *Germinal* where the two men fight for the young girl, Catherine, in the smoke-filled tavern. My composition was approved and for the first time I felt certain I was on the right road. Great perspectives opened out in my imagination and I could not sleep that night, I was so thrilled at the prospect.[22]

Emile Zola's great novel of the miners of northern France must have deeply impressed the young artist; his lucid and realistic description gave her for the first time an insight into the nature of the struggle of the oppressed against their exploiters. Several years later, she tackled the same subject again, but this time more deeply. She chose to illustrate the fight between the strike-breaker Chaval, and the hero of the novel, Etienne Lantier, leader of the miners' strike. Lantier has ventured out of hiding and at the tavern, he meets Chaval, his opponent and rival. Chavel provokes Lantier and assaults Catherine when he is drunk. The fight which ensues between the two men is captured by Käthe Kollwitz in all its brutality.

Six years later in 1894, she produced an etching on this very theme. She chose an unusual format, very wide and low. It is a sinister scene in that stark, almost empty room. On the left are the two men locked in combat; to the right, the horrified woman watches. Leaning forward, she presses herself against the wall, her body bent from the waist. A disturbing light plays over the whole scene. A description of this etching is included here, as it is an important link between the first tentative

Petition to the Berlin City Council

Playbill

ideas of the Munich period and her later treatment of the same theme.

The intellectual life of Munich in 1888 was dominated by the argument between young and old. Käthe Schmidt, whom her fellow students regarded as a Social Democrat, first heard the workers' leader, August Bebel when he gave a lecture in Munich. His words fell on well-prepared ground so far as Käthe was concerned. She was eager to learn and she now studied the political writings of the Social Democrats.

Despite Stauffer-Bern's insistence on drawing, and the fact that Klinger's work continued to influence her, Käthe herself still believed that she ought to express herself in painting. But then Klinger wrote an essay on painting and drawing, and it was this which made Käthe come to a decision. She now realized fully what she had hitherto merely suspected, that her mission was in graphic art. As she herself put it, very much later, it was only by directing her attention firmly to black-and-white that her real artistic development began.

Käthe's second year in Munich proved disappointing. She gained almost nothing new from it, and she returned home in order to work on her own. She visited the dock areas, the drinking dives which the sailors frequented, and the narrow alleys where the workers lived.

Meanwhile, Karl Kollwitz had qualified as a doctor, and had also completed the necessary probation period of one year. He was offered the opportunity to start a practice as a health insurance doctor (Kassenarzt) for a clothing-workers' factory. Since such a life appealed to both Karl and Käthe they decided to get married and settle in Berlin. 'Shortly before the wedding ceremony, my father spoke to me. "Now you have chosen," he said. "You will find it hard to combine the two. But have it your own way." '[23]

Her wedding in the spring of 1891, and the move to Berlin, proved to be a decisive turning point in her life. From now on, Käthe Kollwitz was not a visitor in Berlin, nor studying there temporarily, but living among ordinary people in a typical working class suburb in the north of the city. Weissenburger Strasse[24] in those days was not important enough to be mentioned in the archives, but in the nineties, a voters' association petitioned the City Council that the street should be 'properly paved', and they described it as 'the most beautiful and the finest' street in the Schönhaus and Prenzlau districts. No reply to the petition, part of which ran as follows, was received:

It is not difficult to understand why the local residents feel very strongly on this subject. For many years, Weissenburger Strasse has been regarded as the most beautiful and the finest street in the whole

Part of the political police
report on the performance
of *The Weavers*

Berlin, den 19 Februar 1893

Verein „Freie Bühne".

Sonntag, 26. Februar, Mittags 12 Uhr.

Im Neuen Theater,

am Schiffbauerdamm:

Die Weber.

Schauspiel aus den vierziger Jahren

von

Gerhart Hauptmann.

Dargestellt von Mitgliedern des Deutschen, Adolf Ernst-, National-, Neuen und Residenz-Theaters.

Zutritt finden nur die Mitglieder des Vereins „Freie Bühne". Für den Jahresbeitrag von 3 Mk. wird ein Platz II. Rang gewährt.

Gegen einen Orchester-Fauteuil werden gegen einen Zuschlag von 3 Mk. I. Rang und Parquet gegen einen Zuschlag von 2 Mk. verabfolgt.

Meldungen neuer Mitglieder sind bis zum 24. d. M. an Herrn S. Fischer, Köthener Straße 44., einzusenden.

area. Recently, like many others in past years, it has become a commercial thoroughfare, and this is confirmed by plans to build many more shops here during the present year. Formerly a very quiet street, it has now become extremely busy as a result of this development, and is used daily by hundreds of commercial vehicles. These and the passing omnibuses make such a noise on the cobblestones (which are in a particularly bad state), that many residents feel they must move. The omnibus and horse traffic goes on until about 1.30 a.m., so that those who have to sleep in rooms overlooking the street lose half their night's rest. For many years now considerable stretches of the roadway have been patched up in the autumn, and as all the residents and particularly the drivers of the omnibuses can testify, the condition actually deteriorates after each of these periodical repairs, once the sand covering the cobbles has been washed away. We are of the opinion, therefore, that for the sums spent each year on repairs the whole roadway could be properly paved.

Dr Kollwitz and his wife lived in a house on the corner of this street and Wörther Strasse, where the doctor also had his surgery. At first their financial situation was none too good, and the young couple often stood at the window or on the tiny corner balcony, watching the passers-by in the street below, hoping that one or other of them would find his way into the waiting-room.

Thus it was that in 1891, Käthe Kollwitz came into contact for the first time with the industrial workers of Berlin. Inevitably she met the 'panel' patients her husband treated, and so got to know these ordinary men and women, their longings and their modest pleasures, their sorrows and their struggles. However, one can detect hardly any influence of these new surroundings in the first works she produced during this period. She made studies for etchings, and at the beginning of 1892, shortly before the birth of her first child, she drew a particularly beautiful self-portrait. At the beginning of May, immediately before her son, Hans, was born, she etched the cheerful plate, *Welcome Home*, which was surely intended as a special welcome for the child she was expecting. In fact labour started while the copper plate was still immersed in acid, and it was left there rather too long. Käthe herself attributed the over-darkness of the print to this. Now, in spite of having to spend time looking after her new baby, she continued her own work. There followed two etchings, *Girl Praying* and *By the Churchyard Wall*, whose subjects are so unlike those of the main body of her work that one can only classify them as studies.

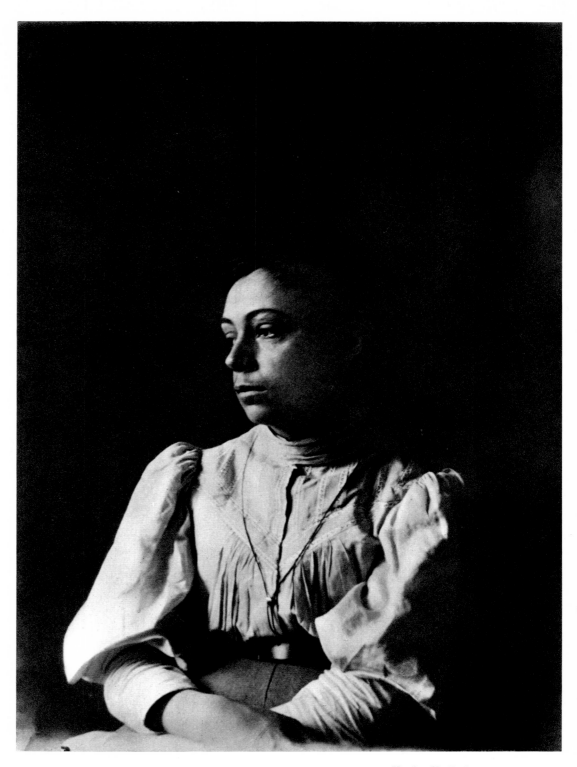

Käthe Kollwitz at twenty-five

About this time Käthe Kollwitz saw the first performance of the play *The Weavers* by Gerhart Hauptmann produced by the Freie Bühne (Independent Stage) company; a play about the 1844 revolt of the Silesian weavers, it deeply influenced her life and work. 'My husband could not come because of his work, but I was there, in a fever of anticipation and interest. It made an overwhelming impression on me. Leading actors performed.'[25] The tense political atmosphere in which this performance took place can best be judged from a contemporary report on it to the 'political' (*i.e.* secret) police, from which I quote:

> The public performance of this play is prohibited. Even though this purported to be a (private) theatre club performance sponsored by the Freie Bühne, the nature and contents of the announcement, which appeared among the other public entertainments advertisements in the newspaper, left no doubt that this was to be, in fact, a public performance. For 3 marks anyone could take out 'one year's subscription' for a seat in the upper circle, a box for 6 marks, or seats in the circle or stalls for 5 marks each. These are rates which correspond to the current prices for a single performance in any theatre, especially when one considers that we are concerned here with the sensational performance of a banned play.

Son Hans at table, 1894

It is reasonable to suspect that the name of the Freie Bühne club which formerly presented plays by Lessing, but which has not, in fact, given any public performance at all for a long time, is being used in this instance as a screen for a public performance; and furthermore, public opinion generally believes that this performance, which may well be followed by others, is designed to evade the police ban on the play.

How far the management of the New Theatre is implicated, cannot be precisely assessed at the moment. It appears likely, however, that the afore-mentioned management were themselves misled.

(Signed) Schwerten, Police Lieutenant.

The impact of the performance on Käthe Kollwitz was tremendous. 'I abandoned the *Germinal* sequence which I had already started, and set to work on 'The Weavers'.'[26]

There followed four highly productive years from 1895 to 1898. During this period, in 1896, her second son, Peter, was born. Although Karl Kollwitz did all he could to see that his young wife had time for her professional work as well as for her maternal tasks, the double burden was considerable, although she gladly bore the strain. Later, in fact, when for a time she had little to do in the house it made her life seem empty, and actually restricted her artistic and creative output. 'When I have no other preoccupations, I work like a cow grazing in a field. My hands go on working, working, and my head seems to know what to produce, though goodness knows how—and yet in the old days, the little free time I had for my work was much more productive. I felt things more intensely, I lived to the full as a person should, passionately interested in everything.'[27]

Gerhart Hauptmann's *Weavers* prompted her to make a study of the subject. The more she delved into its history, the more the 1844 Silesian revolt excited her, and she decided to present the work pictorially. Influenced as she was by the theatre performance, it would have been perfectly understandable if she had made use of it to some degree in her illustrations. But she remained absolutely independent of it in her work and devised a purely graphic concept to describe the revolt of the weavers, in six clear-cut stages from its origins to its conclusions. Many people, especially some younger artists, believe that Käthe Kollwitz created the 'Weavers' cycle and other later historical sequences, on a wave of spontaneous emotion, but this is wrong. In fact she studied the relevant literature most thoroughly, and was guided

by the knowledge she acquired. The 'Weavers' sequence was to lay the foundation of the artist's reputation and she made her father a present of the prints for his seventieth birthday. 'I can't tell you how delighted he was with them. I remember how he ran through the house, calling for Mother to come and see what Katuschen had done.'[28] In the following spring her father died, and Käthe was so grieved that he could not witness the public exhibition of this work that at first she wished to postpone its publication.

I do not think it is an exaggeration to state that if Käthe Kollwitz had done nothing else in her lifetime besides the 'Weavers', this work alone would have earned her a place in the history of art. But happily, it was only the beginning of the immense output of a lifetime.

These plates brought about her first big success. In the Berlin Lehrter Station exhibition hall, the same salon where her Königsberg teacher, Neide, had attracted attention with his sensational picture earlier, they excited considerable admiration. The promoters of the exhibition included Adolph von Menzel who proposed the sequence for the award of the minor Gold Medal. But the Kaiser, who had to ratify

Lyonel Feininger: Moving House, 1898

Hans Baluschek: Women Workers, 1900

Martin Brandenburg: Workers Demonstrating

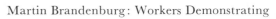

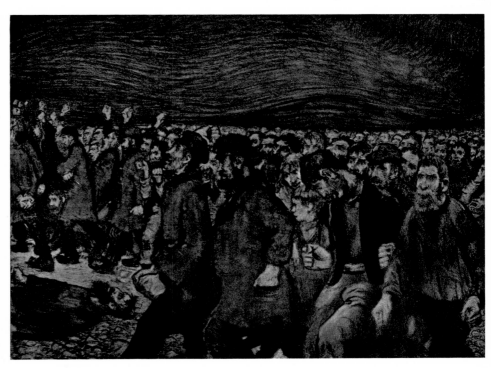

the award, refused to do so. Shortly before, in September 1897, he had promulgated a law for the benefit of big industrialists in Oeynhausen, whereby 'anyone who tries to prevent a German workman who is willing to work from doing so, or who persuades him to strike, shall be liable to imprisonment.' A year later, Käthe Kollwitz received the medal in Dresden, and the prints were also purchased by Lehr, the Director of the Print Room there.

In the same year, 1898, a new and interesting weekly magazine appeared in Berlin edited by Edmund Edel. It was called *The Ship of Fools*, and was to be devoted to 'cheerful art'. Among the contributors were the young artist Hans Baluschek and his friend Martin Brandenburg[29], whose work was characterized by the same socialist aims as that of Käthe Kollwitz. She was especially impressed by Martin Brandenburg, and she wrote of one example of his work: 'That dance of his, the orgy, is something I should like to have done myself.'[30]

Another young artist whose work revealed a talent for well-informed social criticism was Lyonel Feininger, who contributed to almost every issue. Other Berlin artists emerged who were also influenced by the socialist movement, and who began to concern themselves with working class life.

But to return to 'The Weavers'. It was Käthe Kollwitz's first achievement to be completed while she was still young. A few years later she was to start work on another major opus which was to set the seal on her youthful fame.

However, let us take a closer look at the six pictures that make up the series. She varied the effect by using the width of the paper in some and the height in others, according to the demands of the subject matter. The first three, *Poverty, Death,* and *Deliberation,* were lithographed, while the last three were etched. It is surely unique in the history of graphic art that a cycle of works should be carried out using different techniques. She herself explains it thus: 'My technical knowledge of etching at the time was so slight, that my first attempts were unsuccessful. This explains why the first three plates were lithographed, and it was only the last three, *Weavers on the March, Attack,* and *The End,* which were technically adequate.'[31]

In the first picture, *Poverty*, one gazes into the wretched living room of a weaver's cottage. A small patch of light from the poky window pierces the darkness, only faintly illuminating faces and objects in the background, so that they tend to recede. The eye is thus directed to the foreground, where the grieving mother holds her bowed head in her hands, and the starving child lies in its wretched bed, with the light

focused on its small pale face. Although this is a lithograph, because of the linework, it looks almost like an etching, and has quite a different effect from that of the two following prints. This is especially true of the hatched shading of the bedclothes.

In the second plate, *Death*, again the scene is a cramped room. This time, a candle is the only source of light. Only the symbolic grouping round the table is illuminated, with the mother, child, and Death enclosed within its light. The father stands to one side, a dark heavily-built figure, with his back turned towards us. One can sense how the man is suffering, aware of his helplessness.

The third plate is again a lithograph. It shows the weavers deliberating on their plan of action. At first the artist tried to etch this on copper, but she was not satisfied with the result and she rejected the plate, preferring to work on stone instead. When one compares the intended engraving with the lithograph, the difference is obvious. In the etching Käthe was carried away by the possibilities of fine-line engraving, and she paid too much attention to detail. In the lithograph, however, she achieves simplicity, concentrating everything on the most important aspects of the situation.

Her use of light to emphasize the significance is masterly. In this print, her technique reminds one of Rembrandt, the magician of light. In spite of, or rather, because of the simplicity of the presentation, the faces of the conspiring weavers are full of expression. One can feel that they are troubled about the situation, but they are also resolved not to rot helplessly any longer. They discuss their future tactics in the struggle so that they can force their exploiters to give way.

The fourth plate shows us *Weavers on the March*. This time it is an etching and the inevitable hardness of the medium is ideal for the subject. The heavy hands of the men are obviously used to tough manual work at they grip their implements or are clenched into fists. The woman in the foreground with a child clinging to her back is unarmed, but she marches alongside the weavers, a clarion call and a reminder at one and the same time.

The fifth plate in the sequence, *Attack*, presents the womenfolk actively participating. Here they are part of the struggle, tearing up cobblestones and handing them to the men. There is rhythm in the movement as a whole, the women first stooping, then rising, and the curve is completed by the throwing action of the men, as they shatter the windows of the owner's villa. Again Käthe Kollwitz preferred an etching for this plate because the needle technique made it possible to present a massed crowd, and yet to differentiate between the various figures that compose it.

The last picture in the sequence is also an etching, *The End*. The weavers have been defeated; in the room are two of their dead and a third body is being carried through the doorway. In the foreground stands a woman, suffering in silence, her arms hang loose, her fists clenched. It is interesting to witness the development of this plate from the first *tusche* sketch to the finished product, especially when one observes how the artist has changed the woman's posture. In the sketch her arms are folded over her body—she is resigned. At the bottom of this sketch, there are studies of clenched fists. There is also a study for *Poverty* that reminds one a little of a stage set. Even the format contributes to this impression, but what supports the idea most of all is the arrangement of the figures as if they were actors on a stage. The woman's theatrical pose, which is most unusual in Käthe Kollwitz's work, adds to the illusion. In the background to the left stands a man. There is a wonderful study for this picture. A candle flame sheds a faint glow over a figure standing in its own shadow so that one senses rather than sees the suffering in the face.

Originally, it was the artist's intention to conclude the cycle with a piece of symbolism, but this etching would have detracted considerably from the severe concentration of the whole. Julius Elias, the liberal bourgeois art historian, realized it at the time, and he was quite right in his critical appreciation of the complete work:

> It would have been both misleading and irrelevant to end this historical tragedy of modern life with an unnaturalistic symbolism. The seventh plate, showing a dead man stretched out Christlike, with women crucified to right and left, and the caption 'O nation, you bleed from many wounds', was intended as a unifying, metaphysical conclusion... On my advice, Käthe Kollwitz left this plate out. So the righteous struggle of the weavers remained a human one, its happiness and its end, poverty and death, were bound together in a unifying chiaroscuro, an overwhelming epic of our time.

While Käthe was working on the sequence, she also produced a number of individual works which I do not wish to dwell on here. If I have devoted a disproportionate amount of space to 'The Weavers', it is because this opus stands at the beginning of her artistic development, and became the basis for the whole of her later work.

As a result of this success, Käthe Kollwitz was appointed to teach Graphics and Nude Studies at the Berlin School of Art for Women. Teaching also gave her an opportunity to develop both aesthetically

Deutſche Heimarbeit-Ausſtellung 1906.

and technically, especially in etching. It was at this school that she met Hans Baluschek and Martin Brandenburg, who were then both twenty-nine.

During this period Käthe Kollwitz conceived the idea for another major cycle, 'The Peasants' Revolt'. But before she approached this powerful work, she produced a number of important single plates. One of these etchings, *The Downtrodden*, is of special interest. It was originally a tryptich, and the centre and right panels are obviously very much influenced by Klinger. They are strongly symbolic and not at all in the artist's customary style. Later, she herself considered that only the left panel had artistic merit, and both by reason of its content as well as its artistic treatment, it is the most exciting of all her achievements. It portrays the misery of the proletarian family; not struggle, but the rope, will bring release from a life deprived of human dignity. There is a pencil study that goes with this picture; no more than a mother's hands protectively cupped round the delicate head of a child. It is a study I have known for several decades now, yet it still has the power to move me deeply whenever I see it. This was in fact the first time that Käthe Kollwitz revealed herself as the mother figure in all her greatness.

As for the father, his hand hides his face and he turns away his head. It is the 'Kollwitz hand', which can be seen in almost the identical position some nineteen years later in the Karl Liebknecht Memorial woodcut. Outstanding among the works that followed 'The Weavers' are *Woman with Folded Hands*, *Carmagnole*, and *Revolt*. The last two again treat a revolutionary subject historically. 'Revolt' is a first approach to the theme of the 'Peasants' Revolt'. In the background the enemy citadel, the stronghold of the oppressors, is ablaze. Above the heads of the marching peasant rebels hovers a symbolic female figure, the torch of revolution in her hand. In the *Carmagnole* ordinary provincial houses form a back-cloth. The women stamp their feet as they dance round the guillotine.

In 1902 Käthe Kollwitz began work on the 'Peasants' Revolt', which was commissioned by the Association for Historical Art. She made a large number of preliminary sketches and studies, many of which were used in the final execution. In 1903 she finished the first and most powerful plate of the whole cycle, which seizes the moment when the revolt explodes into action. It is both interesting and perhaps also significant that the series was not carried out in strict sequence. Although she put in a great deal of work on *Ploughing*, which was to begin the cycle, she did not complete it first. Perhaps it would be helpful here to establish the cycle in its correct order.

1) *Ploughing* depicts the peasants harnessed to the plough like animals.

2) *Raped* typifies the brutality of the mercenaries roving the country-side, terrorizing the peasantry.

3) *Whetting the Scythe* is remarkable for the expression of fury on the peasant's face as he sharpens his scythe.

4) *Distribution of Weapons in a Vault* shows the peasants arming themselves in secret.

5) *Revolt* captures the 'flash-point', the actual moment when smouldering passion bursts into action.

6) *The Battlefield* is self-explanatory.

7) *The Prisoners* concludes the series.

It was a colossal achievement for so frail a woman to complete this quantity of work in only a few years, for one must remember that between the appearance of the various prints just mentioned she produced many single plates as well.

In considering this major work of Käthe Kollwitz, I shall confine myself to describing the detail of two pictures, *Revolt* and *The Prisoners*.

Revolt is in my opinion the most powerful plate in the whole series. If it is compared with *Attack* from 'The Weavers' sequence, one can perceive at once the artistic and idealogical development that has occurred. This is indeed a *Revolt*; it explodes on the page as the peasants surge forth, there is an unmistakable determination to fight in their haggard faces. The woman in the foreground raises her arms to give the signal. Käthe once told me that she had portrayed herself in this woman. She wanted the signal to attack to come from her.

A similar development has taken place if one compares *The End*, the final plate of 'The Weavers' cycle, and *Prisoners* from 'The Peasants' Revolt'. The weavers are defeated, resigned. It really is 'the end' for them. It is quite different with the captives of the 'Peasants' Revolt'. They too are defeated, probably they will be executed, and yet this is not the end. Their faces are defiant, firmly they stand, feet planted apart. The artist has made much more powerful use of her etching technique and a certain pettiness detectable in 'The Weavers' has disappeared. All the plates in the later sequence are conceived on the grand scale. The figures are not cramped but set in space. There is neither scenery nor 'stage props'.

While she was working on 'The Peasants' Revolt' cycle Käthe Kollwitz was awarded the Villa Roma prize founded by Max Klinger, the artist whom she respected so much. He had bought a house in Florence to enable talented artists to spend a year in Italy free of charge. Although the seven months she spent there did not lead to any creative achievement of her own, the award was useful in bringing her artistic recognition. In spite of her absence from Berlin, and before she had completed

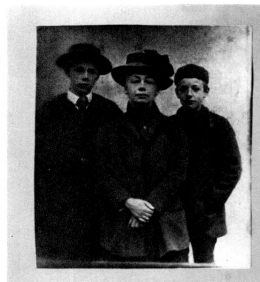

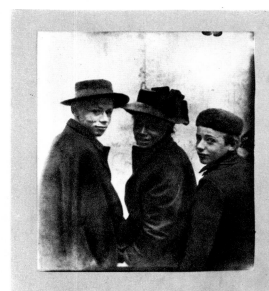

Käthe Kollwitz and her sons, Hans (left) and Peter (right) c. 1910

the 'Peasants' Revolt' cycle in 1908, she published a number of individual works, mainly heads of simple, working-class women, and also several fine self-portraits. During the same period she also produced the partisan poster for the Home Industries Exhibition which took place that year in Berlin. As a result the Kaiserin refused to visit the display unless the Kollwitz poster was removed.

'The Peasants' Revolt' brought enormous success. No one could now dispute the fact that Käthe Kollwitz had risen to the front rank of German graphic artists. The important and progressive Munich periodical *Simplicissimus* recognized her great talent and secured her services. It published a number of her socially critical drawings, most of them in charcoal, drawn especially for this review, whose leading light was then Thomas Theodor Heine.

Käthe Kollwitz, c. 1910

During the years that followed her work became even bolder in conception and more assured in composition. However, for subject matter she returned strikingly often to the mother-and-child theme. After her stay in Italy she tended to use a rather large format for her etchings, which gave them a certain monumental quality. It was about this time, too, that she ventured upon her first sculptures. The larger etchings just mentioned often show a mother either wrestling with Death for a child's life, or sitting holding a dead child. There must surely have been some factor in her personal experience of motherhood that made her give Death such a dominant role in connection with the 'mother-child' motif, something in her inner nature which was responsible for it.

From 1909 onwards Käthe Kollwitz kept a diary which gives us some insight into her thoughts and intentions, so that from now on much of her work can be interpreted more accurately. So far she had been inclined to take historical subjects for her major cycles, and for the individual plates, either studies of heads of working class women or some generally human theme such as the mother-child relationship. From about 1910 onwards, however, she began to concentrate more and more on the representation of reality. This artistic development runs parallel with her ever closer involvement with the working class world about her. In September 1909 she wrote in her diary:

Frau Pankopf was here. She had a black eye. Her husband has started beating her. I asked her to tell me something about him. She replied that originally he had wanted to become a teacher, but instead he had taken a job in a workshop making tortoiseshell articles, which had been very well paid. Then he developed heart trouble, and it was about the same time that he suffered his first bouts of mental

disturbance. He had treatment, and made an effort to work again but it was no good. He tried to get other work, last winter he played the barrel organ in the streets. His feet started swelling and his fits of depression grew from bad to worse. He kept moaning that he wanted to die, that he could not maintain his family and so forth. When the second youngest child died, he was hysterical and remained upset for much longer than his wife. There are six children left. In the end he became violent and was taken off to Herzberg. The more I see, the more I understand the typical misfortunes of working class families. For the woman it's always the same wretched business, she has to maintain the children and feed them so she turns round and abuses her husband, and continually finds fault with him. All she can see is the kind of man he has become, and not what has made him change.[32]

Typical of her output at this period is *Run over*, a harrowing picture which shows the way parents suffer when their child is killed. She also made impressive drawings of heads, mainly of working class women, whose faces are careworn, but not without hope. There is one wonderful, etching, *Mother holding a Child*, an ordinary woman with a beautiful, optimistic smile. Then the artist returned to the mother-child-death theme in several of her etchings, and in the years leading up to 1912, she also produced more of her splendid self-portraits. Etching was now proving inadequate for her purpose, and could not express her intentions fully. 'I believe I shall have to find a more abbreviated way of expressing myself. My work is becoming too detailed these days.'[33]

In 1913 she began, therefore, to change her technique. She turned more and more to lithography, but in quite a different way from the early 'Weavers' prints. She used broad chalk strokes on the grained stone, and varied the graining herself for each work according to its subject. She thus opened up new possibilities for achieving her aims and also in the treatment of the subject matter. Her first effort in the new technique was *The March Cemetery*. It was something of a delayed reaction to her experience as long ago as 1888 when she and her brother Konrad paid their respects at the graves of the victims of the 1848 revolution. How simply she describes the scene, with broad chalk strokes gliding over the surface! These are working class men and women showing their emotion as they honour the heroes of the revolutions, filing past the graves in Friedrichshain.

1914 arrived and with it came the Great War with all its ruthless cruelty. At first Käthe's attitude was one of bewilderment and her feelings were deeply divided. From the very first day her whole being

revolted at the thought of nations engaged in mutual slaughter. She and her husband happened to be in Königsberg when war broke out, and from their hotel room they could hear the soldiers singing as they marched past. 'I sat on the bed and wept, wept, wept. I knew it all, even then.'[34] On the other hand, she believed that youth must sacrifice itself for its country. At a meeting of the liberal political group, the *Sezession*, where Heinrich Zille expressed a very different opinion, she could actually reply to him: 'I'm sorry Zille, you simply don't understand.'

Her son Hans tells how, at the beginning of the war, his mother's sadness abated somewhat 'when the young men started volunteering, particularly my brother Peter and his friends'. People had little idea then of the sordid background to the war; they accepted 'Hölderlin's concept of death for the Fatherland' and the whole idea of sacrifice. 'A mother will keep faith with her son, who offers to lay down his life, by her own willingness to make sacrifices.' On 27 August 1914 she wrote in her diary:

> Where do all these women find the courage to send their dear ones to the front to face the guns, when they have watched over them all their lives with such loving care? I fear that the despair and despondency which are bound to follow will be all the blacker for the present mood of exaltation. The problem will be to keep going not only during the next few weeks but for a long time to come, even in the bleakness of November, and even when spring comes again, for March is the month of the young, of those who wanted so much to live and who will be dead by then.[35]

And one month later, on 30 September, she wrote:

> In times like these, the idea of boys going into battle strikes me as senseless. It is all so pointless, so insane. Among my stupid thoughts: But they can't possibly take part in such madness — and immediately after, like a cold shower — they must, they must! Death is the great leveller, down with youth! It's enough to drive one to despair.[36]

Only when her beloved son Peter was killed in the flower of his youth after no more than two days at the front, were her feelings as a mother stricken; but even then she did not change her attitude immediately. Only after much inner conflict did she do so, reluctant as she was to admit that his sacrifice had been futile.

On 27 August 1916 she wrote:

Poster

How did my implacable opposition to the war come about? Through Peter sacrificing his life. What became clear to me then, and what I wished to preserve through my work, is less certain now. I believe I can only retain Peter, if I keep a grip on what he taught me. The war has been going on for two years, five million lads are dead, and more than twice that number of people have been made unhappy and had their lives shattered. Can anything possibly justify it?[37]

Yet her whole being fought against it. 'But peace, peace—no more war. If only there were an end to the killing.'[38] Even now she wrote nothing about criminal and futile slaughter. She had her art to which she felt dedicated and Peter's death set her a new and important task. She wanted to create a monument for him:

It must stand on the heights of Schildhorn, looking down over the Havel. I want it finished and consecrated on a beautiful summer's day. It is to be a figure of Peter lying full length, his father at his head, his mother at his feet, a memorial dedicated to the final sacrifice of the young volunteers.[39]

She set to work and carried on untiringly, but she kept changing her mind about the appearance and the purpose of the memorial. And at last Käthe Kollwitz admitted: '...we were deceived at the time. Were it not for this monstrous fraud, Peter and many millions of others would be alive today. We have all been duped.'[40] This realization changed both the nature and the aim of the projected monument. What was first intended only for Peter, next for the volunteers as a whole, and then for German youth in general, was finally dedicated to the vain sacrifice of young people everywhere.

Käthe Kollwitz discovered her own personal path as well as a direction for her art. For the time being she still had to struggle with both the form and the content of the memorial, and often she almost lost heart. Nevertheless, she went on with it because she had to, because this was the only way she could release herself from the burden of her self-imposed and sacred trust.

About this time, E. von Keyserling wrote an essay attacking Expressionism, saying that in his opinion after the war people would want less than ever the rarefied art of the studios. What was required was authentic realism in art. Käthe Kollwitz agreed with him:

> Exactly my opinion too—if what K. means by realism in art is the same as I mean... Art for the man-in-the-street need not be superficial. Admittedly it will please him even if it is commonplace, but true art will certainly please him if it is simple. I am convinced that there must be an understanding between the artist and the people such as there always used to be in the best periods in history.[41]

Until the war was over Käthe Kollwitz produced very little new work. As the slaughter approached its end her anti-war attitude became more and more uncompromising. She knew that if Germany were not to be utterly ruined it must preserve the young men who had survived so far. 'That is why the war must not go on for a day longer, once we realize we have lost.'[42] But was the war to be ended merely because Germany's defeat was certain? As late as October 1918 the poet Richard Dehmel made an appeal in the magazine *Vorwärts* (Forward) asking everyone

capable of fighting to volunteer for the colours. He believed that it was necessary, after weeding out 'the milksops' to find an 'elite of men prepared to die' and so save Germany's 'honour'. Käthe Kollwitz immediately replied, opposing Richard Dehmel categorically:

What would be the result? Very likely these volunteers would indeed be sacrificed, and after the daily loss of life for so many years Germany would simply bleed to death. Dehmel's own logic insists that those who survived would not be the cream of the German people. The elite would be lying dead on the battlefield. In my view, such a loss would be far worse and more irreplaceable than the loss of whole provinces. We have had to alter our thinking profoundly in these last four years. I believe we must also change our idea of what constitutes 'honour'. We do not consider that the Russians are dishonourable, because they have agreed to the fantastically harsh terms of the Treaty of Brest-Litovsk. They have done this from a feeling of duty, in order to conserve their remaining strength for internal reconstruction. Her reply concluded with these words: Enough have died! Not another single soldier should be killed in action. I call to witness against Richard Dehmel someone greater than he who said: 'Thou shalt not grind the seed corn.'[43]

When the war ended, the memorial for Peter was not nearly finished. The revolution of November 1918 and the events that followed, plunged Käthe Kollwitz into another set of inner contradictions. After the terrible four and a half years of war all she wanted now was peace and an ordered existence, but at the same time she felt it was not going to be so simple, and she tried to explain to herself wherein lay 'the appeal of Communism.' To Beate Bonus, a friend with whom she had studied in Munich, she wrote:

I expect we shall be disappointed in that direction. The crushing weight of the war years and the complete collapse of the old order, has left Germany naked and new, like a blank coin waiting for the die. One expected everything would be different—there would be the boldest, freshest ideas. One thirsted for truth, for brotherhood and wisdom. That was in the days of the revolution. What actually happened wore a different face from the one we dreamed of. The child has turned out to be no infant prodigy after all, but one who resembles his parents all too much. Against everything we expected, the achievements of the Social Democrats are paltry indeed so far. And now

comes Communism, which indisputably contains an idea, and it is this idea which attracts people. I find it terribly difficult to take sides. I voted for the Social Democrats, but all the same I wish the government would do more. To make matters worse, we have just heard that Liebknecht and Rosa Luxemburg have been murdered in the most despicable and infuriating circumstances.

She went on to say that she had gone to Liebknecht's house on the morning of the funeral to make a drawing of him: 'He looked very proud. There were red flowers round his forehead, where he had been shot.'[44]

In January 1919, Käthe Kollwitz was made a full member of the Prussian Academy of the Arts, and she now returned once more to graphic work. Many of her drawings echoed the recent war. But again she became dissatisfied with the techniques she had used so far and after several attempts, she began experimenting with woodcuts, the first of which was the memorial to Karl Liebknecht. After her previous efforts with etching and lithography, she achieved an increased expressiveness with woodcuts. By forgoing the use of half-tones, with the picture confined to stark black-and-white, the large dark surfaces and the white cut-outs give the picture a strong feeling of compactness. The whole area is used, right to the edges. The white horizontal below is the shroud, to the right we see the proud profile of the dead man. At the upper edge is a serious row of proletarian faces, while in the foreground the centre is dominated by figures of workers saying farewell. The man farthest to the left has his head slightly bowed, the second inclines a little more and the movement continues until the fourth figure is stooping over the body of the revered leader. His hand rests on the white of the shroud, representing the hands of all the workers who mourned Karl Liebknecht's death. On the far right, one man is turning away, about to hide his face with his hand. He stands out from the surface of the picture, and his other hand brushes the shroud for a brief moment before withdrawing. Between the upper row of heads and those bidding farewell, there is a mother holding a child, bending towards the countenance of the dead man. It is a powerful composition, to which the artist gave the caption *The Living to the Dead. Memory of 15 January 1919.*

I saw this wood-cut for the first time in 1920, at the Workers' Art Exhibition in Petersburger Strasse, Berlin-Osten, where Käthe Kollwitz was showing a collection of her works. A year earlier I had already made her acquaintance personally at the opening of an exhibition of the 'Workers' Council for Art', arranged by Adolf Behne, where three of my

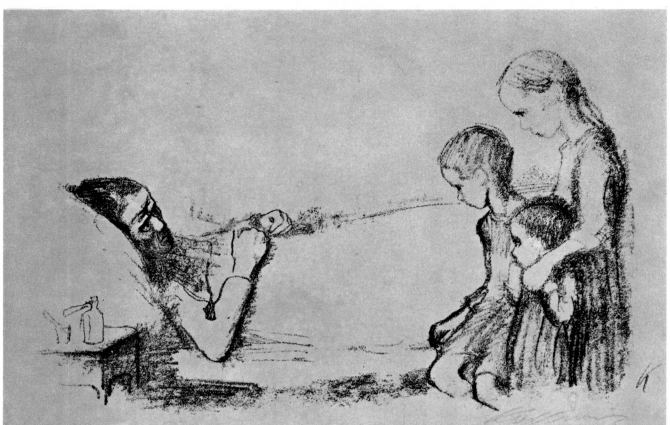

Die Kranke und ihre Kinder

Leaflet, 1920

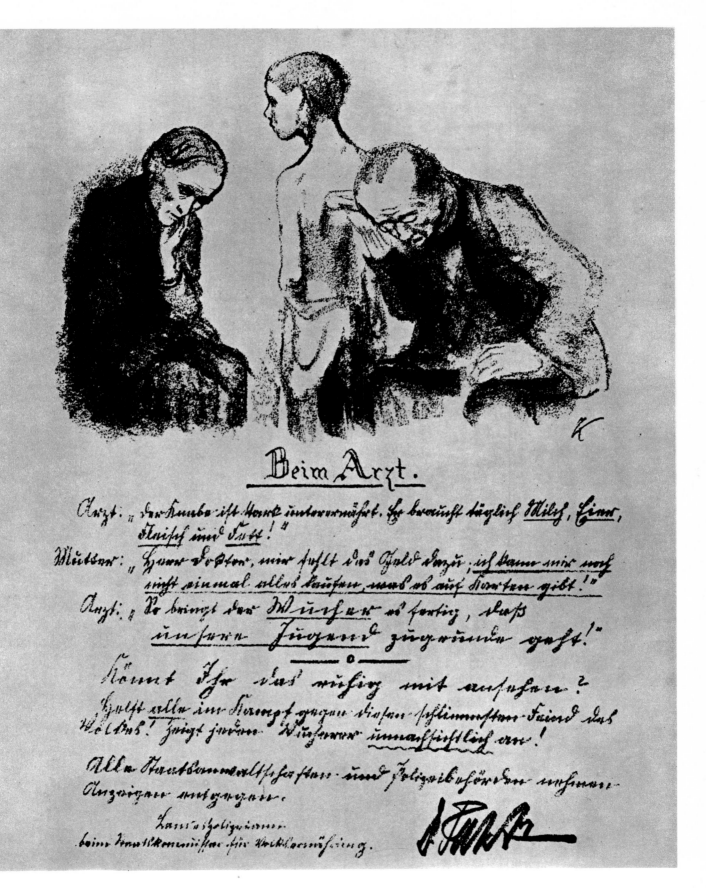

Leaflet, 1920

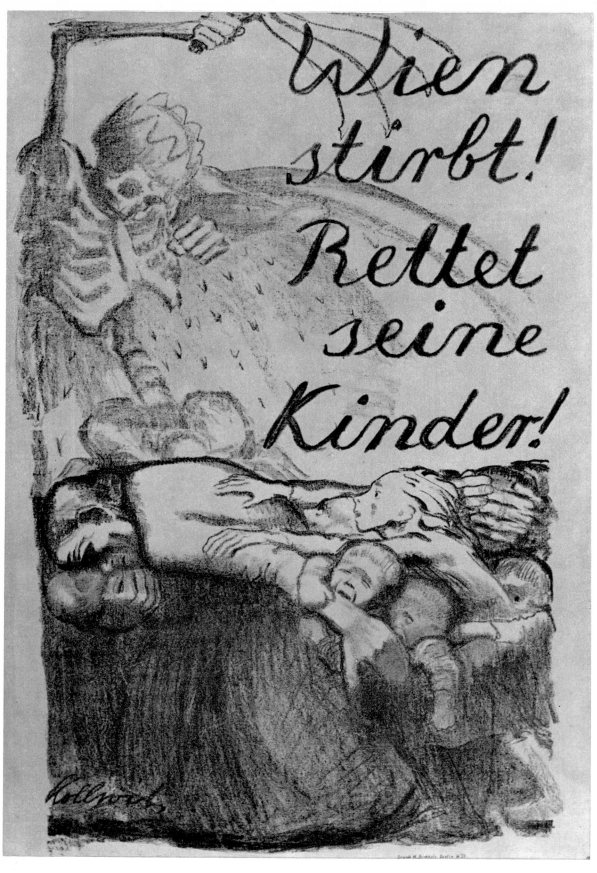

Poster

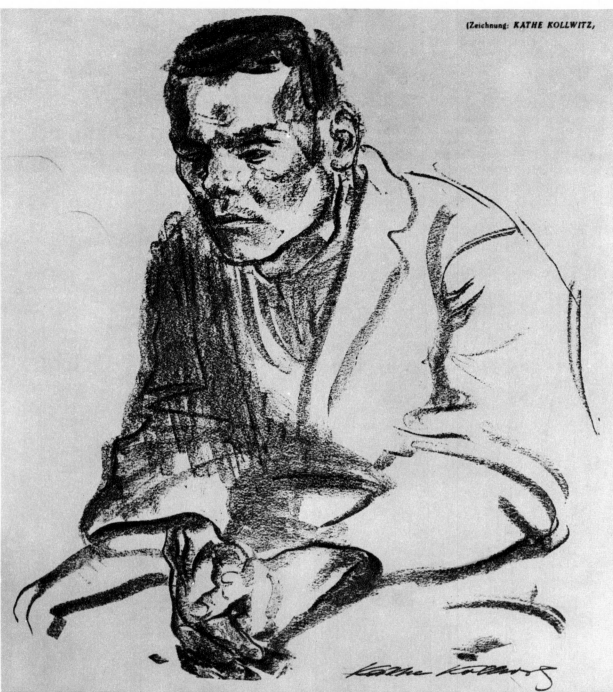

DER ARBEITSLOSE

Achtstundentag! Genosse, sag:
Wie viele der hohen Herren feiern
Tag um Tag, Jahr um Jahr. Für unsern Lohn!
Acht Stunden wollen wir arbeiten,
Du lächelnder Bürger der Straße,
Weißt du es schon?
Weißt du es schon,
Daß Hunderttausende von Arbeitern
Zehn und zwölf Stunden schuften,

Damit wir übrigen keine Luft schöpfen,
Keinen satten Bissen essen,
Damit wir wie der Rinnstein duften!
O wollte ein „gerechtes" Gesetz,
Daß jeder nur
(O, dieses Nur!)
Acht Stunden in banger Fron sich quäle,
Damit die Arbeit
Niemand, niemand fehle!

ARNO NADEL

Illustration to Arno Nadel's poem: Unemployed

Letter to Otto Nagel, 31 December 1924

pencil sketches of workers' heads were displayed.[45] Käthe noticed these drawings and asked to be introduced to me. I met her again at her own exhibition, and there began that delightful friendship of ours which lasted until her death in 1945.

She placed the Karl Liebknecht block at the disposal of the Workers' Art Exhibition to raise money for financing its projects. To my certain knowledge, several hundred prints were sold there at a few marks each. The following year this fund made possible my own first exhibition, which was opened in the same hall in the presence of Käthe Kollwitz. That was also the year, 1921, when the recently established Soviet Union was stricken by a terrible drought in the Volga Basin. Lenin called for solidarity from all progressively minded people. An international assistance committee was formed which included Käthe Kollwitz as well as such personalities as Maxim Gorki, Anatole France, and many others. To help the solidarity movement that followed Käthe published the stirring *Help Russia* poster.

As early as the spring of 1920, she was ready to use her great talents for humanitarian leaflets and posters. She produced a large anti-war lithograph, *The Mothers*, for the International Federation of Trade Unions in Amsterdam. When Vienna suffered a terrible post-war famine she designed the poster *Vienna is dying! Save the children!*

Other lithographs included moving leaflets protesting against the extortions of avaricious profiteers who exploited the appalling postwar conditions for their own gain. In the course of the following months, she continued to produce single works of great artistic power, mainly woodcuts, but also lithographs.

In 1922, Käthe Kollwitz set to work on a new series. In this she transformed into art the terrible experiences of the recent war which still haunted her so vividly. The series consisted of seven woodcuts with the following titles: *The Victim, The Volunteers, The Parents, The Widow I, The Widow II, The Mothers* and *The People*. In some of these, particularly *The Parents* and *The Mothers*, her preoccupation with sculpture is most evident. The figures are enclosed as if within a mould, and they have a sculptural quality about them. The whole series took barely two years, and was completed by the end of 1923.

There followed a number of single works, woodcuts or lithographs. At first the subject of death appeared many times, but later, the artist devoted herself more and more to the service of social and humanitarian demands and tasks. For the benefit of the German Communist Party, she designed a poster protesting against a new law on abortion.

In 1924, I went to the Soviet Union, in order to stage the first German

Art Exhibition that had ever been held there. I took 500 works with me, and Käthe Kollwitz was represented by a large collection. On New Year's Eve 1924, she wrote to me in Moscow:

I am so glad that the Moscow Exhibition has been such a success, and that my work is to remain there. I should very much like to visit Russia one of these days. Vogeler[46] spoke just as you do about the people there, how naturally they behave, and how cheerful they are. How nice that must be. But would one get anything out of a visit, even if one knew no Russian? Remember I don't speak a word of it.

Tonight is New Year's Eve, and my husband and I will see the New Year in together. We do not feel sad, but we are certainly in a serious mood, as are most people here, and that surely needs no explanation. Well, here's to a Happy New Year, 1925. Let us hope it won't resemble too closely the troubled years that are over. We must have courage.

Most sincerely,
Käthe Kollwitz.[47]

What had made the Kollwitzes, and most other people, so grave during 1924 is evident if one studies both the work that Käthe produced that year, and the circumstances that inspired it.

Employers had launched a general attack on the eight-hour-day that had been so painfully won by the workers in the early post war years. Inflation, which had eroded the workers' purchasing power more and more, had now reached its peak and the distress suffered by ordinary people defies description. This was the background against which Käthe Kollwitz produced a poster for the International Workers' Relief Organization, called *Germany's Children are Starving*, which people found profoundly disturbing. It shows children with accusing eyes asking for help as they hold out their empty plates.

Many artists united at that time to support the workers' struggle and to provide some practical help for those involved. As secretary of this 'Help by the Artists' movement, I had first-hand experience of the alacrity with which Käthe Kollwitz responded. An exhibition of the work of about 250 professional artists was put on at the Wertheim stores in Alexander-Platz. All these pictures were donated for sale, including valuable contributions by Käthe Kollwitz. When the committee decided to issue a portfolio of lithographs entitled 'Hunger'[48], to give further financial support to the strikers and to other victims of oppression, Käthe produced the splendid print *Bread*, which is not only a magnificent

View of exhibition at the Wertheim stores, 1924

aesthetic achievement, but also has a strongly moving humanitarian appeal.

How intensely her feelings were roused at this period by the destitution of the masses is revealed in a number of other works, such as the woodcuts *Empty Plates* and *Mothers and children going to their death*. During 1924, she produced more new work than in almost any other year. There were other powerful lithographs such as *Fraternization*, and most important of all, a passionately anti-war poster which is as relevant today as ever it was. This is *War, Never Again!*, and it shows a young man with his arm raised in a passionate oath against all wars. In 1924 there also appeared a self-portrait, perhaps the most beautiful she ever achieved.

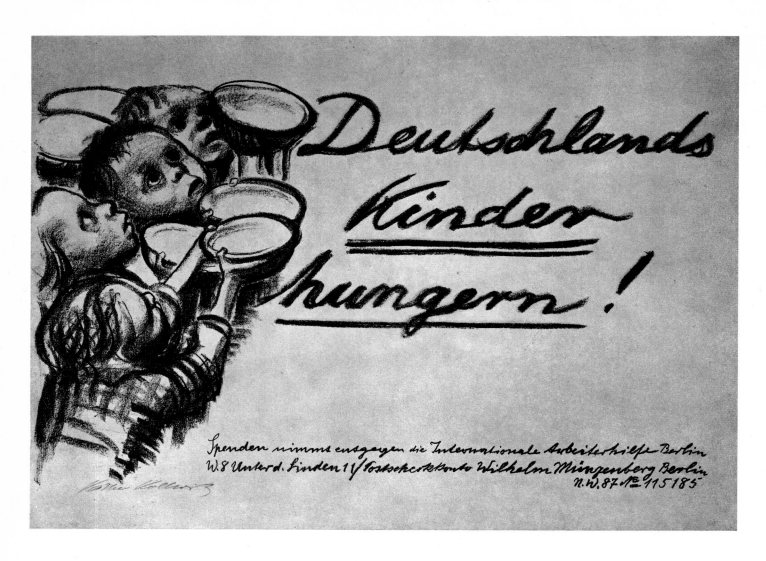

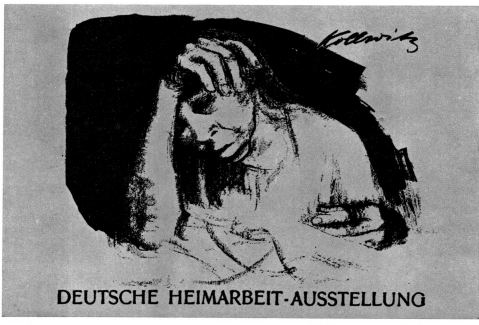

Poster, 1924, and Postcard, 1925

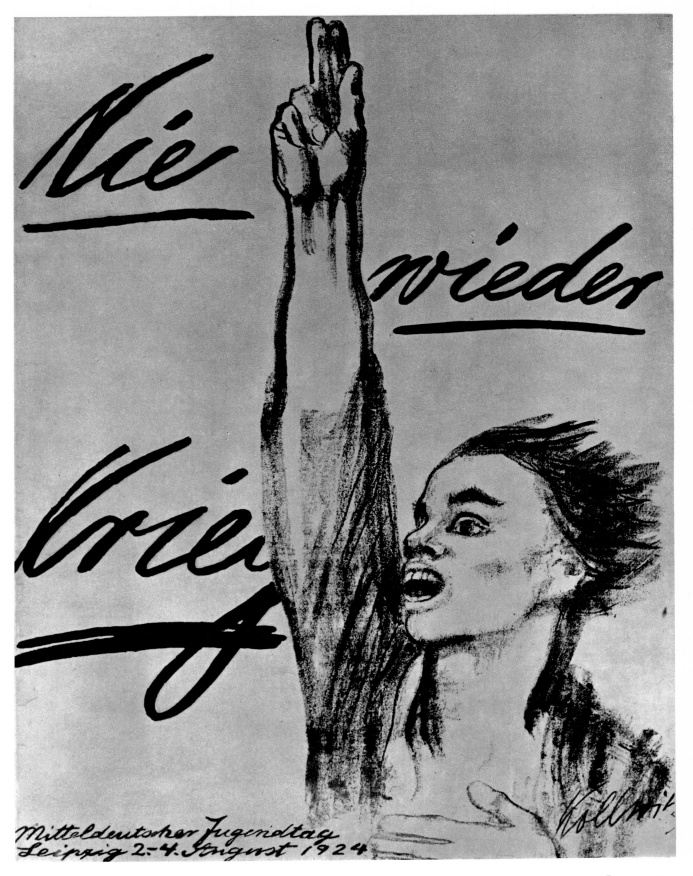

Poster, 1924

The following year saw a new pinnacle. Three woodcuts comprised 'The Proletariat', a sequence treating the topical themes of unemployment, hunger and child mortality. By now, she had achieved in her art the simplicity only a genius can afford. White areas are introduced into the black ground surface with great economy, thus obtaining the most remarkable effects. In these three works, as in her earlier examples, the hands of her models play an important part. There is significance not only in their artistic treatment, but also in what they are actually doing. In *Unemployment*, the father puts his hand to his throat. In the face above, the eyes are dark hollows from which two pinpoints of light gaze at us in despair. In the same picture is the accusing face of a child. The large round eyes stare at us questioningly; an empty spoon is clasped in the small hand.

There followed single plates, mainly lithographs, on the mother-child theme. From this period dates the lithograph *Visiting a Children's Hospital*, which is full of beauty and human emotion in a proletarian context. It shows a little girl, who has been seriously ill; the worst is over and now her parents have come to visit her. How lovingly the mother looks at the child, how tenderly she holds the cup to her mouth, and the girl responds with utter confidence in her mother. The father sits beside them, gazing at the child now miraculously, unbelievably restored to health, his daughter for whom he would like to do so much. His heavy worker's hands lie relaxed in his lap.

The next year, 1926, Käthe and Karl Kollwitz were able to undertake the long desired journey to Roggevelde in Belgium. On 11 June she wrote to Hans, her son, and his wife, Ottilie, who lived at Lichtenrade, describing how she had found Peter's grave at the military cemetery. I quote at length from this letter because it reveals how, through her personal experience, she gained a new insight into her ideas as an artist concerning the location of the two statues she was working on:

The day we arrived in Dixmuiden, we had to go back to Zarren by train, for we had been told that Roggevelde lay between Zarren and Eessen. Probably the village itself was tucked away somewhere, but the war cemetery was beside the road. We came to a crossroads and asked the way; (sketch) then we turned left and we had actually passed the burial ground without knowing it, when a kind young man came running after us to tell us so.

The entrance is just a gap in the surrounding hedge and the young man untwisted the wire that stretched across the gap and then left us alone. The total impression: Cross after cross! On some of the

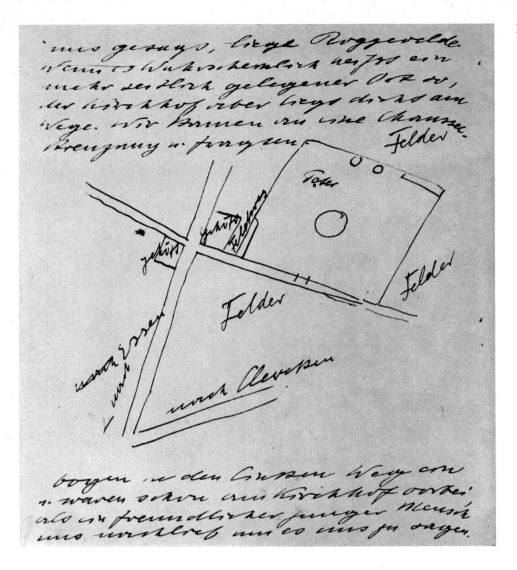

graves, the original large wooden cross had weathered and been taken down; however, mostly there were the usual low crosses of yellow wood. A small tin plate in the middle gave name and number. That was how we found our grave, which is where I have marked it with a dot. The hedge was a mass of wild roses, so we cut three of them and stuck them in the ground before the cross. His remains lie in one of a row of graves, all flat, with no distinguishing mounds. Just the identical little crosses, quite close to one another. The whole cemetery is like this, mostly bare yellow earth. Here and there, relations have planted flowers, mainly wild roses, and they look beautiful as the shoots overgrow the grave and arch above it, often spreading to the untended graves nearby, for at least half of them say simply 'Allemand Inconnu' (unknown German soldier).

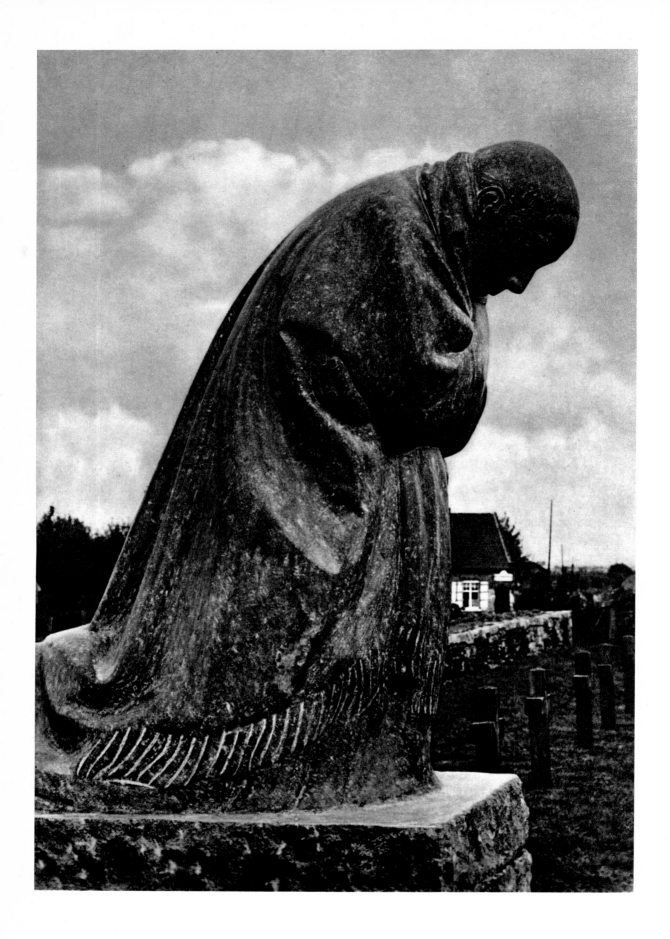

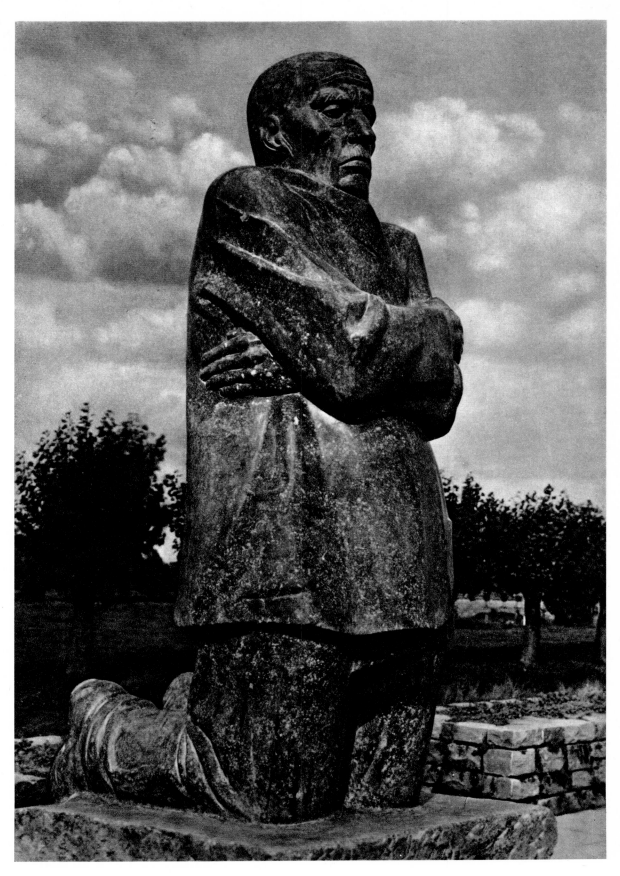

Memorial to the Fallen, Mother and Father, granite

Where I have drawn a circle on the sketch, there is a kind of monument, a short round column set on a square plinth, without any inscription. Although it looks good in its way, I would rather it were not there. We have been thinking where my figures should stand. It is no good putting them among the graves, the rows are far too close together. There is enough space in two places, but in neither of them is the setting right. One possibility is near the entrance, but the ground slopes and as the edge of the cemetery dips right down to the ditch by the side of the road, you stand too low there to get a good view of the burial ground as a whole. So that wouldn't do justice to the figures. In the end, it seemed to both of us that the best place for them would be directly opposite the entrance, by the hedge. There is a kind of garden laid out there, but it could easily be removed. Here the two kneeling figures would have the whole cemetery lying before them — I have marked the position with two small circles. The long rectangle to the right is also a sort of memorial placed there by one of the regiments. It is a fairly tall row of columns. Luckily no one has put up any decorative figures. The total effect is one of utter simplicity and loneliness. Apart from two small farms, there are no houses near, and the graveyard lies among fields. Everything is still but the larks are singing for joy.

When we left, we passed the actual spot, but everything there has been rebuilt. Not far from the cemetery the road dips towards Eessen, one can pick out a large area that was flooded as a defence measure during the fighting. Traces of war still linger, with trenches everywhere. In Dixmuiden itself, on the Yser Canal, two places have been left exactly as they were. One is the Minoterie where the Germans dug themselves in; the other is the Boyau de la Mort (The Guts of Death) which was the Flemish position. The Minoterie is where the mill stood. The whole surface is ridged, the long furrows torn by shells are thickly overgrown with grass now, where goats and sheep are put out to pasture. It is ghastly to see how the metre-thick retaining walls of the dug-outs were blown to pieces. In this area alone 200,000 Germans are said to have been killed during those four years. Their trenches and the Flemish ones must have got closer and closer, they are only twenty or even ten metres apart. Now everything has been filled in and life goes on, only the Flemish network of dug-outs and trenches, the 'Guts of Death' I just mentioned, has been preserved as it was. The Belgians come here on pilgrimage, it is a kind of national shrine for them. As I have already written, they have been kind and friendly to us, but if one happens to mention those four years when the town

was reduced to a heap of rubble, they break into Flemish and tell you with passionate gestures how the position was fought for, forward and back, forward and back, without any respite.

On the journey to Ostend, the picture was just the same. More dug-outs with here and there a war cemetery, the monotonous rows of soldiers' graves. Last night I dreamed there would be war again, a new outbreak was imminent. And in my dream I imagined that only if I abandoned my work altogether, only if I got together with others to preach against it with all the power at our command could we stop it.[49]

This dream of Käthe's, the idea that she must abandon her artistic work and combine with others to preach against war, was based on a misconception. Much later, she rejected not only pure pacifism as such, but also the idea that one could prevent a war by speech-making. Indeed, with her impassioned drawings protesting against the slaughter of one nation by another, through works like her *War, Never Again!* poster, she herself led the 'war against war', and thus admitted that her dream idea was totally inadequate.

In July 1927 Käthe Kollwitz received many tributes in celebration of her sixtieth birthday. Once again the previous year had been ex-traordinarily productive artistically speaking, and its last quarter brought with it the fulfilment of a long-cherished wish. The Soviet government invited her and her husband to Moscow for the tenth anniversary cele-brations in November. In October 1927, she wrote to my wife: 'I am looking forward very much to my visit to Russia.'[50]

The following extract from an article written in 1926 by Anatoli Lunacharski, the then People's Commissar for Culture, is some indica-tion of the deep respect with which Käthe Kollwitz was regarded in the USSR. In his essay, 'An Exhibition of the Revolutionary Art of the West', Lunacharski wrote:

Käthe Kollwitz:

Es ist dies nicht die Stelle, uns auseinanderzusetzen, warum ich nicht Kommunistin bin. Es ist aber die Stelle, um auszusprechen, daß das Geschehnis der letzten 10 Jahre in Rußland mir an Größe und weit-tragender Bedeutung nur vergleichbar zu sein scheint dem Geschehnis der großen französischen Revolution. Eine alte Welt, unterhöhlt durch vierjährigen Krieg und revolutionäre Minierarbeit wurde im November 1917 zerschmettert. Eine neue Welt wurde in größten Zügen zusammengehämmert. Gorki spricht in einem Aufsatz aus der ersten Zeit der Sowjet-Republik von dem Fliegen „Sohlen nach oben". Dieses Fliegen im Sturmwind glaube ich in Rußland zu spüren. Um dieses Fliegen, um die Glut ihres Glaubens habe ich die Kommunisten oft beneidet.

Statement by Käthe Kollwitz in the AIZ No 20, 1927

This truly admirable 'apostle with the crayon' has, in spite of her advanced years, altered her style yet again. It began as what might be described in artistic terms as *outré* realism, but now, towards the end of her development, it is dominated more and more by a pure poster technique. She aims at an immediate effect, so that at the very first glance one's heart is wrung, tears choke the voice. She is a great agitator. It is not only through her choice of subject that she achieves this effect, nor by the exceptional, indeed, one may call it the physiological accuracy with which she evokes an event—no, it is mainly by the exceptional economy of her means. As distinct from realism, her art is one where she never allows herself to get lost in unnecessary details, and she says no more than her purpose demands to make an immediate impact; on the other hand, whatever that purpose demands, she says with the most graphic vividness.[51]

In November 1927, Dr and Mrs Kollwitz made the journey to the Soviet Union. On New Year's Eve 1927, she wrote in her diary:

> But the sadness of the previous year, the sadness of old age, has decreased. This is due to the wonderful experience we were granted; Ascona in the spring. Then my sixtieth birthday, with all the joy it brought. Then Hiddensee with my loved ones, and after that, Russia. Moscow where the atmosphere is so different that Karl and I felt as though we had been thoroughly 'aired'. That we have been allowed to do these things together, and in addition to spend so many pleasant hours and days with our friends, the many hours when we were so close and felt that we were one. Much happiness—Thanks! Thanks![52]

From Moscow, Käthe brought back with her a beautiful drawing called *Listening*, which she later lithographed.

The number of unemployed in Germany had risen to approximately six million. The people in the working class districts in Berlin were no longer saying: 'How will it all end?' but 'The tobacconist over the road has gone bankrupt... So has the greengrocer a bit farther along... And the hire-purchase chap at the corner has closed... Oh, he's gone bust too, has he? He'd been in business a lifetime... It's one after the other...'

The workers' children invented a new game. They ran along the streets counting how many empty shops had red 'To Let' cards in the windows. But soon, when they reached a three figure total in only a very few streets, it got too easy and they stopped. In the tenement blocks, no one had much to say. The people ate their hearts out in silence; near

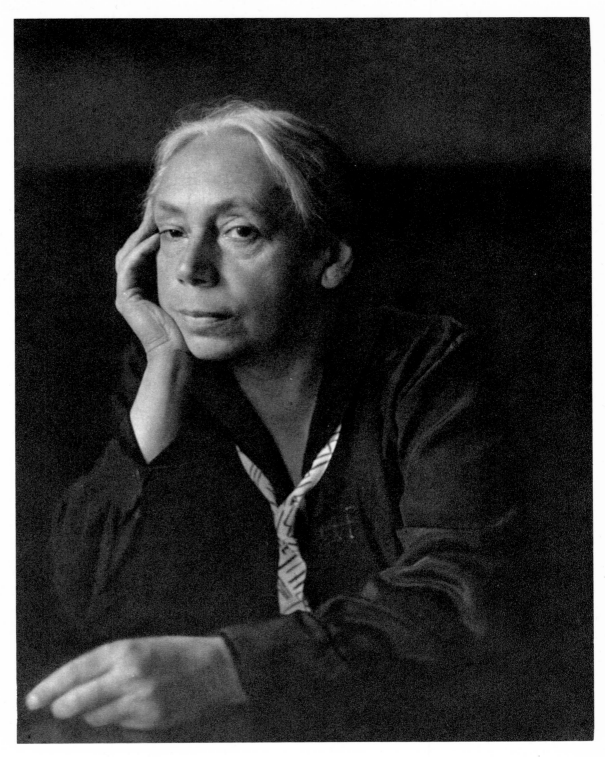

Käthe Kollwitz aged 60

Käthe Kollwitz with Ricarda Huch

Käthe Kollwitz with Max Liebermann

the end of their tether, they did not raise their voices, for that was for-
bidden. The police cars sped through the slums and when the shrill
hooters sounded, hungry eyes flickered anxiously, or grew cold. Clench-
ing their teeth the people muttered: 'It won't be long now—things'll be
different soon...'

No one bothered to open the door when there was a knock. 'It'll
only be a beggar...'

Things got worse. Out in the western suburbs respectable middle-
class citizens were attacked. They were not robbed, but they were beaten
up because they refused to give money to beggars. The bourgeois news-
papers raised a hue and cry and demanded protection. 'A scandal!'

61

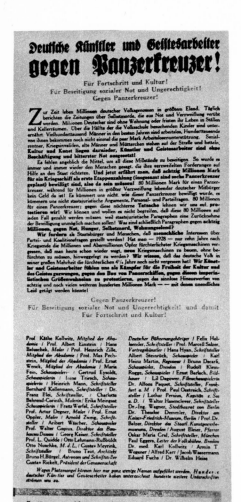

declared the well-fed, and they said harsh things about the police who did not put a stop to such goings on. The authorities did indeed arrest several hundred beggars, but they released them next morning because they simply did not know what to do with them. And still the empty bellies of the poor rumbled with hunger.

In the slums the people stared at shop window displays, filled with things they needed but could not afford to buy. Their eyes blazed and they growled to themselves like chained dogs who have food near enough to smell but not to eat. In Berlin there were huge but orderly hunger marches. Käthe Kollwitz produced only a few important graphic works at that time; she buried herself in her studio working on the figures for the soldiers' cemetery.

It was only ten years since the grim events of the Great War yet the German militarists were already prepared to challenge liberal opinion. The Reichstag granted approval for 80,000,000 marks to be spent on the building of a battle-cruiser. This intention provoked a strong reaction, not only from progressive workers, but also from leading artists and intellectuals, and there was a call for a referendum. Käthe Kollwitz was the first to sign a protest against the battleship proposal, and she made a striking drawing for a contemporary publication.

Appeal against the building
of a battle-cruiser
(from 'Eulenspiegel')

Drawing from the
'Battle-cruiser' issue
of 'Eulenspiegel'

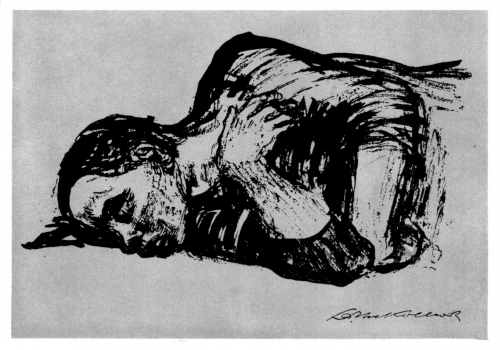

Käthe Kollwitz with Otto Nagel at the studio for the Heinrich Zille memorial film:
Mother Krausen's Journey to Happiness

In 1929 Heinrich Zille died at the age of seventy-three, and for the last time Käthe and I visited the house in Sophie-Charlotte Strasse together. A Zille memorial film was made, *Mother Krausen's Journey to Happiness*. I was much involved in its production while Käthe not only designed a poster for it, but was also joint patron of the venture with Hans Baluschek. On 30 December 1929 the premiere took place at the Alhambra cinema in the Kurfürstendamm, and both Dr Kollwitz and his wife were there. Like everyone else in the hall they were much impressed by the showing of this realistic film, and after the performance the four of us walked arm in arm along the Kurfürstendamm as far as Aschinger's at the Zoo Station, where we sat talking together for a long time.

Käthe Kollwitz was still working on the memorial figures for her son Peter, a task which had already occupied her for several years. Her final decision had been to make two separate statues representing a mother and a father, and although they were almost complete, there was still a problem to solve. It suddenly occurred to her that she ought to give the mother figure her own face and the father that of her husband. During this critical stage she allowed hardly anyone to enter the studio, not even her husband, who told me that he resented it. Her son and her friends were similarly excluded until the plaster models were finished. Then at the beginning of 1931 the figures were displayed at the Academy's

spring exhibition. As an exhibitor myself, I was present at the opening, and so I experienced at first-hand the stir they caused. These sculptures were the artistic sensation of the day. I had never seen Käthe as excited as she was then, which is understandable, for she was showing publicly for the first time the result of more than fifteen years' intensive work. Her work was highly praised by her colleagues, and established Käthe Kollwitz as a sculptor as well as a graphic artist. She had not only succeeded professionally but had also redeemed the promise she had made to herself so many years before.

I was approached by the editor of the *Workers' Illustrated Newspaper* to ask Käthe Kollwitz for permission to reproduce one of the sculptures in the periodical. She agreed, but a week later, she telephoned me and asked me to come round to her studio. A pleasant surprise was waiting for me, for she had produced two new lithographs for the intended publication, fine works artistically, and full of revolutionary content. One of them she had called *Demonstration*, a picture of workers on the march, their faces determined, and with banners waving overhead. The second, *The International*, again showed demonstrators not unlike those of the other picture, but one of the workers is singing as he carries a child on his shoulders. We decided to take *Demonstration*, which appeared as a valuable illustrated supplement to the May issue in 1931.

Another graphic work which appeared at this time was a lithograph full of human beauty. It shows a family, the father tenderly holding a small child between his powerful worker's hands, while the child stretches out its arms towards its smiling mother.

A year later, in July 1932, the artist was to celebrate her sixty-fifth birthday. For this occasion I took 142 of her works to the Soviet Union to stage the most comprehensive exhibition of her achievements so far. Dr and Mrs Kollwitz accompanied my wife and I to the station. The prevailing political and economic situation made our parting a solemn one, but Käthe rejoiced whole-heartedly that her work was to be shown in Moscow; she was glad, too, that her two sculptures had now been completed in granite and were to be taken at last to her son's grave in Belgium. However, she wanted them first to be displayed publicly in Berlin, and the question of where they should stand to show off to their best advantage was still worrying her. On 16 April, she wrote in her diary:

Where can one exhibit these figures here in Berlin? I don't want them on show at the Academy, that is too academic (sic!); Nagel suggested the Schiller Park, but they would have no association there

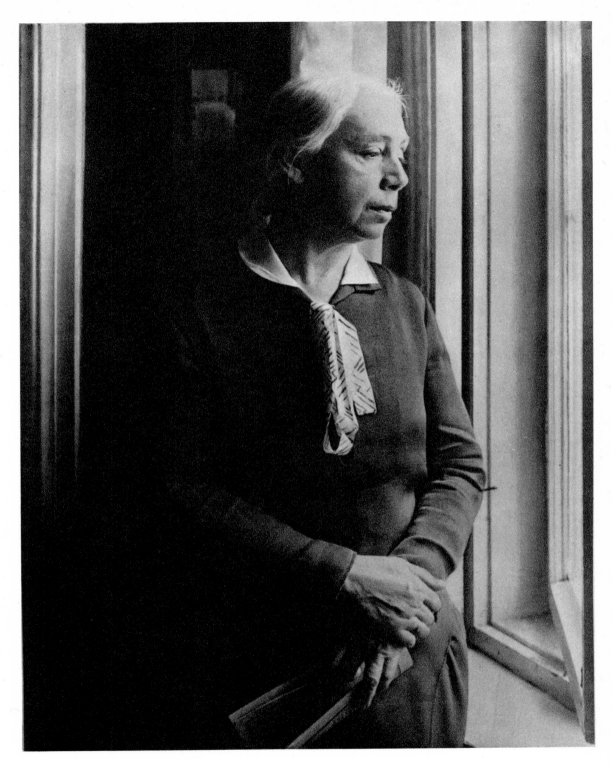

Käthe Kollwitz about 1930

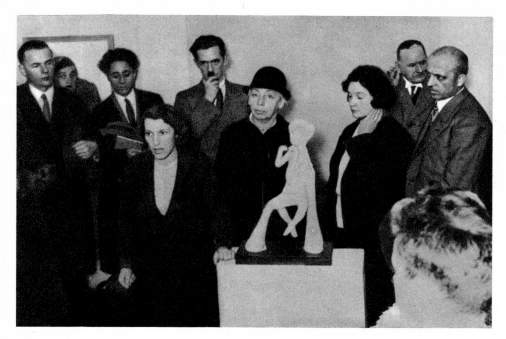

Käthe Kollwitz at the opening of the International Exhibition
'Women in Need', Berlin 1931

The opening of the Käthe Kollwitz Exhibition in Leningrad
1932 — third from the right, I. I. Brodski

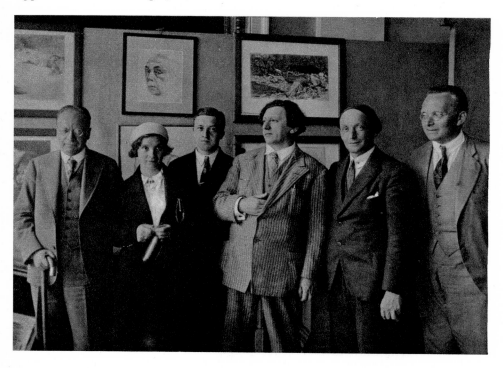

Part of the Kollwitz Exhibition, Leningrad, 1932

with their surroundings. I have misgivings, too, about the Memorial Hall because it has been taken over by the right wing. There would be no supervision outside and the figures might easily be daubed with swastikas or damaged. The problem remains unsolved.[53]

The Kollwitz Exhibition in Moscow was followed by one in Leningrad, which coincided with the fifteenth anniversary of the founding of the Soviet Union. For this the artist prepared an especially large lithograph which I took with me as a gift, and to which she gave the title *We Protect the Soviet Union*. It is described in the catalogue as *The Propeller Song* and is now in the Pushkin Museum in Moscow. It shows four workers, arms foreshortened and hands clasped, forming part of a continuous human chain. The men are portrayed full face, defiant and resolute.

18 Juni 1932

Letter to Mrs Wally Nagel, 18 June 1932

Letter from Karl Kollwitz to Otto Nagel (extract)

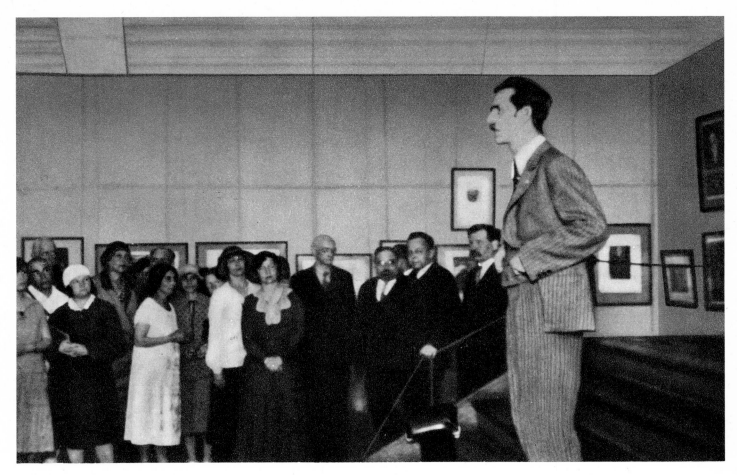

Opening of the Kollwitz Exhibition in Moscow, arranged by Otto Nagel

This Moscow exhibition was a tremendous success. The Soviet people came in great numbers to see and discuss the work of this eminent German artist. I received a letter from her while I was still in Moscow in which, among other things, she told me:

For the last two weeks my granite figures have been on display in the hall of the old National Gallery. The public has shown such great interest that the exhibition has been extended for another week. On the 27th they will be sent to Belgium. My husband, Hans and I shall be leaving at the beginning of July to arrange for the figures to be erected. This completes the work of many years. The newspapers all gave me very good notices, except the Communist *Red Flag* which deplored my 'failure to use the opportunity to protest against the imperialist war'. I did indeed expect them to see things in that light, but I regret

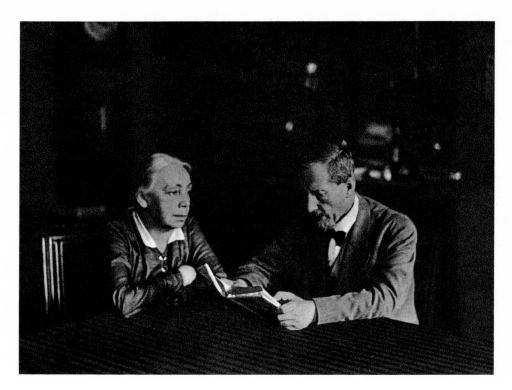

it all the same, for of course the review kept many workers away. If only you had been here. . . I feel sure you would have found some way of attracting the Communist workers as well. . .[54]

A letter from Karl Kollwitz was enclosed, and he wrote:

How I wish I were with you in Russia. We are slowly preparing for our visit to Belgium to erect the statues, which radiate a wonderful life of their own. They are so successful that I keep going to see them on a kind of pilgrimage, to yield myself entirely to their effect. About us, I can write only that we are already suffering under the impact of the growing terror. What will it be like later? We still have hope in the strength of the proletariat.

A few days later, Käthe Kollwitz wrote to me that she 'had been allowed to continue in office for a further year (as professor of the Master Class for Graphic Art at the Academy). A further term would need fresh confirmation, and with the right-wing government that has just come to power, this will probably not be forthcoming.'

In 1932 her brother Konrad died. At one time his talents and his former friendship with Friedrich Engels had led many socialists to hope

that he would make a contribution to the development of Marxist doctrine, but his death put an end to such hopes.

At the end of July the Kollwitzes went to Belgium as planned, to be present at the setting up of the statues. On her return home Käthe wrote in her diary:

Looking back on our stay in Belgium, my most beautiful memory is of our last afternoon when Van Hauten drove us back to the cemetery. He left us alone and we went from the figures to Peter's grave, and everything was alive and deeply felt. I stood before the woman and looked at her—my own face—I cried and stroked her cheeks. Karl was standing just behind me. I did not know he was there until I heard him whisper: 'Yes, yes.' How much together we were at that moment.[55]

In Germany, the brown-shirted Nazi hordes were terrorizing progressive people more and more and the police stood by, indifferent. The

Käthe and Karl Kollwitz—
A day in the country

Exhibition poster, Amsterdam, 1934

split in the working class movement paralyzed resistance, and Nazism was becoming an enormous danger. Recognizing this, prominent progressives among the intellectuals published an appeal for the unity of the working classes in order to resist Fascism. This appeal was posted on the advertisement hoardings in the streets, and was signed by Käthe and Karl Kollwitz, among many others, including Heinrich Mann. For the two Kollwitzes, as for so many other sincere anti-Fascists, there was a bad time ahead. Of course they had no illusions from the outset, and knew that they would be subjected to drastic repression. But in addition, there were also personal troubles, when Karl developed cataracts in both eyes and a speedy operation became necessary. Käthe wrote to Beate Bonus:

> My husband is haunted by the fear that we may live longer than our bit of capital will last. It would also be very hard for him to have to economize all the time and to watch every coin spent, and if we could no longer contribute to various radical causes.[56]

It was not long before the Nazis attacked Käthe Kollwitz openly. At an exhibition of sculpture at the Academy, not only were her works

removed from the display two days before the opening, but she had to call a halt to all her plans for future exhibitions. Her removal from the Academy followed soon after; like Heinrich Mann she was forced to resign. In a newspaper article, some 'well-wisher' tried to 'rehabilitate' her. This she rejected categorically:

If, as the author says, countless members of the working class have the warmest regard for me, they will certainly cease to have any respect for me if ever I am given 'honourable recognition' once again. I wish to and indeed must stand by those who are subject to oppression. Financial loss as a result is a foregone conclusion, for me and for thousands more. One must not whine about that.[57]

Poster: A warning to take care at work

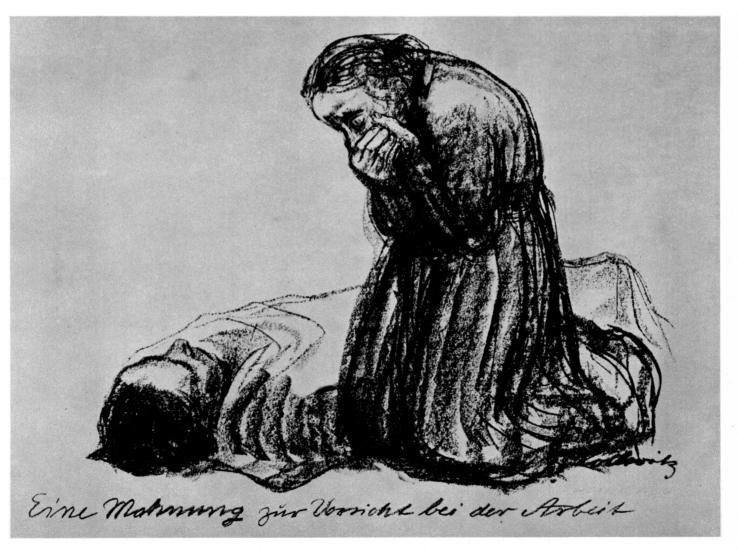

Eine Mahnung zur Vorsicht bei der Arbeit

Letter from Ernst Barlach to Otto Nagel (extract)

At first when the Nazis came to power, my wife and I avoided visiting our friends, or telephoning them, so as not to worry them unnecessarily. I had already had my flat searched and I had also been arrested, although I was not detained for long. One morning, very early, there was a ring at our door. We jumped out of bed, and braced ourselves for an unpleasant visit. But to our joy and surprise Käthe and Karl Kollwitz were at the door. These two old people were so concerned about us that they had made the journey to our flat in the Wedding district and they were very pleased that we were both well and still at liberty.

After many years there Käthe Kollwitz had to give up her studio in Hardenberg Strasse which had been at her disposal as long as she was on the Academy staff. However, she found a suitable room in a studio apartment block in Kloster Strasse. By now, she was already working on her last great graphic cycle, 'Death'. It was a subject she had treated frequently before, and now, towards the end of her life, she returned to it once more in a series of variations. I shall deal with this cycle in detail a little later. Besides this, she was also engaged in completing other sculptures. One group, *Motherhood*, presented many problems for her, but nevertheless, she often re-experienced her old joy in creativity as she worked on it. She did not make things easy for herself. She drew hundreds of studies which often covered the studio floor. Nor was it always simple to find the right model, and she was delighted when she discovered 'a marvellous "fatty"' as Käthe Kollwitz described her, laughing. There is something unusually compact about this group. Once in a conversation she recalled that a great artist had defined a good piece of sculpture as one that could be rolled down a mountainside and still be intact when it landed at the bottom.

When the Nazis came to power, the works of Käthe Kollwitz filled a whole room at the *Kronprinzenpalais* (Crown Prince Palace). Now her sculptures and graphics were removed and relegated to the cellars, together with the works of Ernst Barlach, whom she admired more than almost any other living artist. He wrote to me at that time:

There are regulations these days which would not suit either of us if, as often happens, my letters are by any chance opened, or even suppressed. Still, there is no need to refrain from pointing out that one has lived in Germany for more than sixty years, and now people are trying to tell us how to be a German. You feel the same way about it and so does Käthe Kollwitz. There is no need to dwell on it... That I am still alive is a miracle, but ought one to be surprised at something that demands so little effort? Things could reach the point overnight

where one says: I don't want to go on. Yet, one must and it is a hard 'must'. Give Mrs Kollwitz my best wishes, and say, that although I seem to be living like a lord here by the lake in the forest, it is only a façade. Tell her, too, that although the ship almost sank last winter, it is still afloat and sailing steadily on course.[58]

Barlach's death some years later shocked Käthe Kollwitz very much. The defamations to which he was subjected angered her more than the hostility to herself. She went to Güstrow to be with his friends and colleagues at the funeral. She told me about this last visit, when she saw Barlach lying in the open coffin. 'His head lay right over to one side, as if he wanted to hide his face.' In the evening there was a gathering in his study, and a reading was given from one of his plays.

Not long after an unpleasant incident occurred. The representative of an international press agency was sent to Germany to find out how progressive artists were living under the Nazi regime. He arranged an interview with Käthe Kollwitz who asked me to be present. The journalist was both intelligent and competent and as he openly declared his anti-Fascist opinions, we spoke frankly to him. A few weeks later Käthe Kollwitz sent me a message through an intermediary, asking me to meet her at the Exchange Station. She had chosen the rush-hour and although I was very punctual, she was already there sitting on a bench waiting for me. She told me that as a result of the interview, the Gestapo had come to search her apartment and they had ransacked her studio. The article by the foreign journalist had appeared in an important periodical in which he described the visit. Among other things, he said: 'The three of us sat talking about Hitler and the Third Reich, and as we spoke we met each other's gaze.'

This remark was excuse enough for the Gestapo to take action against Käthe Kollwitz. She told me that most of all they wanted to know who had been the third person present. Her face was deeply flushed as she told me, not without pride: 'I did not tell them, Otto, and I never shall. And although they threatened they will send me to a concentration camp if I commit the slightest offence in future, I shall not go. I always carry something with me.' She took a tiny bottle from a pocket and showed it to me. At that moment, I could have hugged this slight figure of a woman, who was not only a great artist but also a courageous comrade-in-arms.

The great cycle 'Death' for which Käthe Kollwitz had made many preliminary studies, was finished at the end of 1937. It was her last comprehensive work, and it is, in a way, the beginning of her farewell

to creative activity. There are eight lithographs and in them her consummate artistry is suffused by her knowledge of the last stage of all, to show us death in many different guises. In this cycle she was not concerned with demonstrating her artistic skill as such, but quite simply with communicating the wise, human knowledge she had acquired. Such works can only be created by a person who stands quite close to death, who has already taken the first step into the dark. How vividly has she shown Death snatching his victims from among a group of children! A premonition of the cruelty of the war years to come emanates from this print. Like a spectre, the cruel bird-man swoops among the terrified children, the black splash of his cloak looms above them. How straightforward is her *Death by the roadside*, where the man, dying alone, is revealed with the utmost simplicity. There were others too on the same subject, in which to some extent Käthe Kollwitz presented in a new way themes she had tackled earlier. The last plate of the sequence, *The Call of Death*, shows the artist herself. The hand of Death touches her shoulder, summoning her to go with him. Here she depicts herself weary, ready to answer the call, her sad eyes closed.

Title page with signed dedication to Otto Nagel from Heinrich Zille and Käthe Kollwitz

Other artists in the past have also drawn or painted themselves in pictures associated with the theme of death, among them Arnold Böcklin and Hans Thoma. In the background of the pictures of both these artists, stands the symbol of the skeleton, in one of them it is even playing a fiddle. In contrast to them, Käthe Kollwitz describes the event without a trace of sentimentality or romanticism.

By now Dr Karl Kollwitz was in poor health. The eye operation did not have the result they had hoped for. We went with Käthe to see him in the eye clinic in Luther Strasse after the operation. Karl was most optimistic and told us that the bandages were to be removed from his eyes in a day or two. A little later, we learnt to our dismay that something had gone wrong at the last moment, probably through some error on the surgeon's part. An additional blow came when Karl was told that for political reasons the Nazis would not let him continue to practise as a health insurance doctor.

Any book concerned with the life of Käthe Kollwitz is bound to have something to say about her husband. He was such a good man, a splendid doctor and a sincere socialist. He accompanied his wife through life, demanding nothing. He was the most modest person but full of understanding and always ready to help. It was a heavy blow when he had to hand over his practice to a young colleague and retire, but his wife who knew how her husband was suffering found a partial solution with the help of this co-operative young doctor. She turned a small room in the

flat into a consulting room where her husband could receive private patients. His eyes might have failed but with his vast experience and extensive medical knowledge he could still give advice and information and so continue to be of service to the sick.

The artists who used the studio block in Kloster Strasse, were preparing an exhibition during this period, and Käthe Kollwitz contributed a big bronze group, *The Tower of the Mothers*. It is a strong, self-contained work, compactly designed, in which she used a motif she had often depicted graphically, mothers defending their children. These women are militant, full of determination, ready to protect small and helpless creatures. The Nazis removed the group from the exhibition on the following pretext: 'In the Third Reich, mothers have no need to defend their children. The State does that for them.' This must surely be the height of cynicism, when one realizes that only a little later, these same brown-shirted barbarians drove millions of young people ruthlessly to their death.

On 19 July 1940 Karl Kollwitz died after a long and serious illness. During his last months the old couple had probably been closer than ever before. The crematorium where the funeral took place was filled

Käthe Kollwitz with Leo von König and Ernst Wiechert

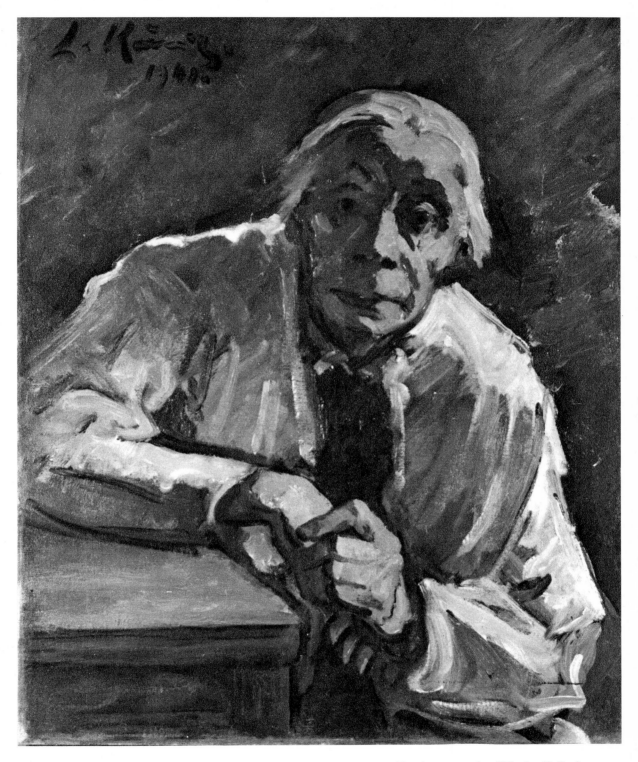

Leo von König: portrait of Käthe Kollwitz, 1940

to overflowing and as his father had wished, Hans Kollwitz gave the address:

My dear Father, you had grown old and tired, and now you have found peace and quiet at last. Yet how you fought against the quiet life during your career. Almost every evening of your life, after a day crammed with work, you fought against sleep and held it at bay a little longer, so that you could carry on into the night with your silent tasks... You had a hard childhood, yet you never became hard yourself. As a child you suffered humiliating poverty, even destitution, and so you made it your life's task to help the poor and destitute, as much as your strength allowed, indeed, more than it would allow. This was your attitude to the world and your philosophy, and this was how you lived. You were always ready to help anyone who came to you with your professional skill, with spiritual guidance and with money. You were never too tired, there were never too many flights of stairs for you to climb, there was no case too hopeless, no patient too poor; for you always found as much time for everyone as they needed.[59]

From the day her husband died Käthe Kollwitz needed a stick for walking. In the autumn of that same year she gave up her studio in Kloster Strasse and used instead the big room in her flat which had been the comfortable living room of the Kollwitz family for about fifty years. It was there that we had had so many friendly conversations, both gay and sad. For five decades so many and such various people had gathered round the big table in the middle of the room, over which hung a light with silhouettes on the lampshade, the work of an affectionate young friend of theirs. Now there were modelling blocks everywhere, and lumps of clay wrapped in damp cloths. All the chairs were stacked with materials and the artist's current work.

Meanwhile, her grandson Peter, to whom she was greatly attached, had been called up for military service and this meant yet another anxiety for the old lady.

It must have been in 1941 that I paid her a visit at home. At that time her health was already poor, and her son, who was also her doctor, had asked me to limit my call to a quarter of an hour. However, that proved impossible. Käthe was overjoyed that I had come to see her for now she could unburden her overflowing heart. I can see her before me still, her stick tapping as she wandered up and down the studio, furious as she told me of some new brutality of the Nazi regime she had just heard

about. A troop of the Hitler Youth movement could be heard shouting in the park opposite and she covered her ears with her hands. 'I can't bear to listen to them these days.' But a few moments later she recounted enthusiastically how she had been painted by the great portraitist, Leo von König, a couple of days before. He had done three oils of her in two days, and one of these, a superb picture of her in old age, hung on the wall. It was one of the finest portraits von König ever painted.

A few examples will be enough to show how shamelessly the Nazis misused the work of Käthe Kollwitz and other progressive artists. One Nazi-Fascist periodical printed in both German and Italian, contained a full-page reproduction of the seven prints comprising the 'Hunger' Portfolio of 1924. We were suddenly described as important German artists, and the distress of the German working class we had portrayed there was misrepresented as if it were 'Hunger in the Red Paradise'. In *Warte*, the National Socialist women's paper, Käthe Kollwitz's *Bread* from that same series was reproduced under a forged signature, St Frank, and used to illustrate a poem of hatred in Spanish and German. Both picture and text were said to have come from an appeal 'to the people distributed by one of the "National Aid Action Committees", and published by the Nationalist troops in territory they had conquered.' Käthe was livid with anger and wanted to demand an official correction. We had to dissuade her, and she herself finally agreed that it would be better not to protest. She wrote to a friend of hers: 'If I do not hold my tongue but insist on a correction, I might very well be told: "We apologize for the mistake and of course we shall restore your name immediately." Then it would look as if I were working for the Fascists in Spain for the poem speaks of the 'Reds' as murderers.'[60]

In 1941 Käthe Kollwitz drew her last self-portrait, this time in profile, the conclusion of a long series. Actually she had reproduced her own likeness almost ninety times, in drawings, lithographs, etchings, woodcuts and in sculpture. She had shown herself as a girl, as a young woman and as an old one, pessimistic, defiant, hopeful, ageing and summoned by Death, covering her whole life as an artist. This last self-portrait moves everyone who sees it. It contains no deliberate artistic intention of any kind, it is wholly a reflection of the person she had become. Here is an old woman, one who has grown unutterably weary, for whom there is no longer any joy in life. The dark profile, the heavy eyes that have seen so much and whose gaze is so sad, the thinning white hair only faintly suggested, the slight stoop of the body and the simple indication of a wrap over her shoulders. As I look at this work I think of the aged Rembrandt von Rijn, who painted himself for the last time 300 years

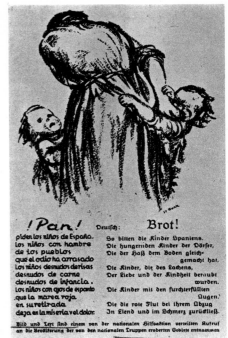

Misuse of one of Käthe Kollwitz's lithographs in a Nazi periodical

ago. He too had become impoverished and was at odds with the society in which he lived, the society that had once heaped him with honours. His portrait indicts the wealthy burghers and councillors of Amsterdam, people whose names are only remembered now because they treated the great painter so disgracefully. 'He cared nothing for public opinion when he painted this portrait, underlining the deterioration of his external appearance, the softening of the features, the drooping cheeks, the wrinkles, the lines of fate and the scars.'[61] Käthe Kollwitz loved this late Rembrandt, 'an old lion' as she called him with passionate reverence. Her own fate in old age was not unlike that of the painter of Amsterdam.

In 1942 Käthe Kollwitz produced her last graphic work of all, a lithograph of a mother protecting her children; the title she gave it is the quotation from Goethe's *Wilhelm Meister*: 'Thou shalt not grind the seed-corn.'[62] Once before she had used this same quotation in her open letter to Richard Dehmel at the end of World War I. In 1942 danger again threatened the youth of Germany and this danger roused her fighting spirit to one final achievement. This was the last mother of all those that Käthe Kollwitz drew, one who is prepared to defend her children to the last, and there is indeed something about the figure that suggests an eagle shielding its young with its wings.

In September 1942 her grandson Peter was killed. She wrote in her diary: 'Meanwhile Hans has been. It was Wednesday 14 October. He came in to me without speaking. I knew at once that Peter was dead. He was killed on 22 September.'[63]

Her only pleasure in life now was to spend the time occasionally with her remaining family in Lichtenrade. And this joy is referred to in the last entry that she made in her diary for May 1943:

It was the loveliest May night. Hans and Ottilie could not bear the thought of going to bed. They sat in the garden listening to the nightingale...Next morning it was Mothers' Day. Hans came again, bringing me a big bunch of lilac from the garden. How happy it makes me to know that I still have this dear son, and that he is so fond of me.[64]

By now the British and the Americans were bombing Berlin continually by day and night and it became necessary for Käthe Kollwitz to leave the city. In the middle of May 1943, accompanied by her sister Lise, by Lise's daughter, the dancer Katta Sterna, and Lise's niece, Clara Stern, they arrived at Nordhausen in the Harz mountains where a young sculptor, Margaret Böning, had placed part of her house at their disposal. It was not easy for Käthe to say goodbye to Berlin, for it

was a farewell to the city where she had lived for more than fifty years, with all its memories, good and bad alike. On 17 May 1943 her son and daughter-in-law received the first letter from her in Nordhausen:

Dear Children,

I wish I could give you an idea of how lovely it is here. The balcony which was covered with hen-droppings, has been swept clean and now I am sitting there writing letters. Margaret is working out of doors, she is always busy. I am glad that my memory is still good, so that I can remember whole sections of verse by heart (such as the introduction to Part II of Faust which ends: 'And we have life in its rainbow reflection.') For the first time, the air is summery, but not oppressive. The lilac is exquisite, ready to burst into flower... Don't worry about me. I obey all the regulations and am always prepared to take shelter in the cellar if need be. It hasn't been necessary so far, but no one shall say I had only myself to blame. I intend to be ready at any time...[65]

Group, 1937

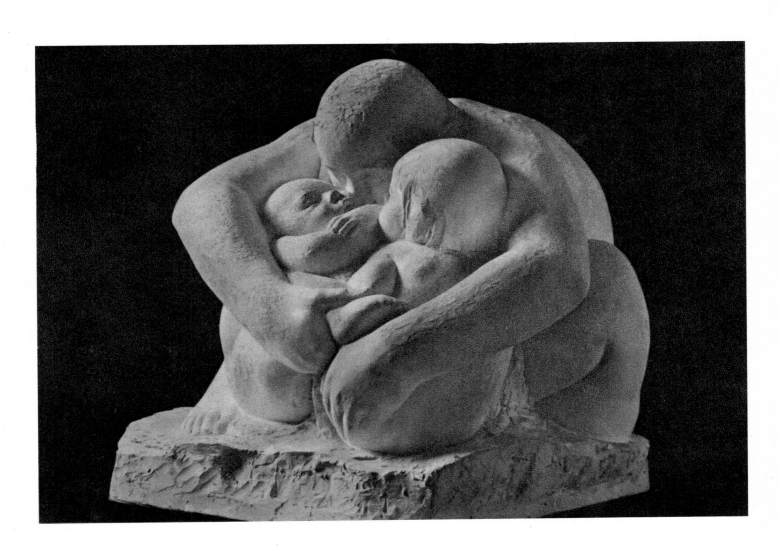

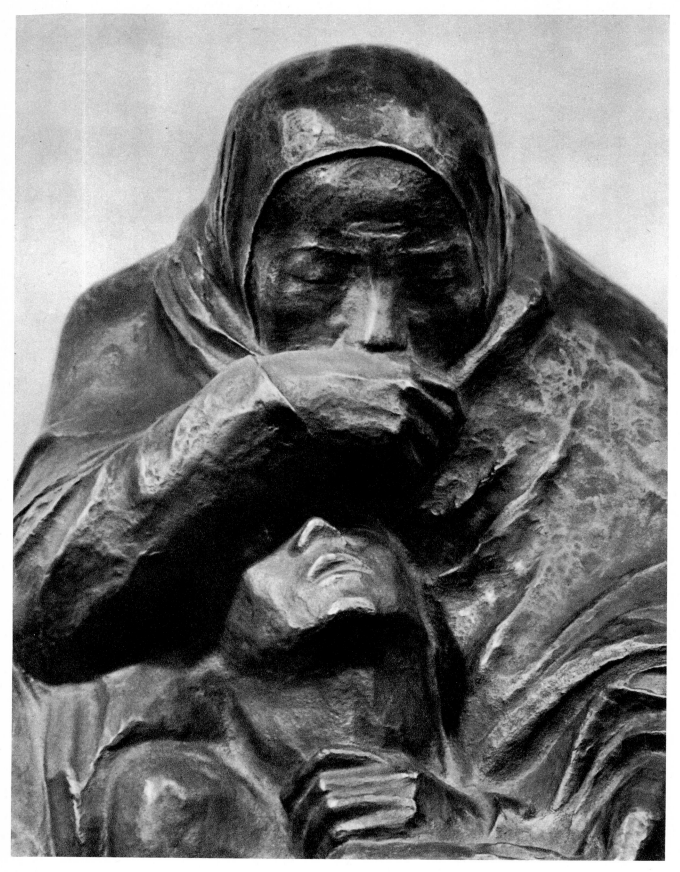

Pietà (detail)

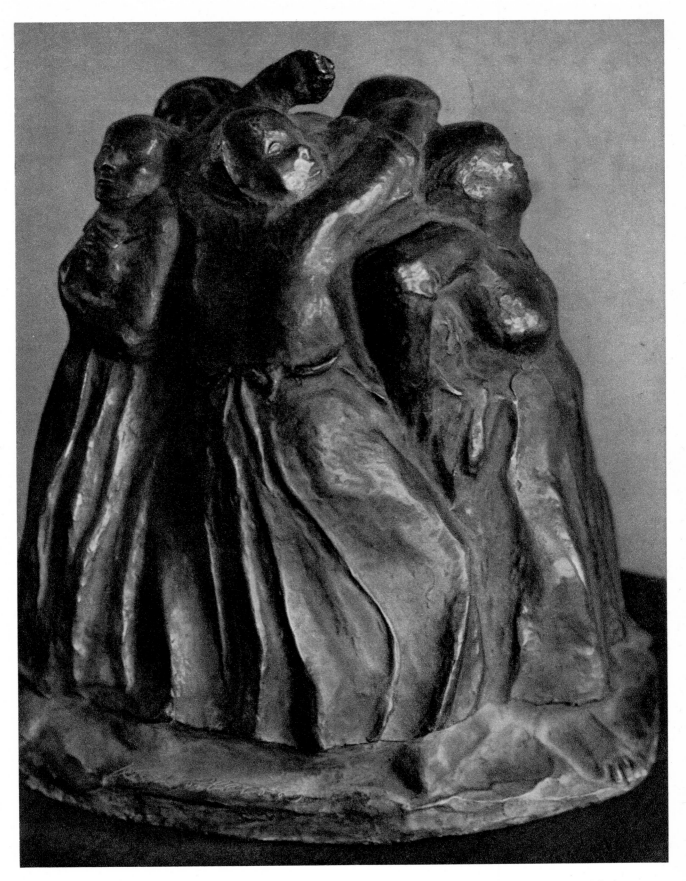

The Tower of the Mothers, 1937

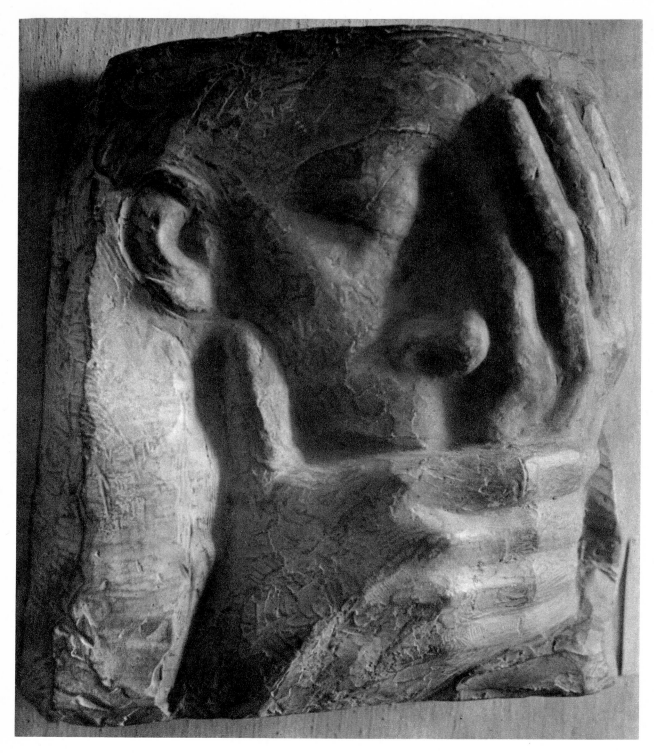

Lament, 1938

In August 1943, when we were evacuated to Forst, my wife gave birth to our daughter. We wrote to tell Käthe and were most surprised that in spite of her weariness she took such an interest in the new arrival. Often she wrote us only a few lines on a postcard, but she always told us something of the way she was living so far from Berlin, and also what she was thinking. When she was too tired to write herself, she dictated letters to Clara Stern, but the latter, too, gave us her own reports on her aunt's state of health:

Saturday 13 July 1943
(misdated)

Dear Nagels,

Your news made me so happy that I can hardly find words to express my feelings. So little Lotte has arrived (I feel sure you will call her that) and Wally is well and you have left that inferno. Life goes on, it always will somehow or other. Here's to a better future. Clara too is delighted.

I also got away in a great hurry, actually there are four of us here. A charming and splendid friend of ours refused to rest until she had got us out here, and life is as good as it could be anywhere. Do write and send me news again soon, Otto, and the best of good wishes to the three of you.

Your
Käthe Kollwitz[66]

Dear Otto and Wally, 27. 8. 43

Your news made me very happy. What a shame though that there are these feeding troubles. Aren't there any other children with whom W. can share her abundance?

Today I had news from Lichtenrade about a big air raid on Berlin. There is no gas or electricity. Hans had just left with a party of children. It is ghastly to know these things are happening and to be so far away. But we are all right here—very well off, in actual fact. You must make me a drawing of little Sybille Charlotte. How I wish I could see her for myself—but how long will it all go on?

With warmest wishes,
K.K.[67]

Dear Nagels, 5. 10. 43

I am so glad that the news from the three of you is still so good. You say the baby can smile already. Yes, things like that help one to forget the bad side.

Letter to Hans Kollwitz, May 1943

I am still here, of course, and see no possibility of my return for the present. Clara is still at the flat, I know, but there is hardly anything of myself left there now, I mean of my work, of course. Hans had a tremendous job getting the big stucco group with the children into the cellar of the Kronprinzenpalais, but he managed it and it is now there on permanent loan. Many of my drawings have been sent away for safety, recently another portfolio went to the Prince of Saxony at Moritzburg near Dresden. He was kind enough to offer to take it. So now my home has gone, and I have no place to call my own either here or there. But all is well where I am now and I have my dear sister Lise with me too. But one waits day after day, waits without any stable background, waiting for the end of everything but no one can say what the end will be. A little while ago it did look from one angle as if the end were in sight, but the fog has closed in once more.

Well, at least you have a future in your Sybille. What a blessing she must be to you. My dearest love to you all.

<div align="right">Your old friend,
K. K.</div>

As soon as you have a snap of S. you will let me have it, won't you?[68]

(Dictated) Nordhausen 4. 2. 44

Dear Otto and Wally,

I am so very happy about Sybille. I can see Otto's eyes in hers. What a good thing you have the child somewhere safe. Berlin is destroyed. My own flat went up in flames but they managed to save my most important work, although it took some doing. Ten days later, my son's home was blitzed. Such misery everywhere, there's no end to it. Gerhard Marck's work was completely destroyed. Keep well and look after the baby. Your very old, not very well and terribly tired.

<div align="right">Käthe Kollwitz[69]</div>

<div align="right">4. 2. 44</div>

Dear Otto and Wally Nagel,

Many thanks from me too for your kind letter. I kept wanting to write to you, but I did not know your address. On 23 November the flat in the Weissenburger Strasse was burnt out. I was there, but as I had a double fracture of the ribs at the time I could not rescue many of the precious things that were still there. Now I am better and am here with Käthe. She has taken the loss of her flat and also of her son's home very much to heart.

Since 9 January she has been in bed with a severe heart condition. It was extremely serious but now she is out of danger and she spends a couple of hours every day in an armchair. The worst thing is that she is very despondent and in a terribly depressed state of mind. Objectively, her pulse and her appetite are both good and she sleeps well. But her optimism has gone completely. Communication with Berlin is still cut off and she spends all her time waiting for her son to come, but so far in vain.

I shall write again to give you news of her. Your letter sounded so cheerful that it was a pleasure to read. Many thanks for it.

<div align="right">Kindest regards.
Yours,
Clara Stern[70]</div>

It was about this time that Käthe Kollwitz who had become so inexpressibly weary, suddenly grew wide awake again. Some Nazi hack or other had hit upon the idea of asking one hundred well-known artists to give their views on the subject of 'dignity' in art. Oddly enough, he also approached Käthe Kollwitz, although to be sure, he was prejudiced from the start, and convinced that her work was that of a pavement artist, vulgar and ugly.[71] Käthe Kollwitz gave this impertinent journalist a severe dressing down. She wrote to him as follows:

> To the best of my knowledge, 'vulgar', 'disgusting' and 'repulsive' have never been accepted as terms applicable to art, although the notion of what is vulgar, disgusting or repulsive has varied with the times.
>
> As a rule, the artist is a child of his times, especially when the period of his personal development occurs during a time such as the early days of socialism. My own development coincided with that period and the idea of socialism captured my mind completely. At that time there was no question of my deliberately using my work to serve the proletariat. But what had I to do with the laws of beauty, with those of the Greeks, for instance, which were not mine, and with which I had no sympathy? The proletariat was my idea of beauty. The appearance of typical members of the working class fascinated me, and it was a challenge to me to reproduce it. It was only later, when I really got to know about the want and misery of the working classes through my close and personal contact with them, that I felt I also had a duty to serve them through my art.

After explaining at greater length her ideas on dignity in art, she finished with these words:

> I set no store by the fact that I am among the hundred prominent artists whom you have approached. But if you do decide to include me in your symposium, I must ask you to print my reply as it stands, in full and unabridged. Just one word in conclusion. I stand by every work I have ever produced.[72]

Whilst Käthe Kollwitz was writing the above, her health was far from good. This is clear from a letter of 13 February 1944 that she dictated to Clara Stern. Her honest and courageous rebuff of the Nazi journalist is, therefore, all the more praiseworthy:

(Dictated) 13. 2. 44

Dear Otto,

I was so glad to get your letter and the snap. Sybille is an enchanting little creature and I should have liked so much to see her for myself. But I cannot believe that I shall. I am glad too that she has inherited your blue eyes. I also am convinced that the war has now entered its final phase...

Käthe is too tired to go on dictating, and so I just wanted to add that we were really charmed with the baby's photo and it was the nicest mail we have received for a long time. K is not too bad in herself, just tired, tired, tired. She walked through the room today using two sticks, otherwise she just goes from bed to armchair...

<div align="right">

Yours,

Cl. Stern.

</div>

More good wishes to the three of you,

<div align="right">

from

Käthe.[73]

</div>

On 17 February, Käthe Kollwitz wrote a very revealing letter to Lichtenrade. It shows how clearly she foresaw what was to come:

Most of all, I would strongly advise you to let Arne start learning Russian right away. Later on, no matter what happens, he will have a clear advantage. The people here are already beginning to come to terms with everything Russian. There are bound to be so many dealings later on between the two countries and if he knows the language he will be a move ahead. So do have him taught in good time.[74]

A few days later, on 21 February, she developed her thoughts, which are very much to the point:

Germany's cities are in ruins and worst of all, every war has another war in reply ready to hand. One war provokes another, until everything, everything is destroyed. Goodness knows what the world will look like afterwards, what Germany will look like. This is why with my whole heart, I am in favour of a radical change to end this lunacy, and one's only hope lies in world socialism.[75]

25. 4. 44 (postmark)

Dear Nagels,

How glad I was to get your news and to know that Sybille can say 'Papa!' That is lovely, really lovely. Thank God you have the baby, it has changed your lives, and given them so much more purpose. I am feeling pretty low, not to say awful. I am really and truly old. At this age, my husband had already passed away. My dearest love to you.

Your own,

K. Kollwitz[76]

6 June 44

Dear Nagels,

I just wanted to send you greetings. How is Sybille? And how are you? How old is the child now? How I should love to see her, but as there is so little prospect of this you must accept my good wishes instead. There is nothing I enjoy these days. I am too old and I've had enough.

My love to you, all three.

Your own,

K.[77]

Nov 24 (sic) (Postmark 26. 11. 44)

Dear Nagels,

Just a word of greeting to the three of you. There is nothing to say, just to send you my love.

Your old,

Käthe Kollwitz[78]

At the end of 1944, we received the last news from her personally. She had moved to Moritzburg near Dresden, where the Prince of Saxony, an enthusiastic art collector, had offered her a house to live in in the castle precincts.

5. 12. 44 (Postmark)

Dear Otto and Wally,

Thank you very much for the snap, it is perfectly charming and stands before me now. The baby has Otto's eyes, which is nice, but otherwise she looks like Wally. You have given me much pleasure, and I should love to see the child for myself, but that is quite out of the question. At least I have the photo. Only I am afraid that things are not good with you, my dear Otto.

Letters to Otto and Wally Nagel

For me the long winter months drag on, but I am glad that at least my window looks out on to a wide lake. My thoughts keep returning to so many, many things, those we laughed about together and those that saddened us too.

My dearest love to you,
Your old,
K. K.[79]

Dr Hans Kollwitz had very little free time, and so he was seldom able to visit his mother in Moritzburg but he went whenever he could. He wrote to me telling me of his last recollections of her:

> My last visit was on Good Friday 1945. I read her the Easter story from the St Matthew gospel, which she had heard so often as an oratorio, and also the 'Easter walk' passage from her beloved Faust. In spite of all the ravages of time, she bore herself like a queen in exile, radiating an overwhelming sense of goodness and dignity. That is my last memory of her.

Towards the end, her granddaughter, Jutta, came to stay with her, and this made the unfamiliar surroundings in which she lived a little more like home. The wise old woman and the young girl, who was still searching for the answers, had many discussions together which revived Käthe's spirits. In one such conversation she expressed her idea of the world of the future that others would live in. 'But one day, a new ideal will arise, and there will be an end to all wars. I die convinced of this. It will need much hard work, but it will be achieved.'[80]

Letter to Otto and
Wally Nagel

House in Moritzburg, her last residence

In July 1945 Käthe Kollwitz's body was exhumed and cremated, after a funeral service at Meissen. As she had wished, the urn with her ashes was buried beside those of her husband in the Central Cemetery in Friedrichsfelde, Berlin.

Käthe Kollwitz received her first political impressions in the early days of socialism. Her personal life and her artistic career ran parallel with the development of the German working class movement. If her initial approach to the proletariat was at first one of emotional sympathy, it was transformed later through knowledge and experience into something increasingly better informed. Although in her youth she had dreamed of loading rifles for the fighters at the barricades, she was not a revolutionary, in spite of the fact that she later endorsed the aims of Marxism and sympathized with active fighters in the struggle for socialism. Her own attitude is reflected in many of her works. In *The March of the Weavers*, a woman carrying a child on her back strides along beside the men. The etching *Attack* from the same 'Weavers' cycle, again shows a woman, this time in the foreground on the right, holding a child by the hand. Like these two women Käthe Kollwitz is herself among the fighters, exhorting and demanding at one and the same time. The child,

whose joyless existence in these works is intended as a reminder to their fathers, is portrayed from many points of view in Käthe Kollwitz's work, but always with the same intention. If one assesses her Mother-and-child works in the light of this knowledge, her maternal compassion takes on a new and specific meaning, and one which bears a close relation to her own life and her aims. Even to her son Hans, Käthe Kollwitz, who in her art displayed the essence of motherhood, was not 'a tender mother. Love was indeed there, but it was felt, not displayed.' Käthe Kollwitz had her work and that was the most important thing for her. Private life with 'all its intimacies, all its little foolishnesses' was no one else's business, not even her children's. 'And their works do follow them', she used to quote, acknowledging the example set by her parents and grandparents at home: 'To take one's work seriously, but not oneself'. This attitude of hers is one I have respected throughout this book. Only where it was indispensable for understanding the artistic meaning of her work and its inner content, has the personal side been included here.

Attempts have been made to find a religious meaning in the work of Käthe Kollwitz, but there is absolutely no foundation for this, either in her life, her work, or her utterances. Her art rings with a noble humanism that owes much to the strong influence of Goethe, who meant so much to her. His works gave her much pleasure and they accompanied her personal and her artistic life from her childhood onwards. They gave her renewed strength and wisdom when she needed them most, that is, in her last years. In many letters from those last days she discussed Goethe as she had done earlier in life, and she sat down to re-examine his work, to test her memory and the condition of her mind, reciting aloud to herself long portions of his poems. Towards the end, when she could no longer express herself in artistic creation, she drew for spiritual comfort on the great minds of the past, on those who were allotted an old age as unproductive as her own:

> It is right and proper that man should reach a pinnacle and then descend again, this is no cause for complaint. But, of course, it is a bitter experience to live through. When Michelangelo was an old man, he drew himself sitting in a child's pushcart, and Grillparzer said 'Once I was a poet, now I am none. The head on my shoulders is no longer my own.' But that's the way it is.[81]

Käthe Kollwitz was not the kind of person to take refuge in the past. She always lived for the present day, and she drew on Goethe to help her to face it. True, she looked back to the Königsberg of her youth,

where she grew up 'in stillness, but a rich and fertile stillness.' Nevertheless, she put on record later that she had 'survived and conquered those early days. That's all they were, just days.'

As an old woman naturally her mind harked back to many things that had brought joy and suffering into her life, and she also recalled the stages of her artistic development. But the present, and with it, her increasing age, she experienced as reality. Once her creative powers failed her, she acted accordingly. She made one last attempt to work as an artist. On 14 November 1944, she wrote from Moritzburg:

> Yesterday my dear Jutta brought me drawing paper and even drawing materials with her from Dresden, and we made a bargain. Every morning, I am to drink a cup of real coffee, then I must get up and try to do a little work. It is a very good arrangement, but unfortunately my eyes have been getting very bad as well...Glasses no longer help, I see better without them.[82]

There is an eye-witness report of what happened next: 'It was a moving moment when they gave the great artist a stick of charcoal and placed the paper in front of her. After a slight hesitation her fingers tightened round the charcoal and she sat there looking down pensively at the white drawing paper. Then she put the stick down again and said in her brusque, determined way: "No, I shan't work again. I'll not do anything second-rate."'

She had come to terms with herself and her life, and she took it for granted that her time had come. But she believed in a new order for the future, when there would be no more war or social distress.

So it is logical that although her life came to its end in the midst of the hell of Fascism, she pinned her hopes on world socialism.

Those of us who were her friends and are alive today, and all who honour her work and use its great humanistic aims for their proper purpose, are trying to create a world that corresponds to her ideas. The anti-war struggle she waged so tirelessly is as necessary today as it was in her lifetime. We and our successors will accomplish it; as Käthe Kollwitz put it: 'It will mean much hard work, but it will be achieved.' Her example will help us in our purpose, to win the battle in order to give her work its final fulfilment.

> No matter whether life be long or short—the important thing is to hold one's banner high and to fight in the struggle. For without struggle there is no life.[83]

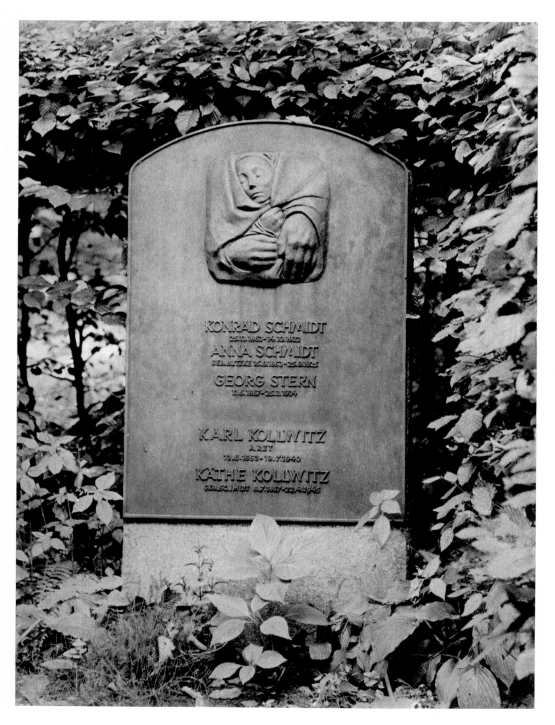

KONRAD SCHMIDT
25.12.1863 – 14.10.1932
ANNA SCHMIDT
GEB. BUTZKE 15.9.1863 – 25.9.1925
GEORG STERN
11.5.1867 – 25.3.1934

KARL KOLLWITZ
ARZT
13.6.1863 – 19.7.1940
KÄTHE KOLLWITZ
GEB. SCHMIDT 8.7.1867 – 22.4.1945

Grave in Friedrichsfelde

Plates

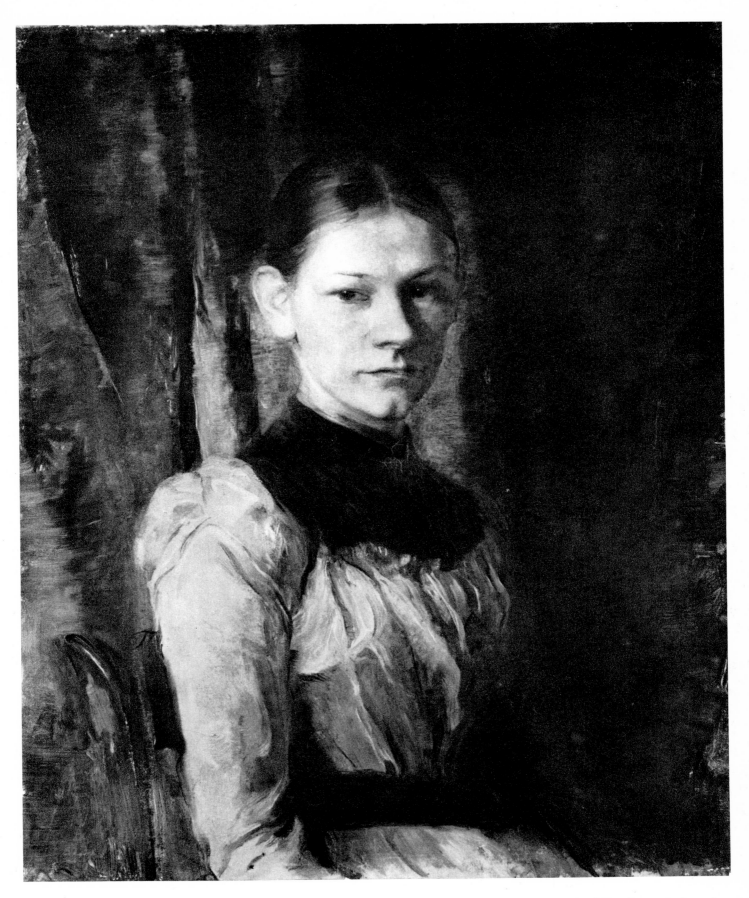

1. Portrait of Else Rupp, before 1890

2. Early self-portrait, 1889

3. A page of studies, 1890

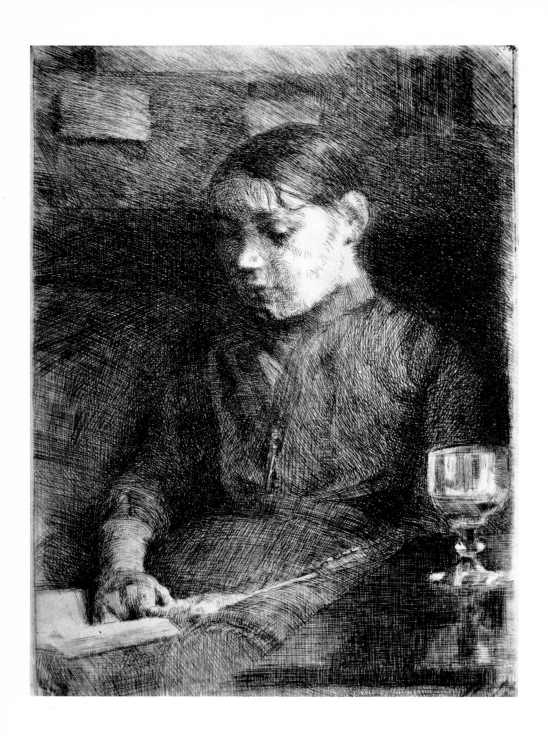

4. Girl reading, with wineglass, 1890

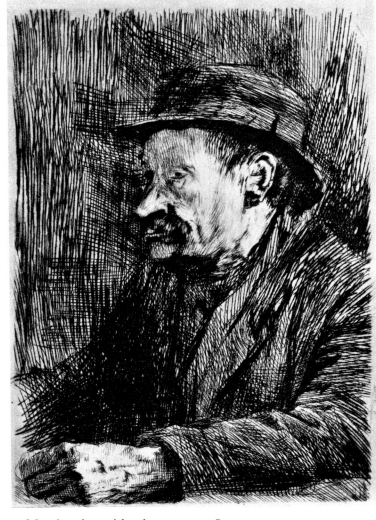

5. Man in a hat with a low crown, 1891

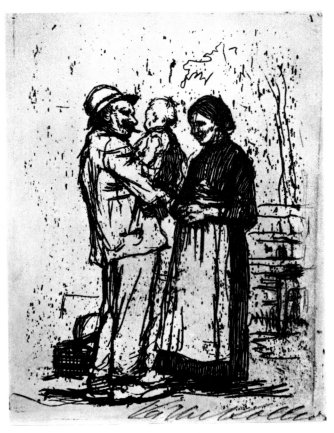

6. Welcome Home, 1892

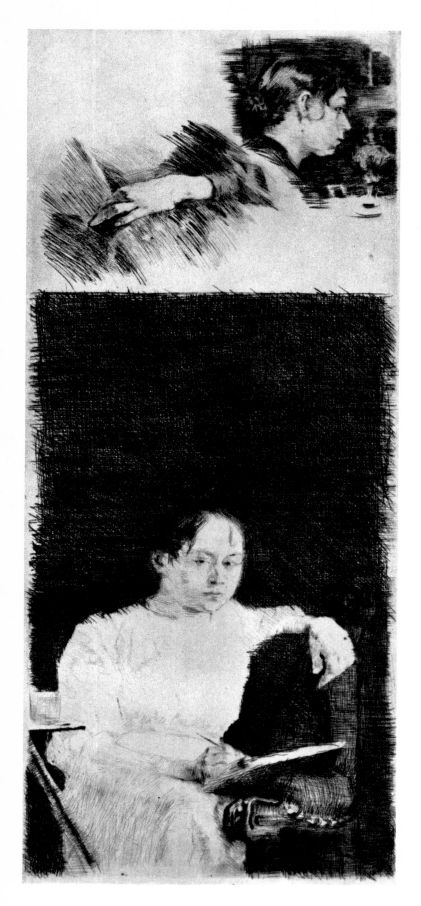

7. Two self-portraits, 1891

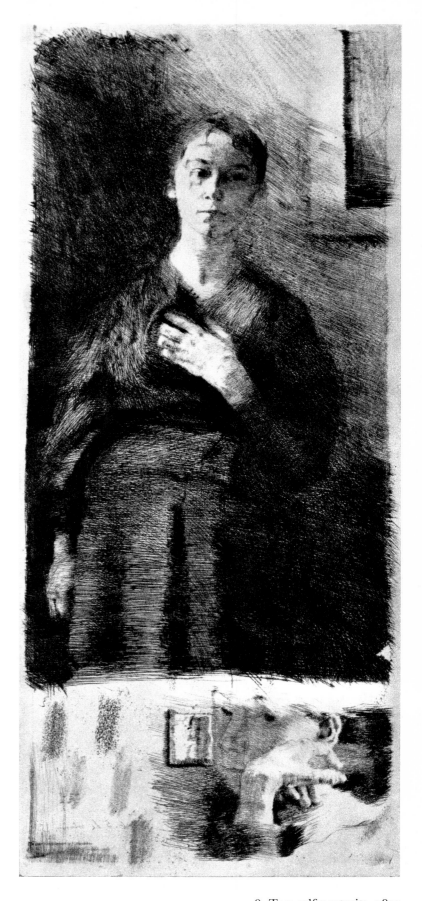

8. Two self-portraits, 1892

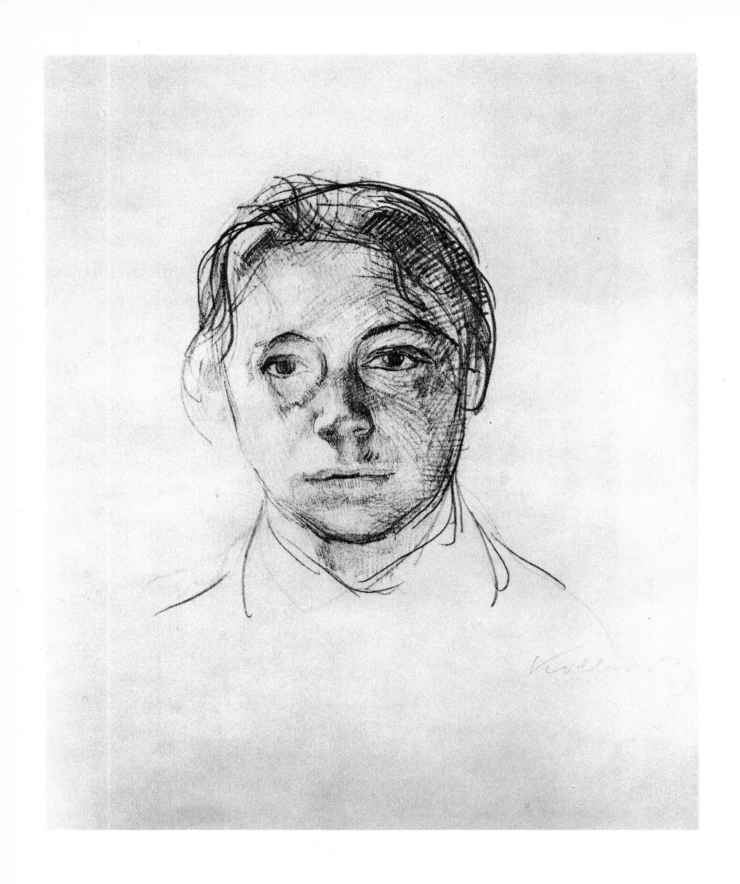

9. Early self-portrait with hair loose, c. 1892

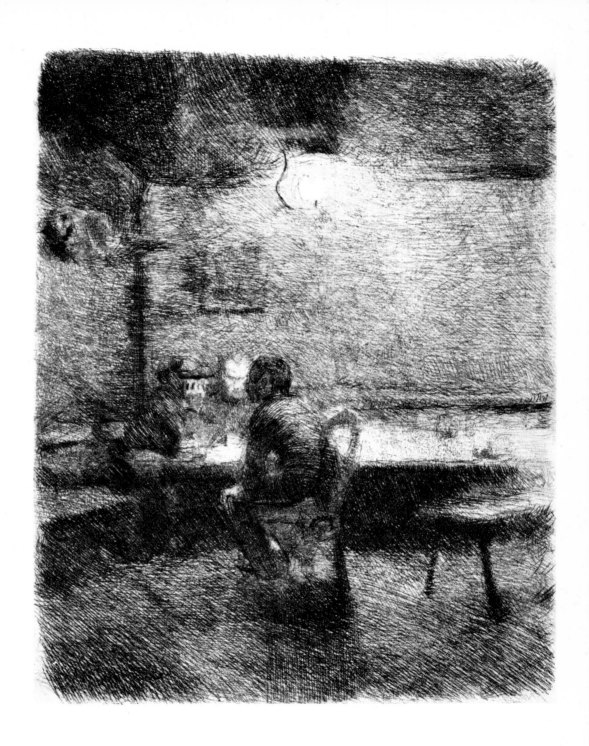

10. Three workers at an inn table, 1893

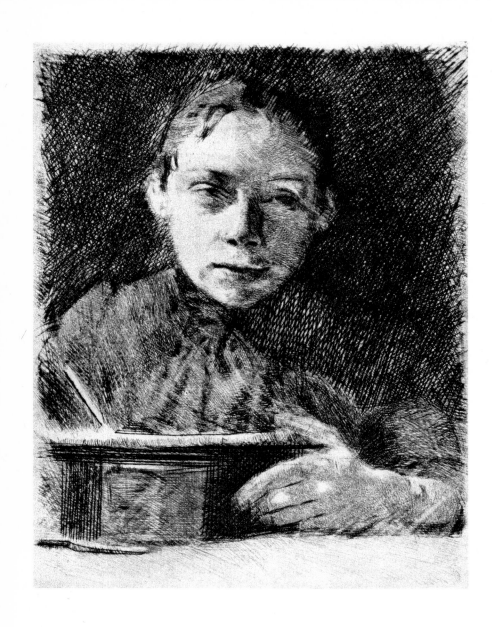

11. Self-portrait at the drawing-board, 1893?

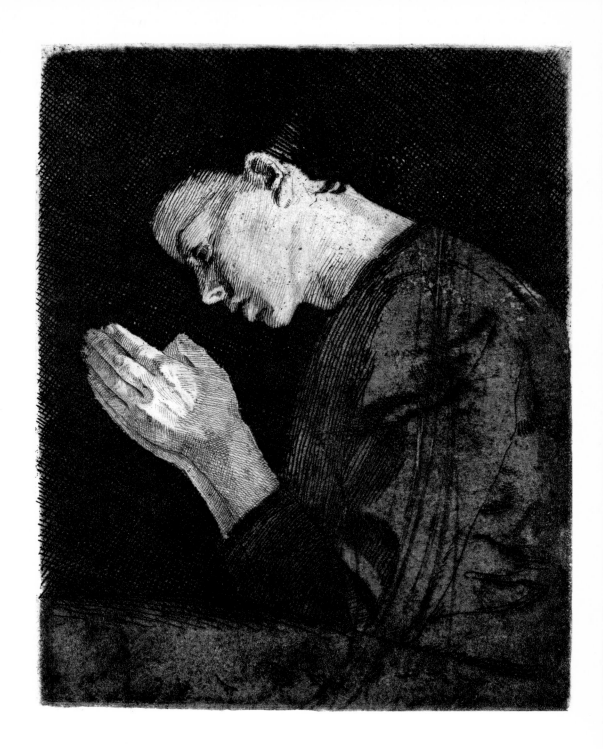

12. Girl praying, 1892

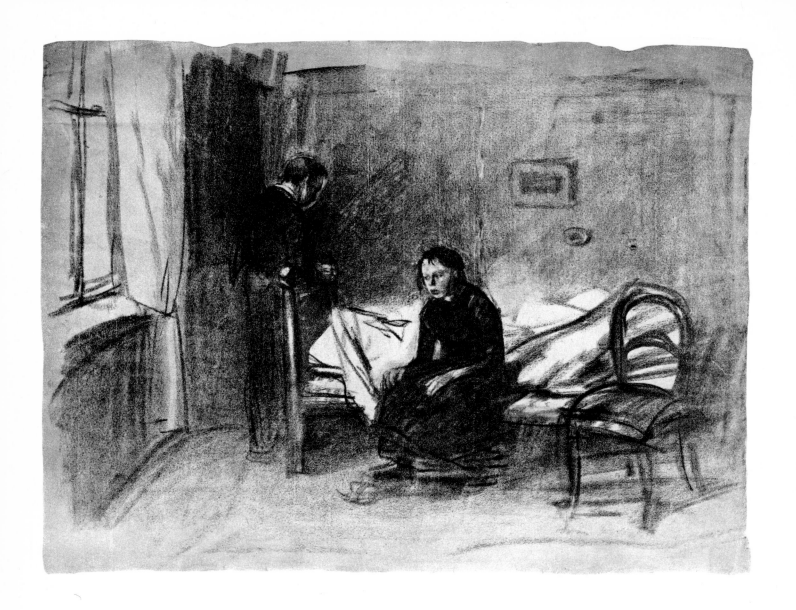

13. Young couple, c. 1893

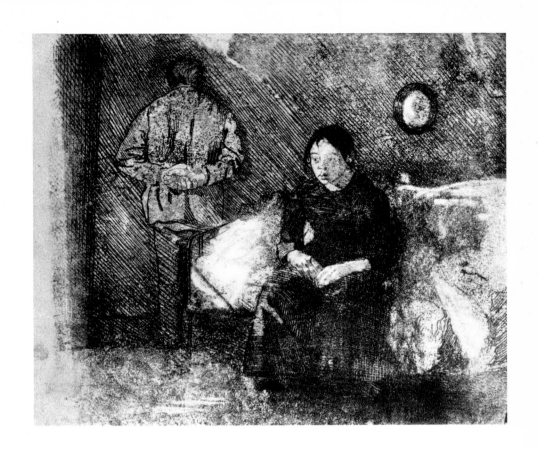

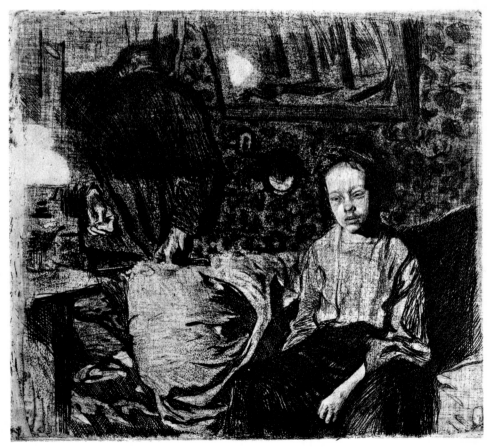

14/15. Young couple, 1893 and 1904

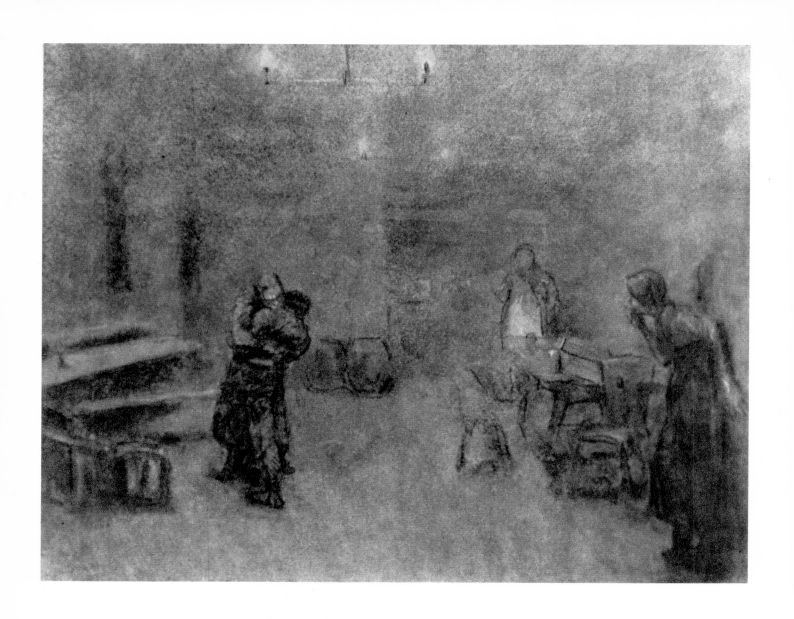

16. Scene from *Germinal*, 1888?

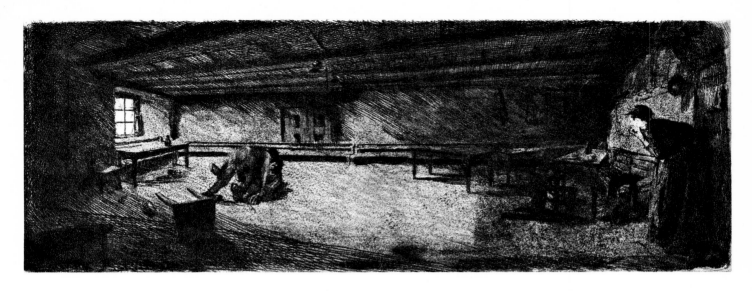

17. Scene from *Germinal*, 1893

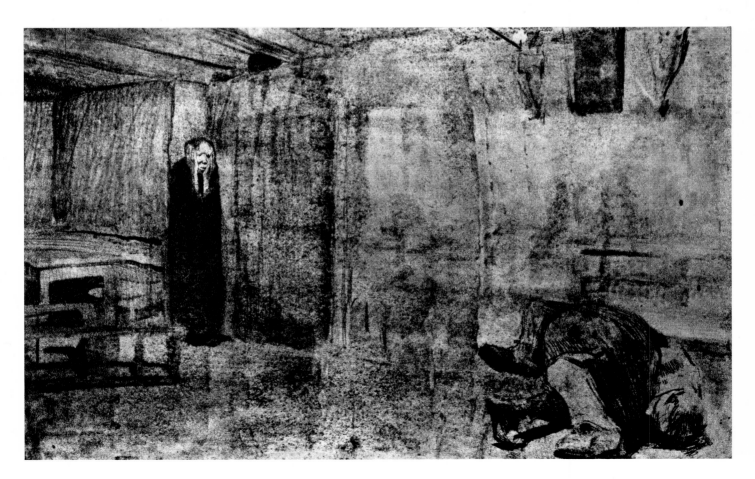

18. The fight in the bar, *Germinal* 1904?

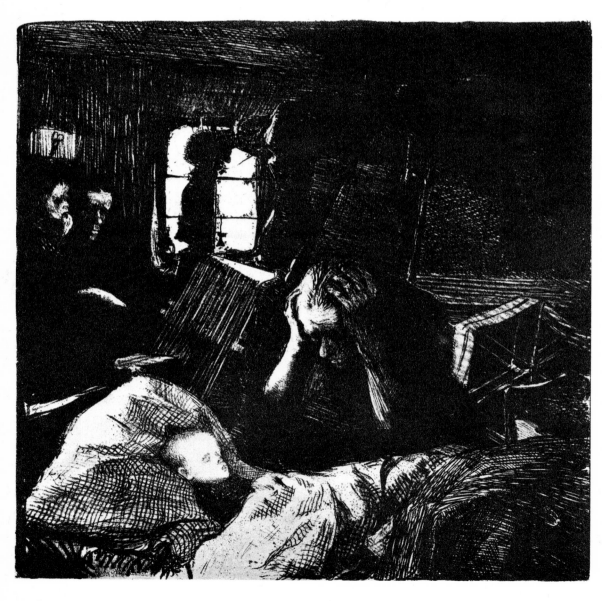

19. Poverty, 1897

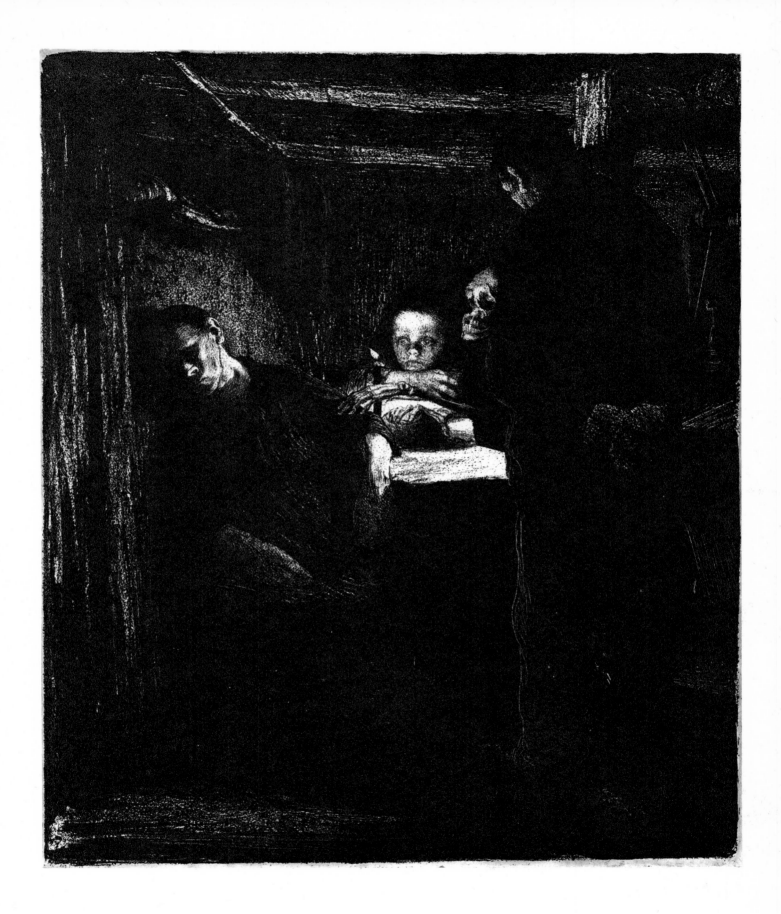

20. Death, 1897

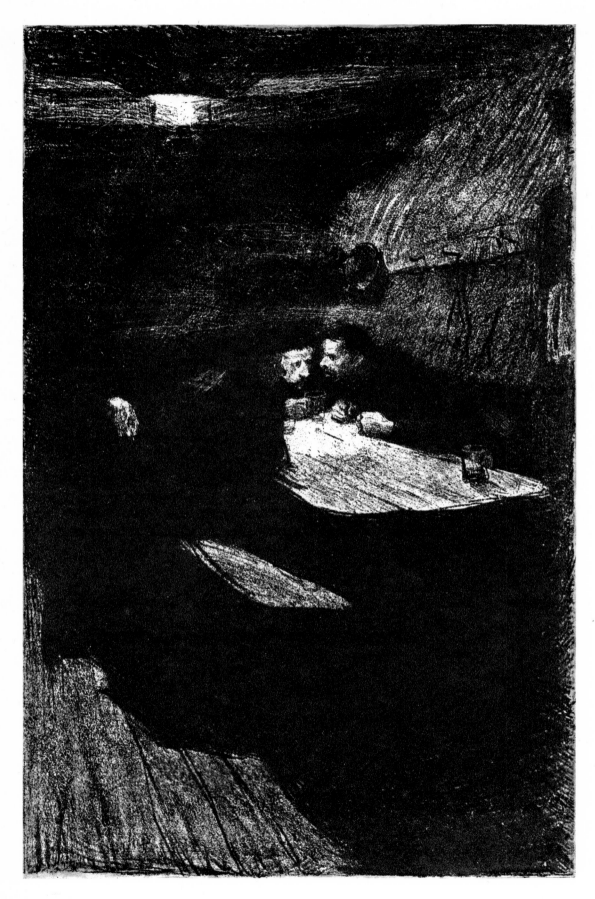

21. Deliberation, 1898

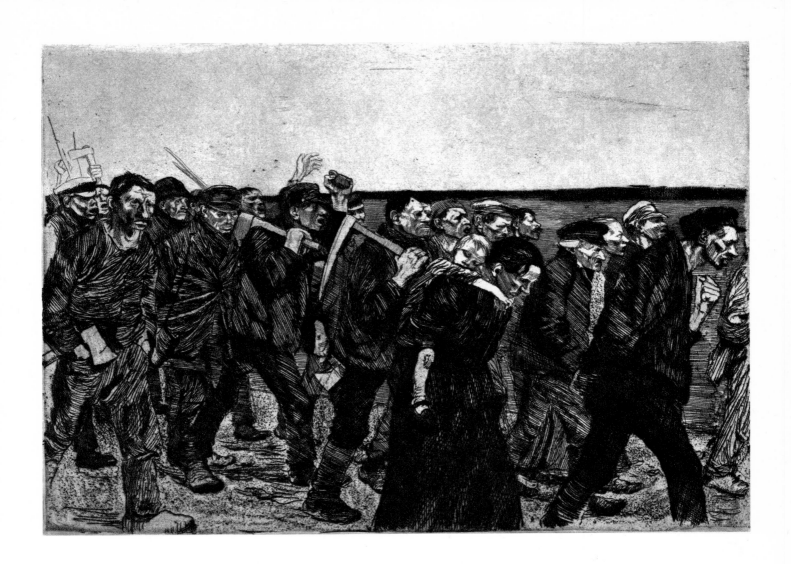

22. Weavers on the march, 1897

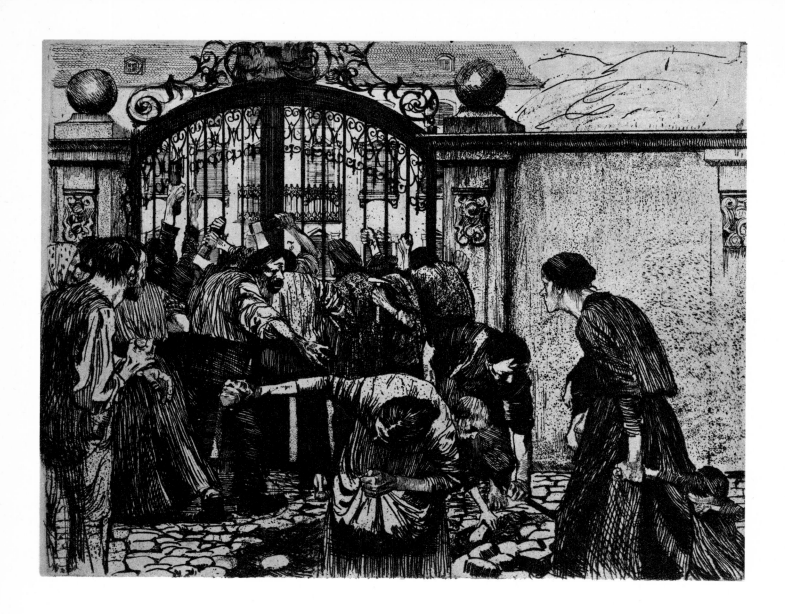

23. Attack, 1897

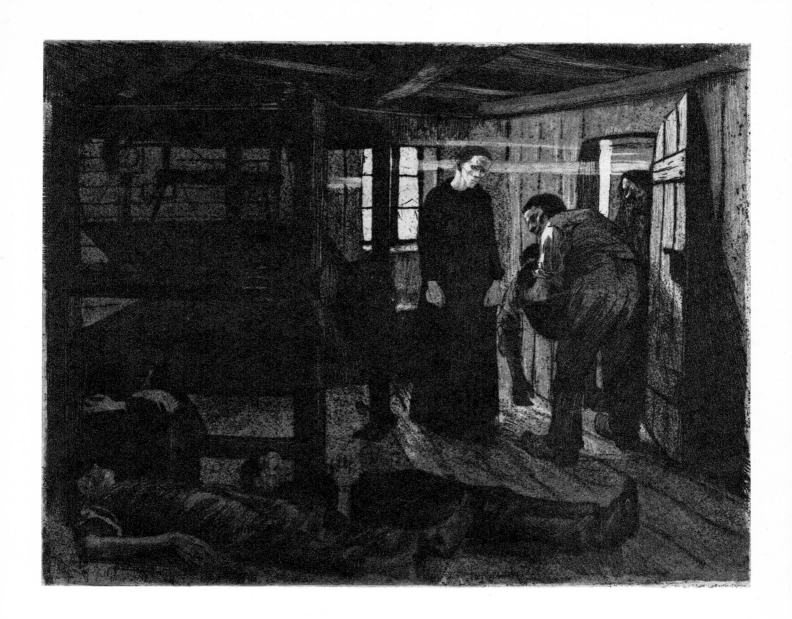

24. The end, 1897

25/26. Poverty, 1893 and 1893/94

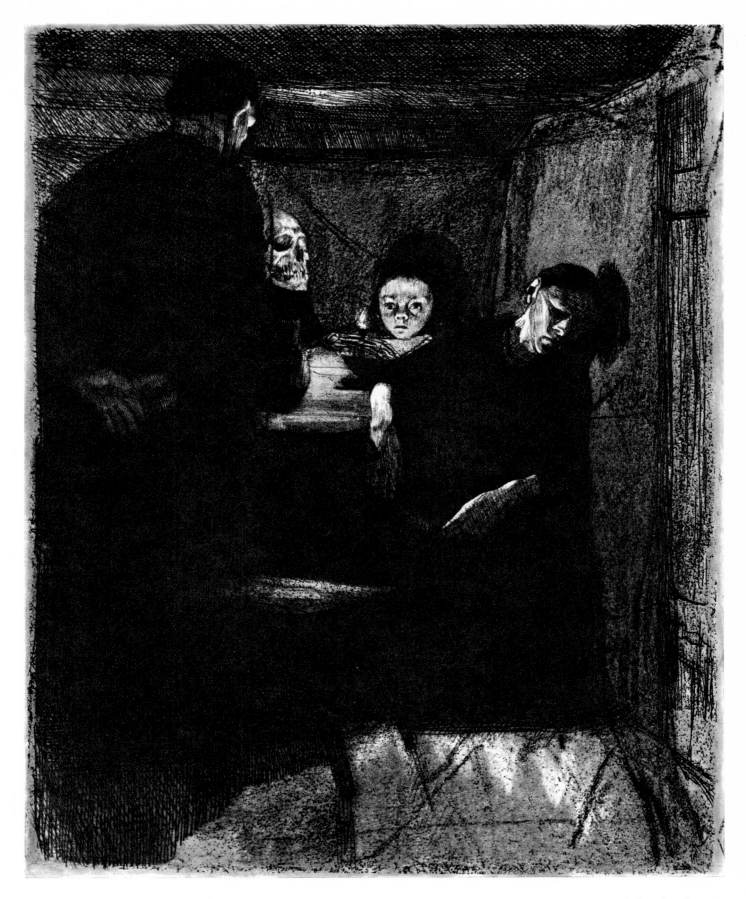

27. Death, 1894/95

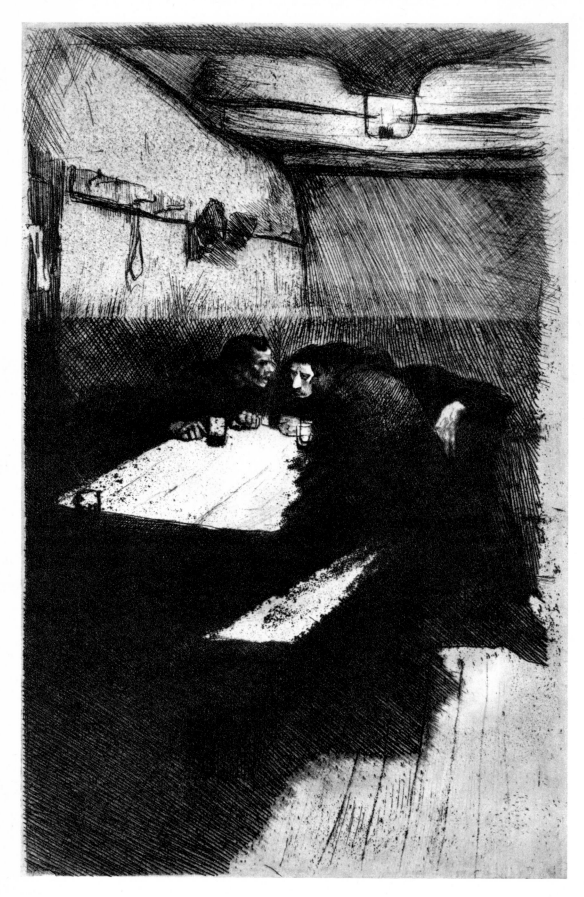

28. Deliberation, 1895

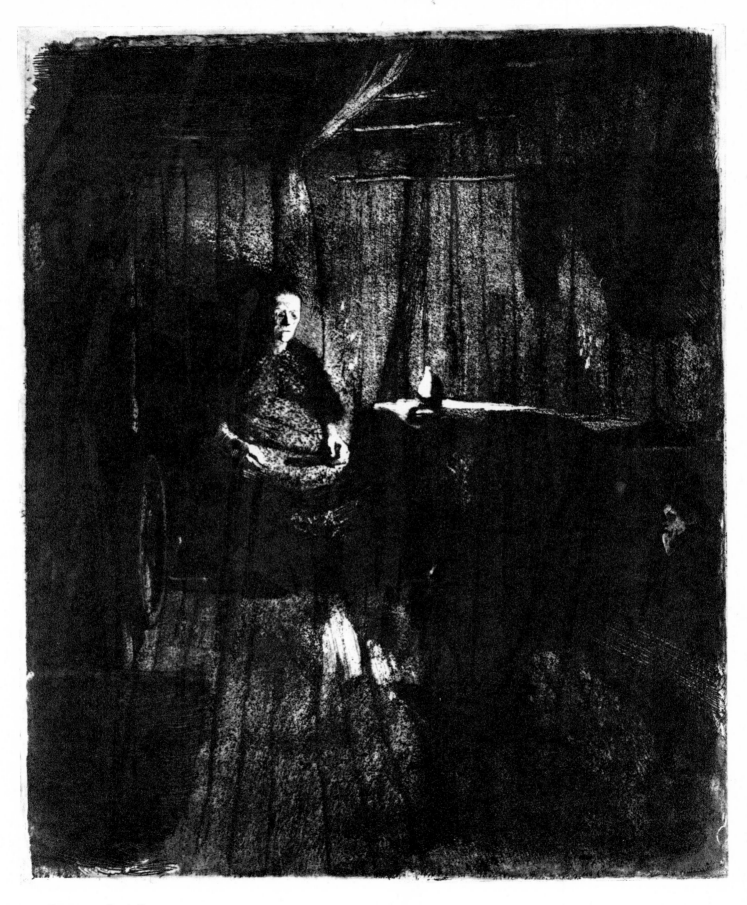

29. Poverty, 1894/96

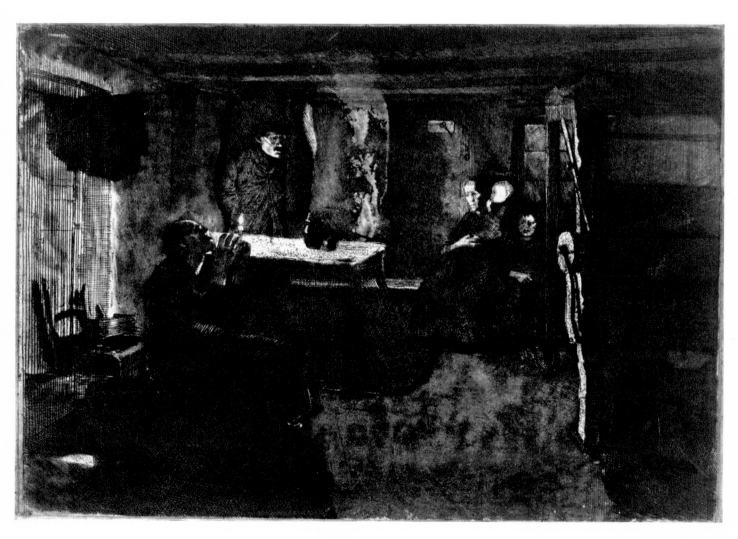

30. Poverty, 1895

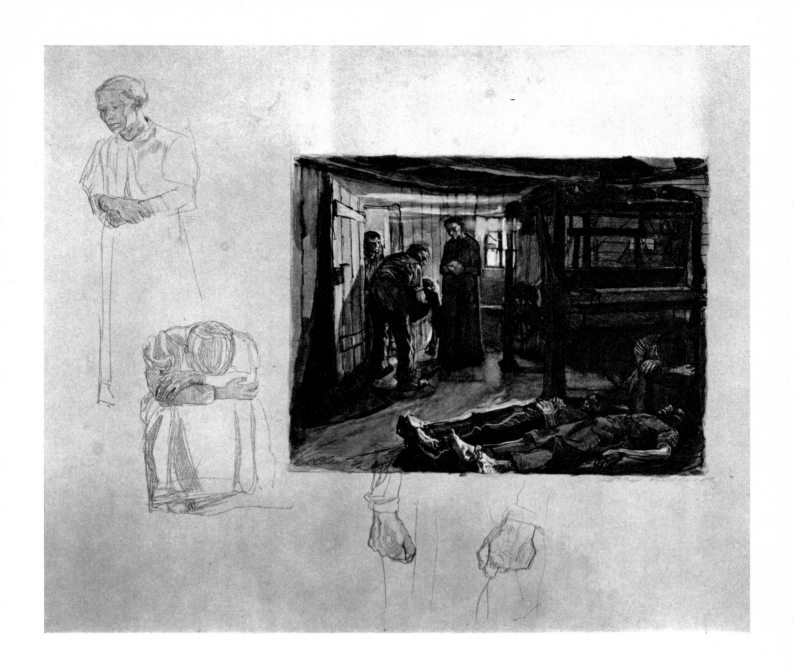

31. Sketches and study for 'The end', c. 1897

32. Man behind a table, study for 'Poverty', 1895

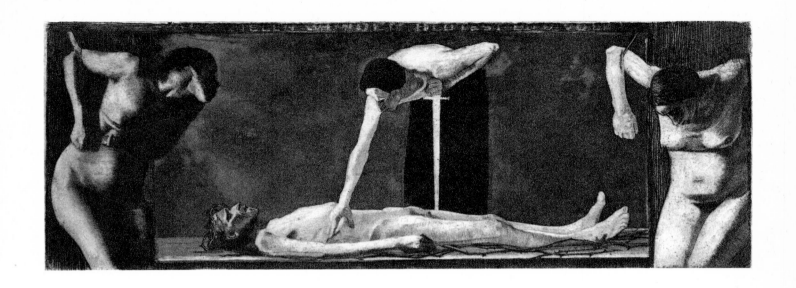

33. 'O nation, you bleed from many wounds', 1896

34. Self-portrait, and nude study, 1898

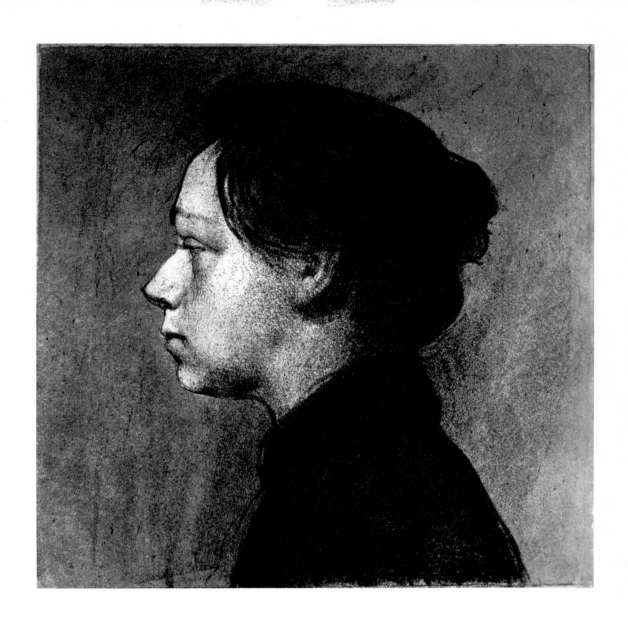

35. Self-portrait, left profile, 1898

36. Female nude, c. 1900

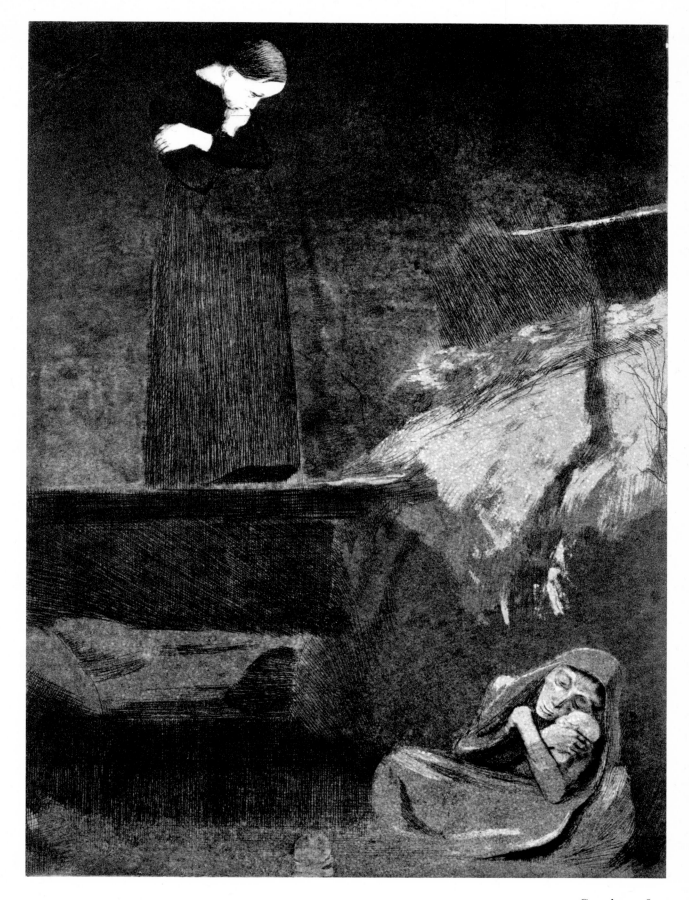

37. Gretchen, 1899

38. Study of child, and hands, c. 1900

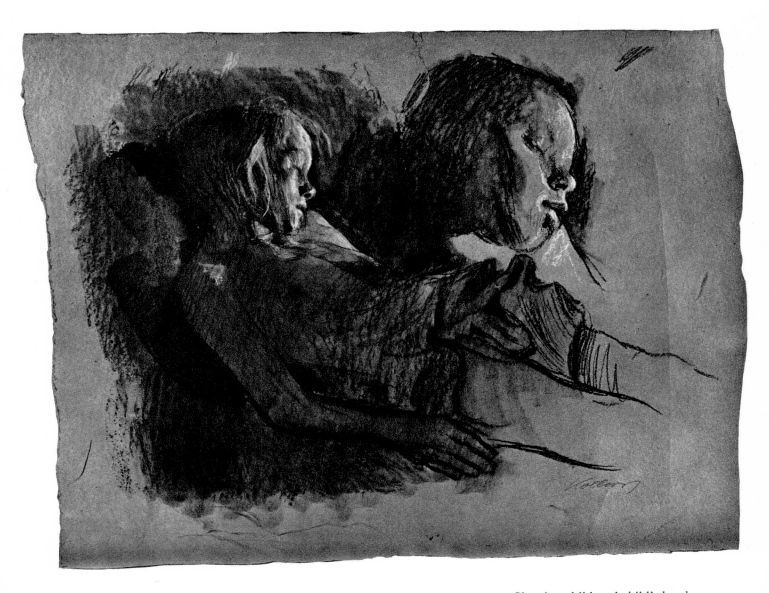

39. Sleeping child and child's head, c. 1900

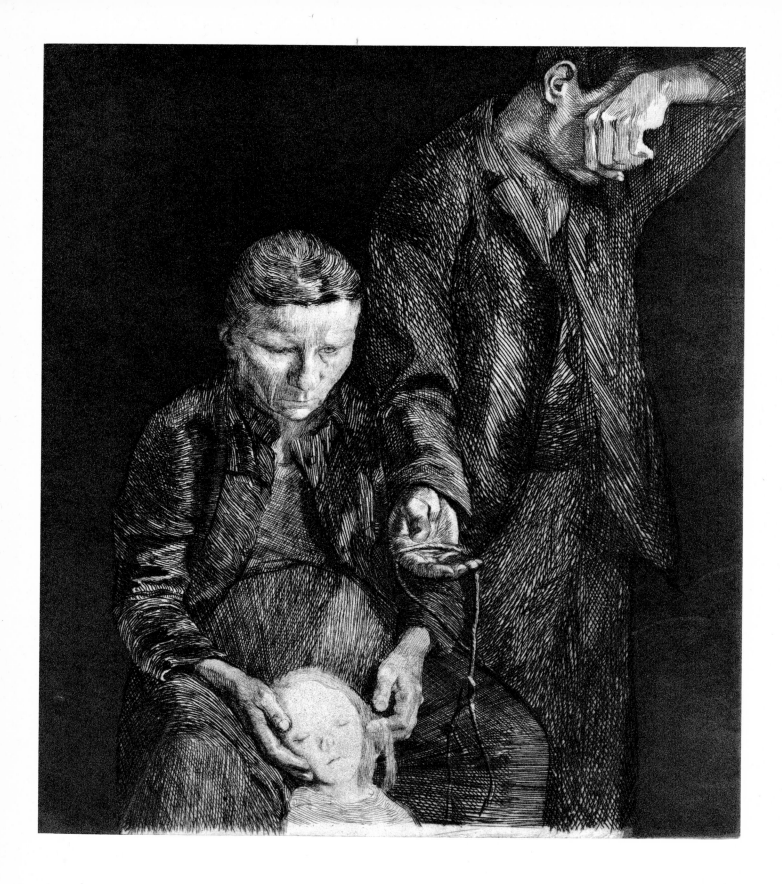

40. The downtrodden, (left panel), 1900

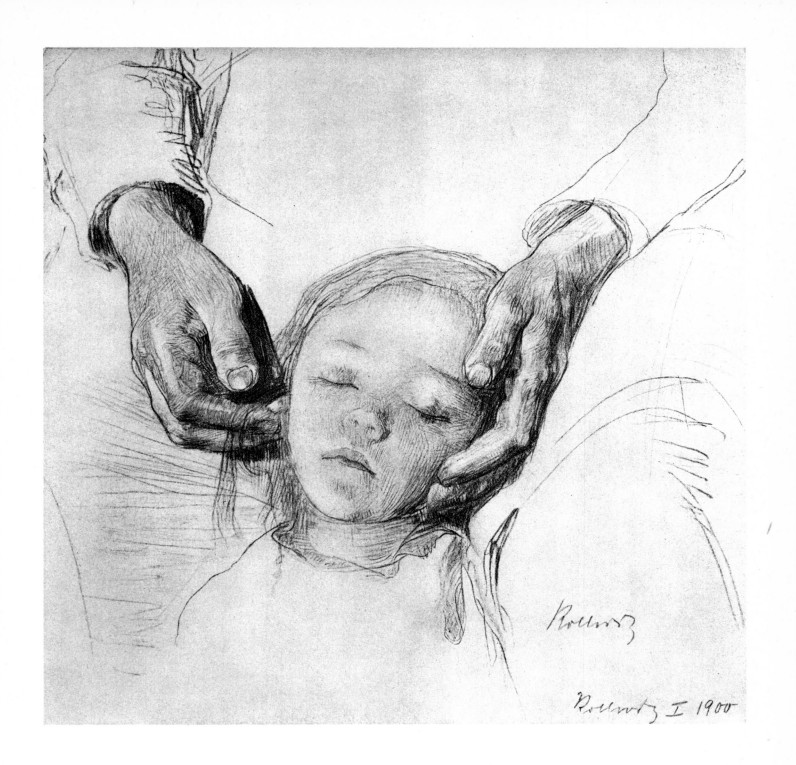

41. Head of child in its mother's hands, (study for Plate 40), 1900

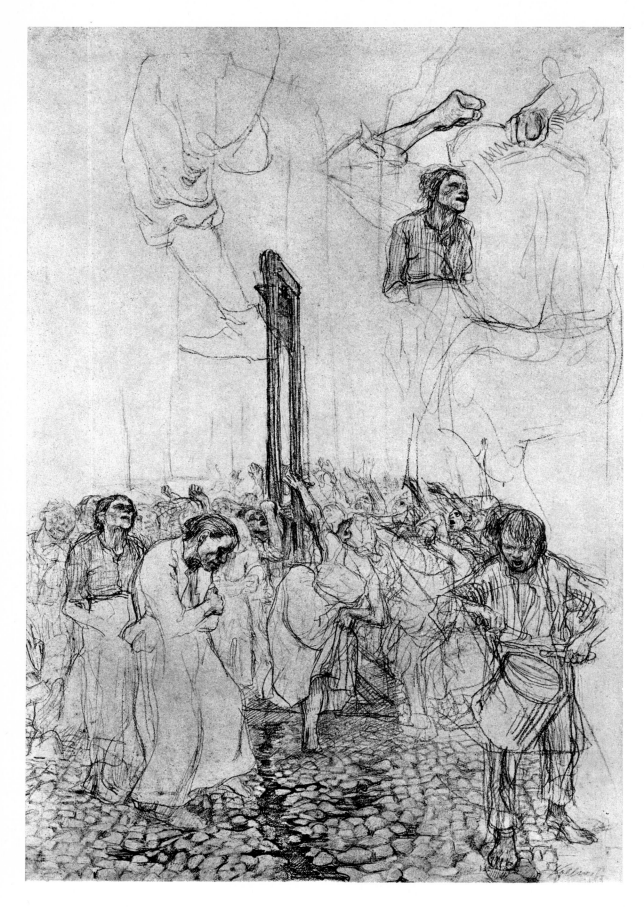

42. Study for 'Carmagnole', 1901

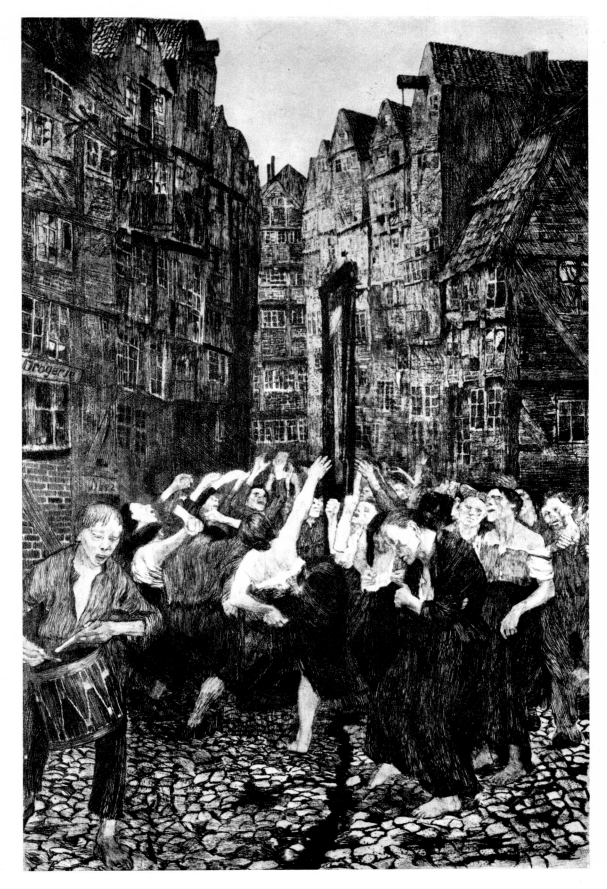

43. The 'Carmagnole', 1901

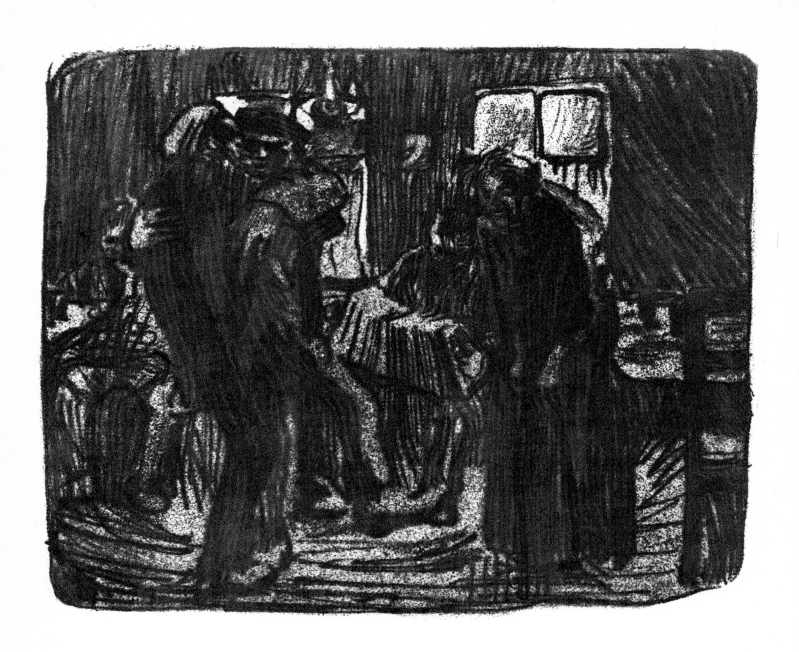

44. Hamburg drinking den, 1901

45. Woman laughing, 1901

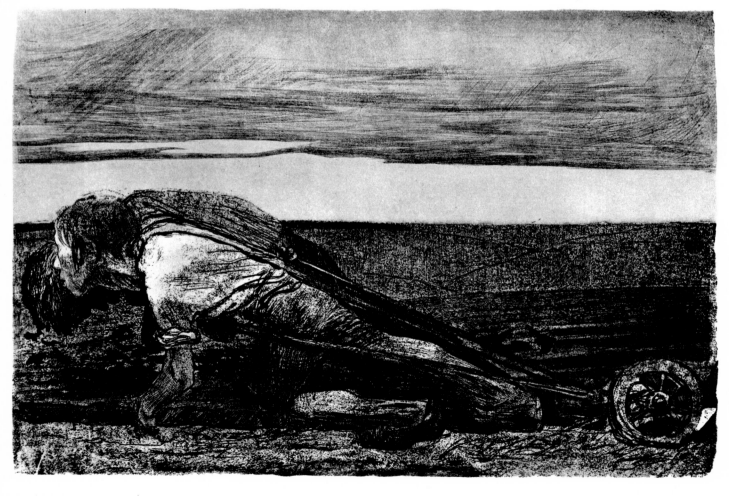

46. The ploughmen, 1906

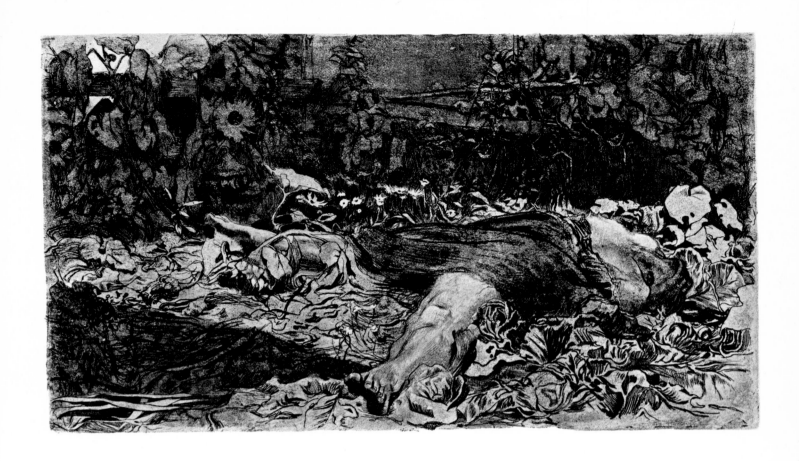

47. Raped, 1907

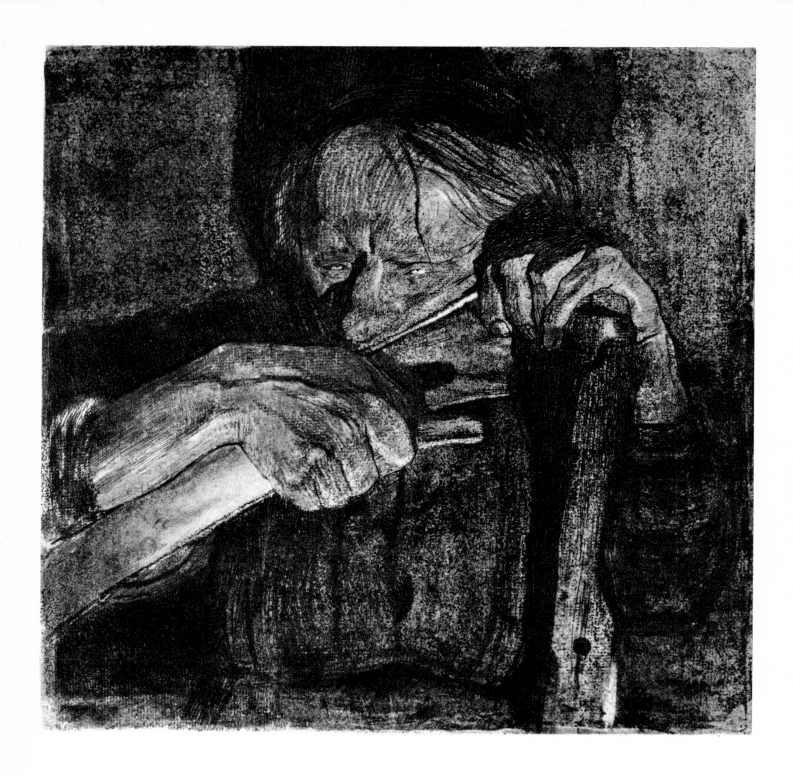

48. Whetting the scythe, 1905

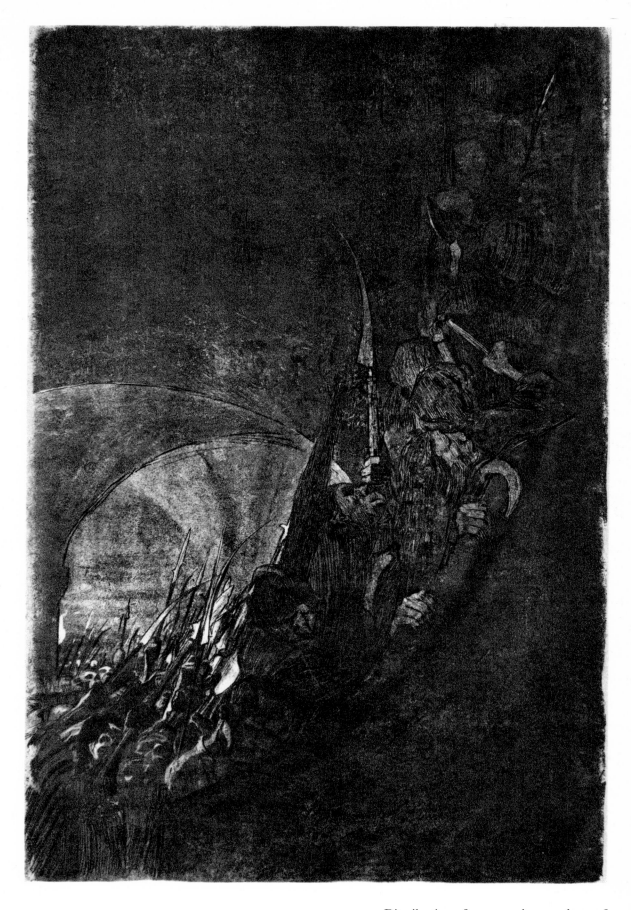

49. Distribution of weapons in a vault, 1906

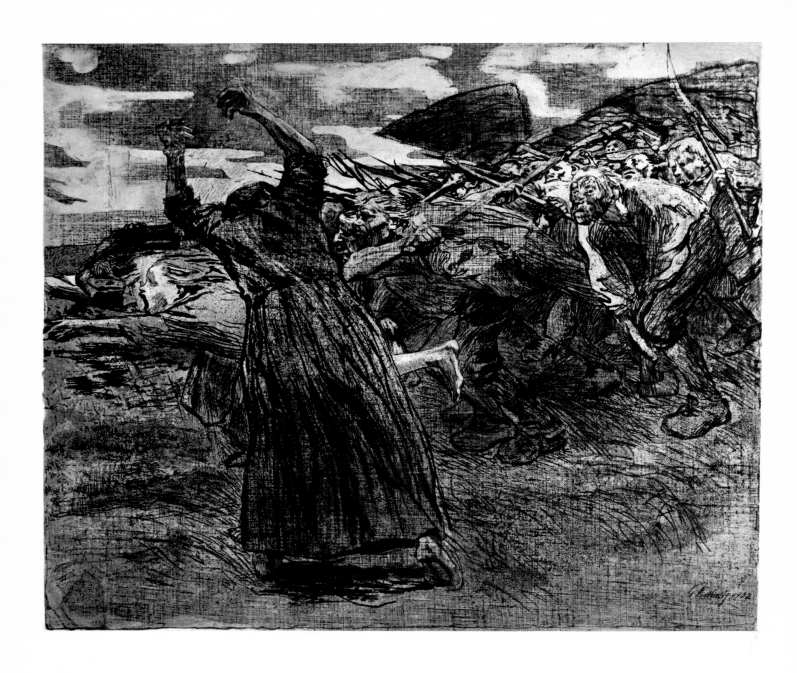

50. **Revolt,** 1903

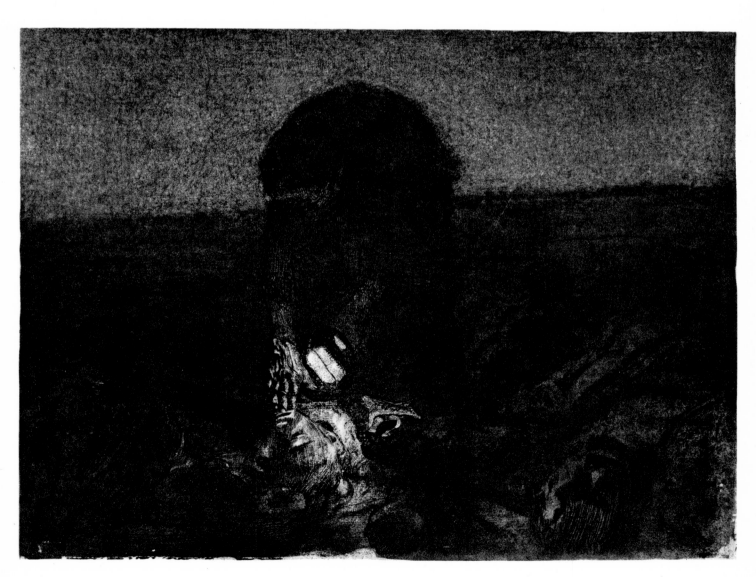

51. Battlefield, 1907

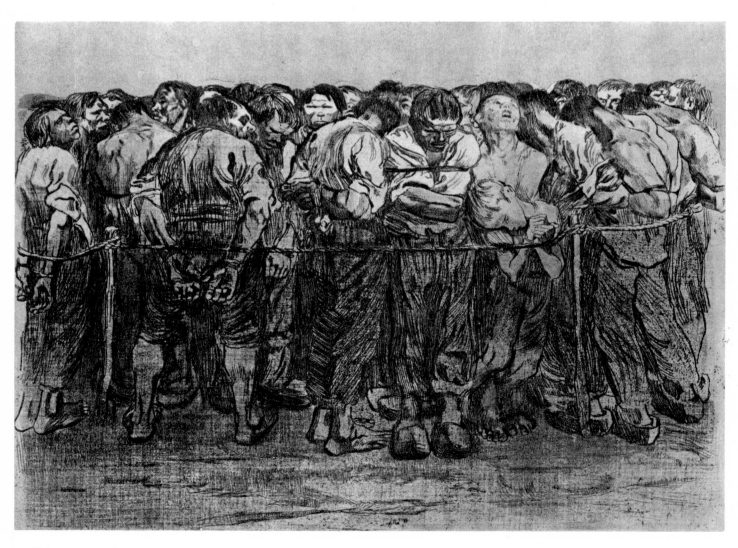

52. Prisoners, 1908

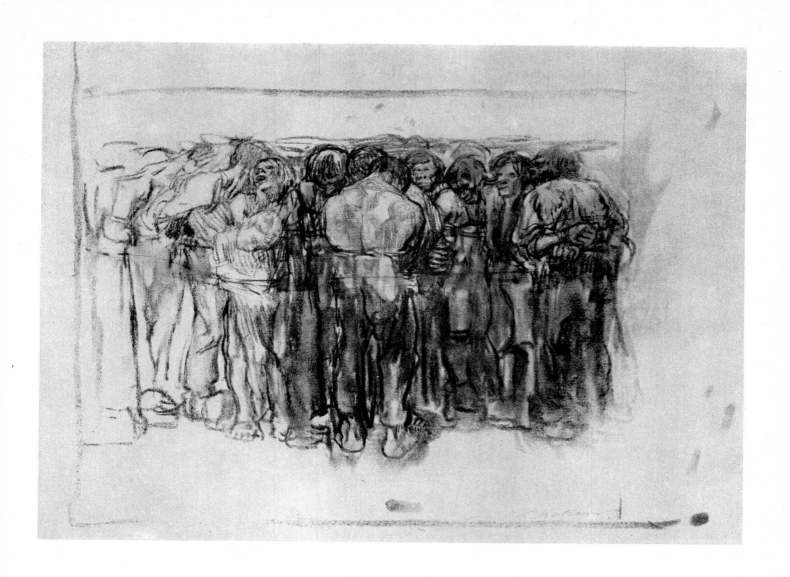

53. Prisoners, study for Plate 52, 1908

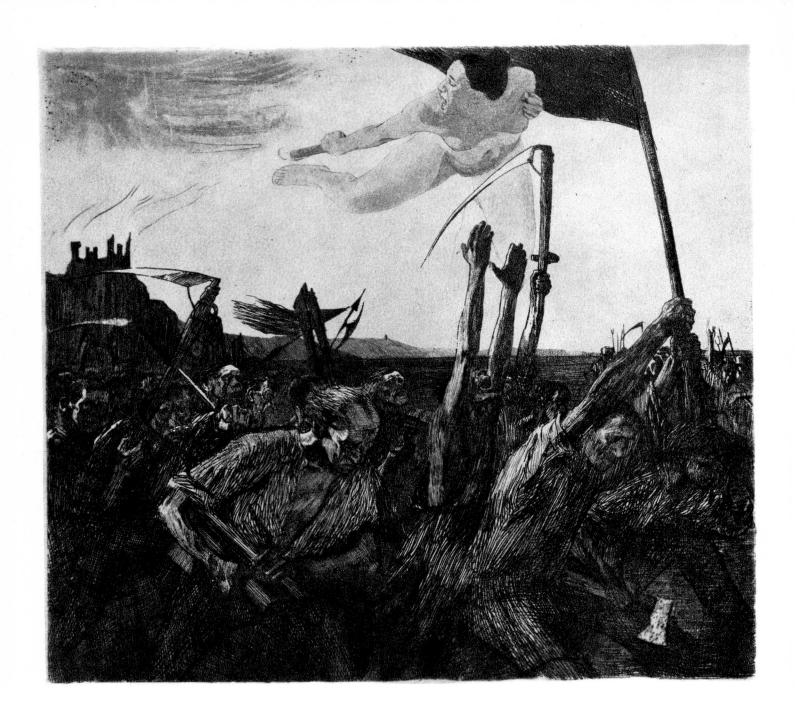

54. Insurrection, 1899

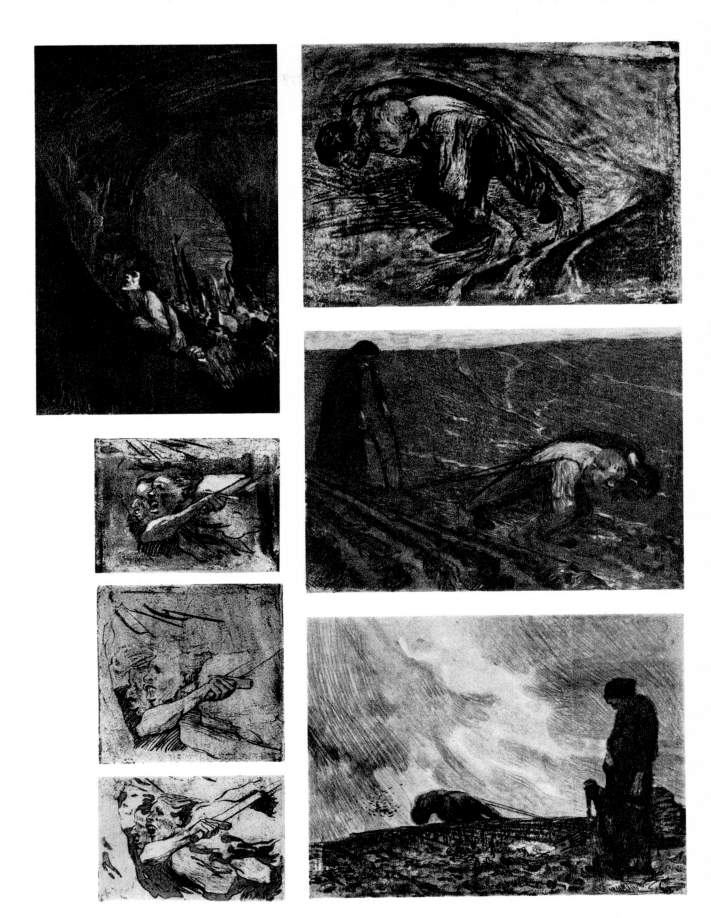

55. Rejected studies for the 'Peasants' Revolt', 1902—1905

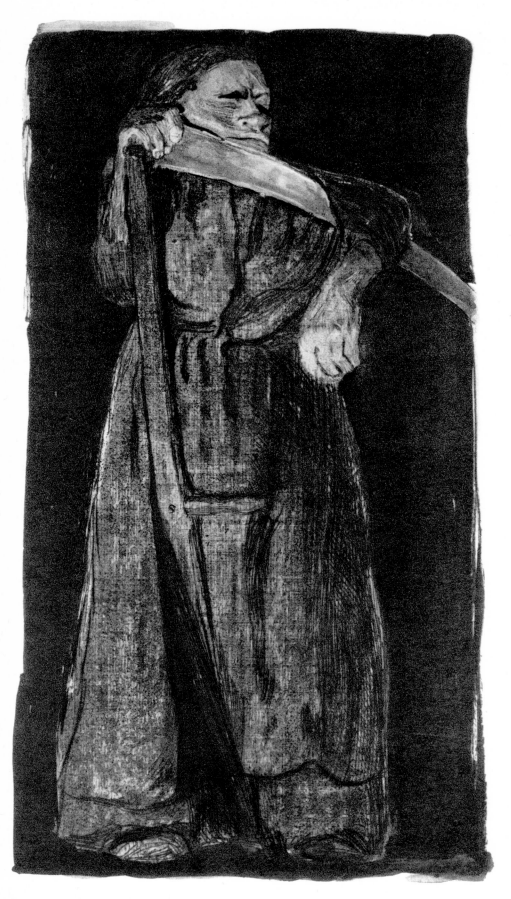

56. Woman with scythe, 1905

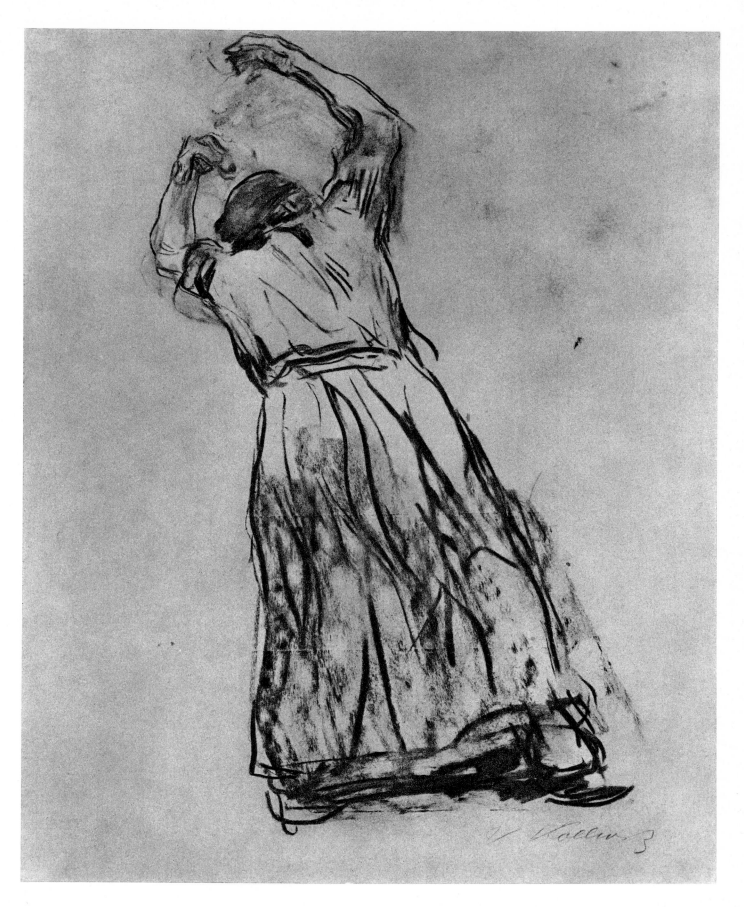

57. Revolt, 1902

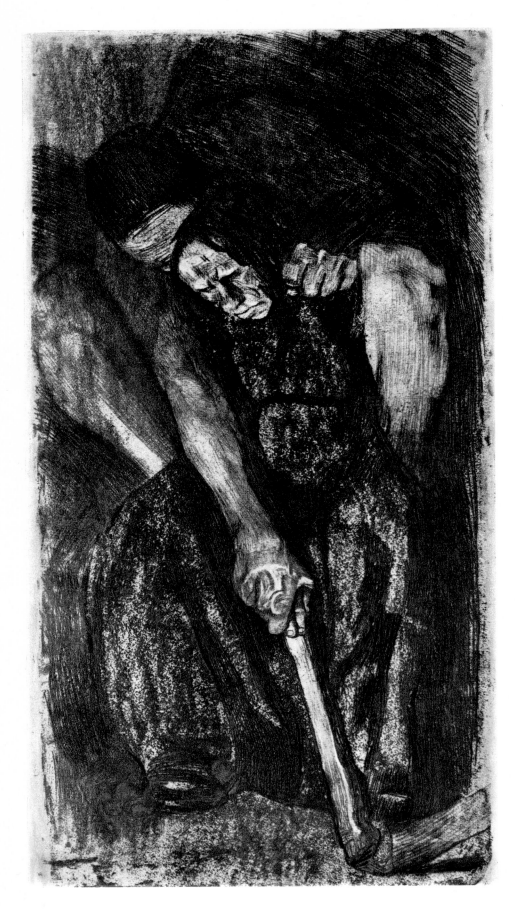

58. Inspiration, 1905

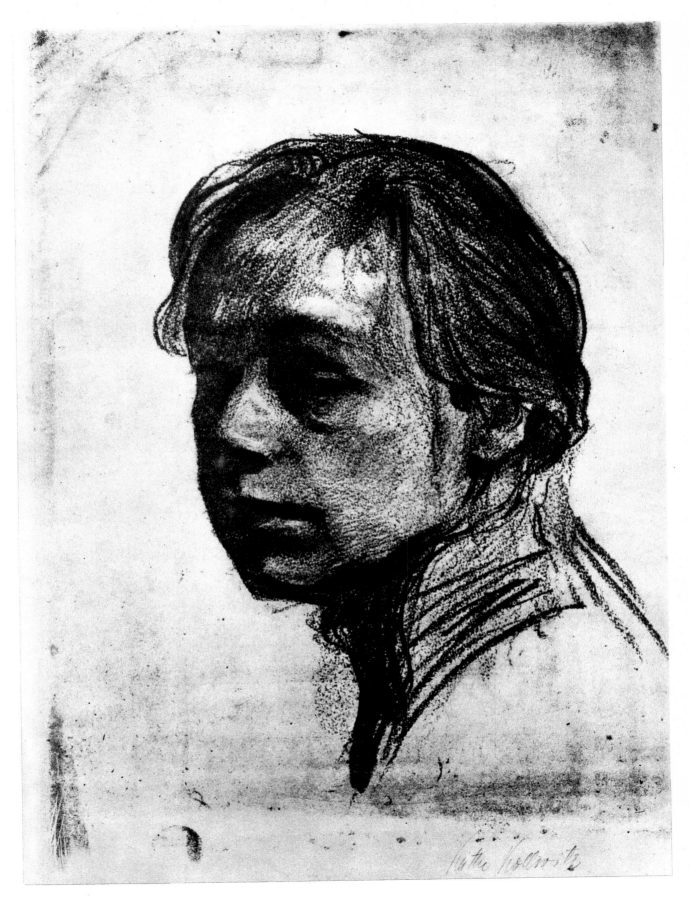

59. Self-portrait with high-necked collar, left view, 1903

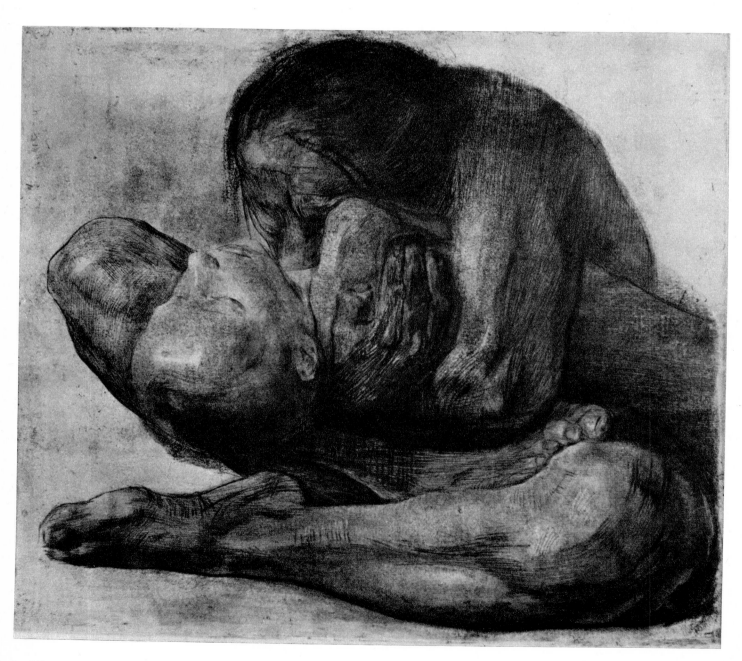

60. Woman with dead child, 1903

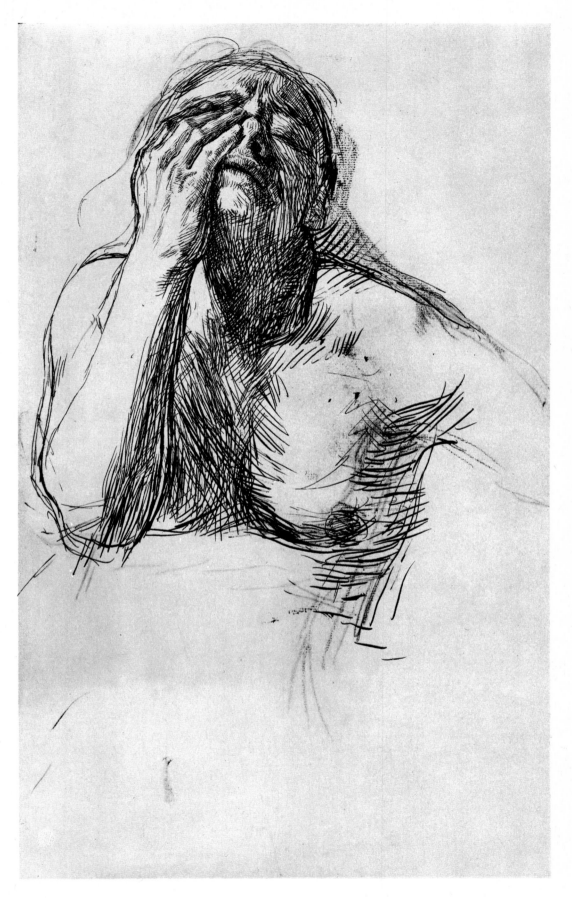

61. Study, c. 1903

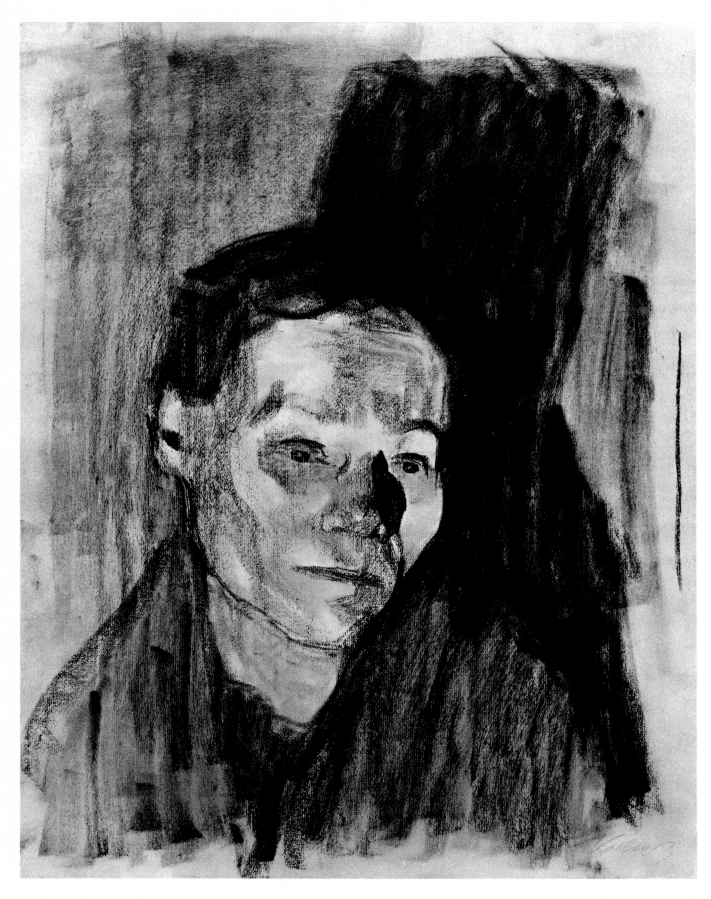

62. Study for poster for German Home Industries Exhibition, 1905

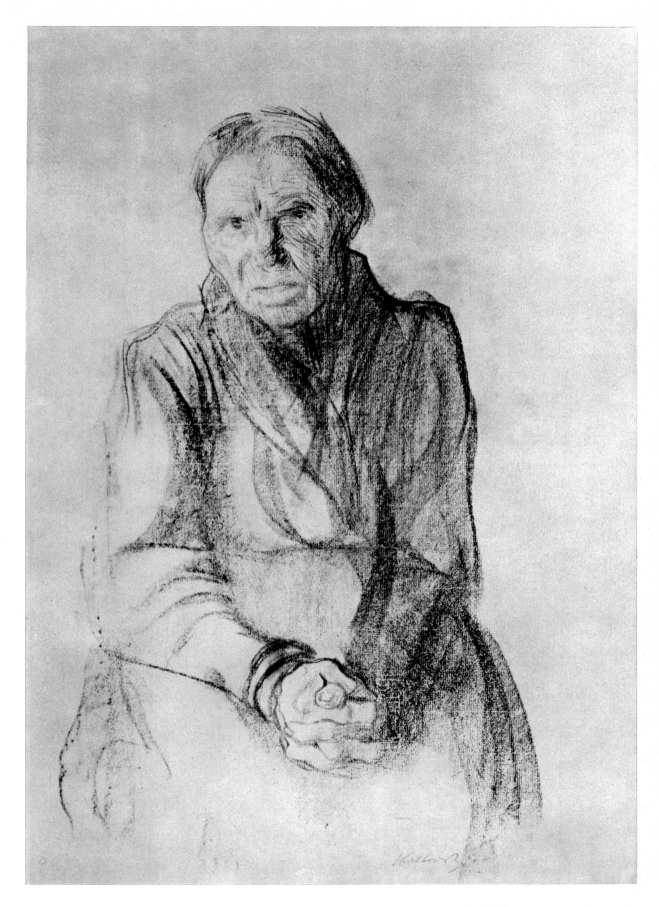

63. Old woman seated, c. 1905

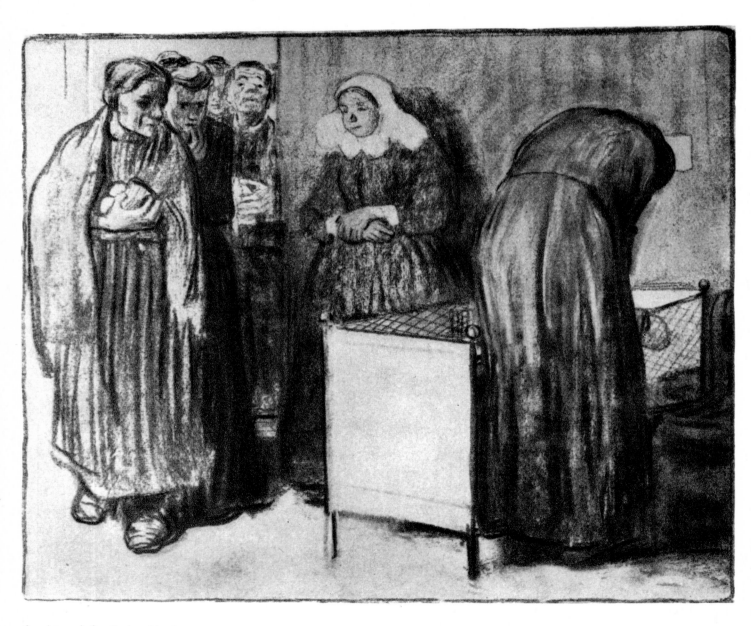

64. At an infant's deathbed

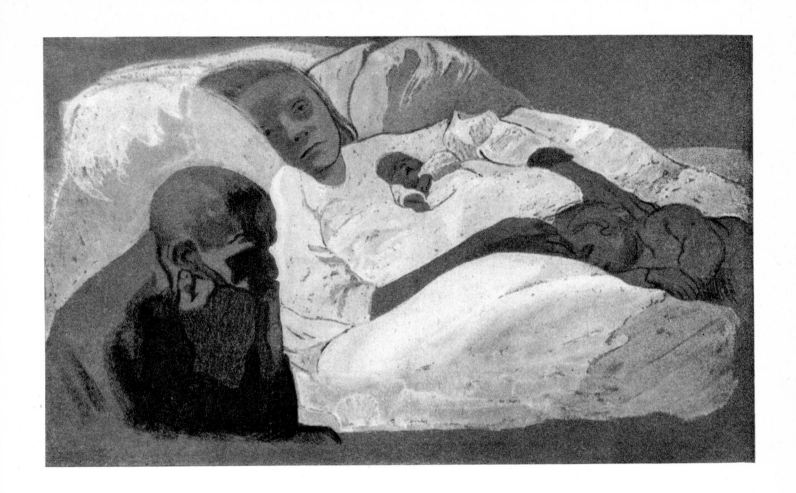

65. Their only happiness

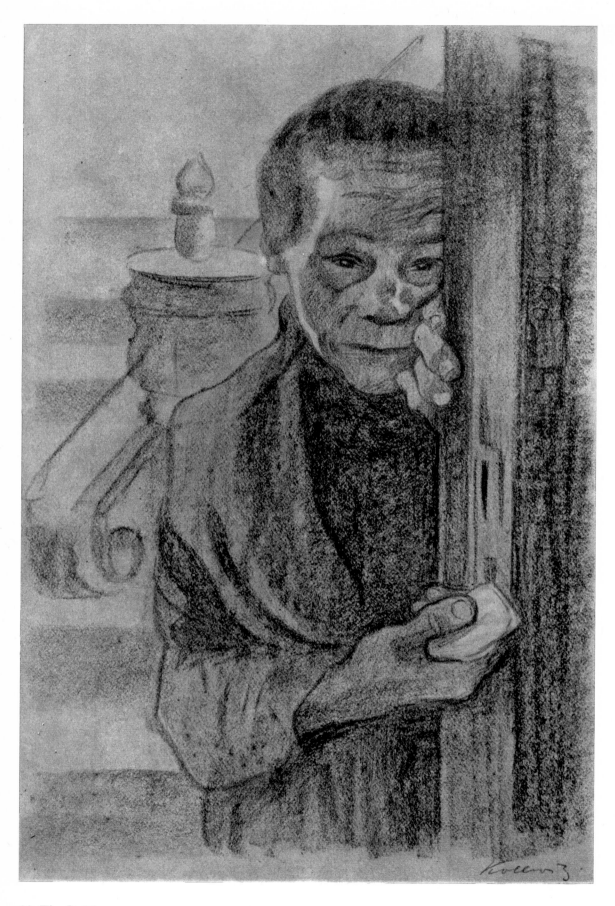

66. The Petitioner

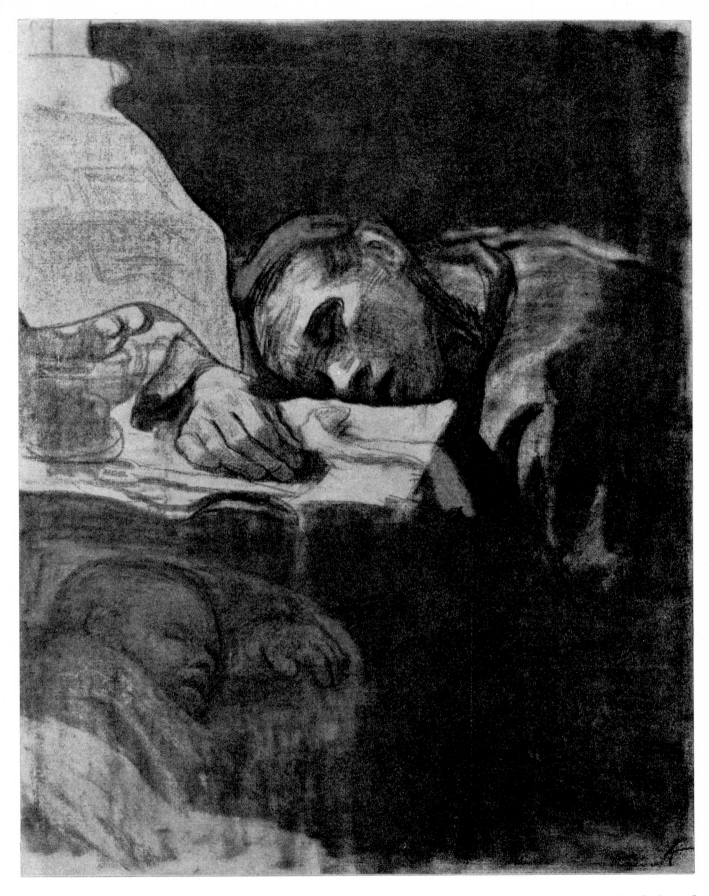

67. Portraits of misery, I

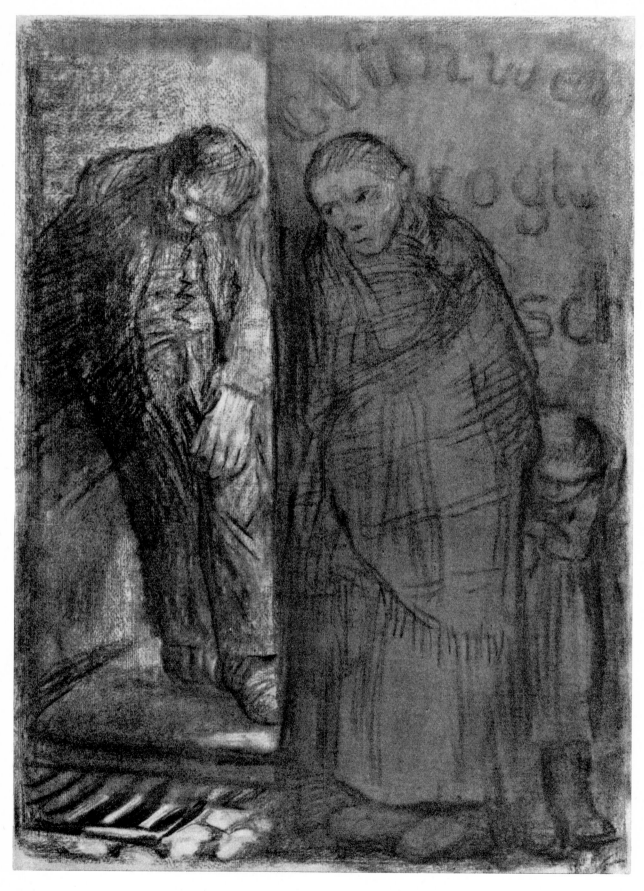

68. Portraits of misery, II

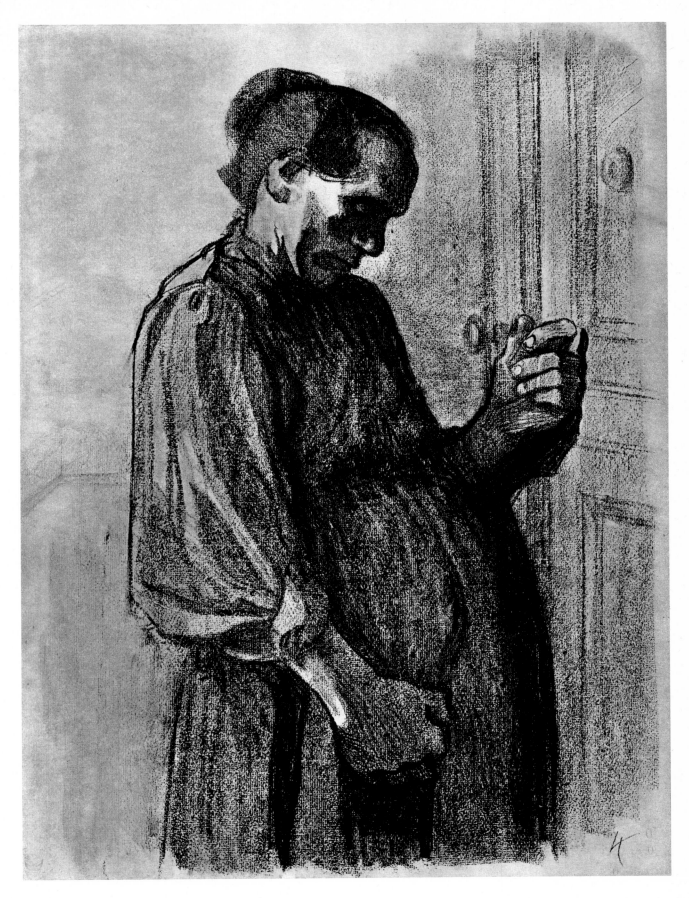

69. Portraits of misery, III

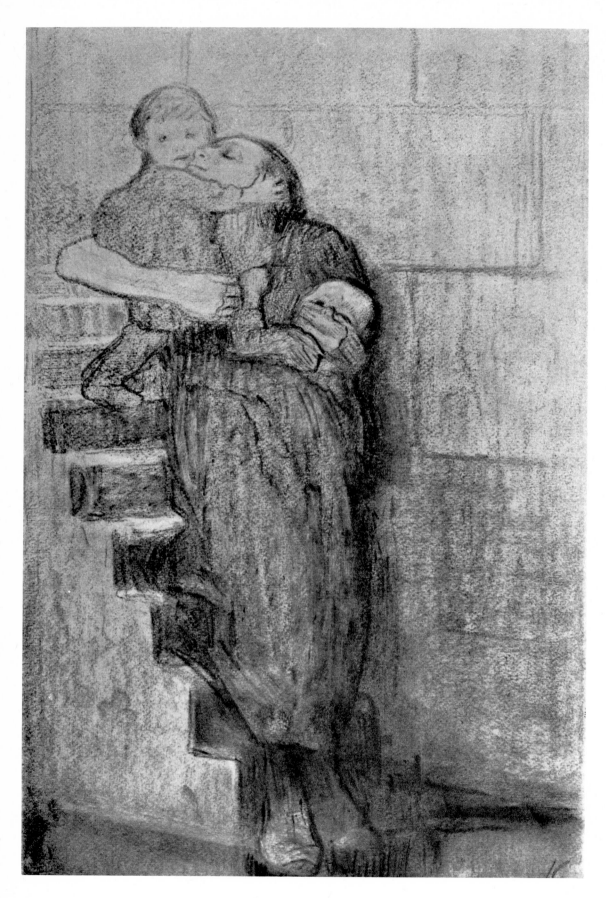

70. Portraits of misery, IV

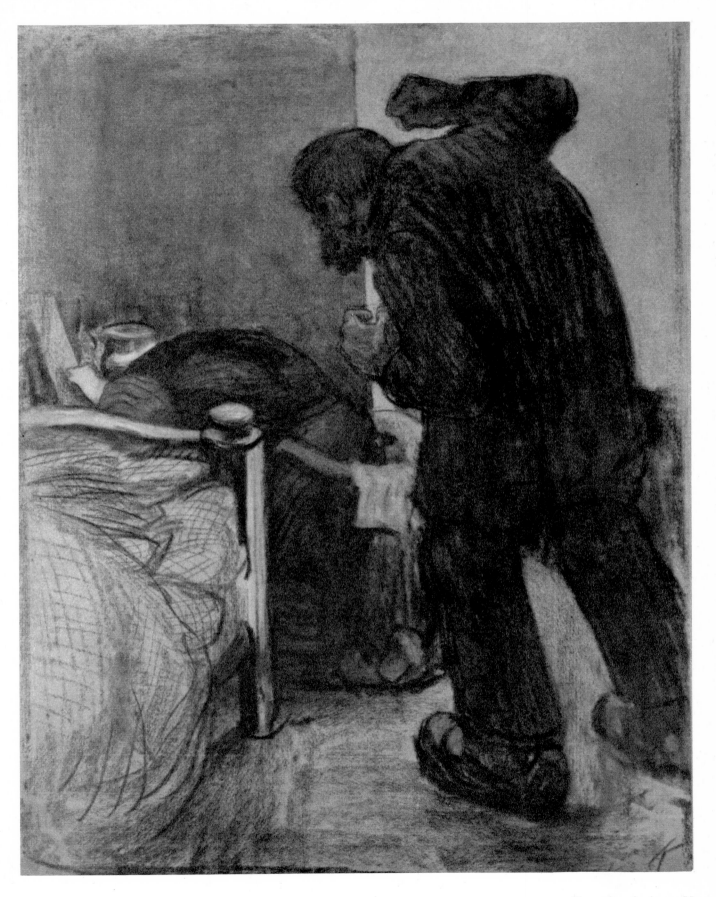

71. Portraits of misery, V

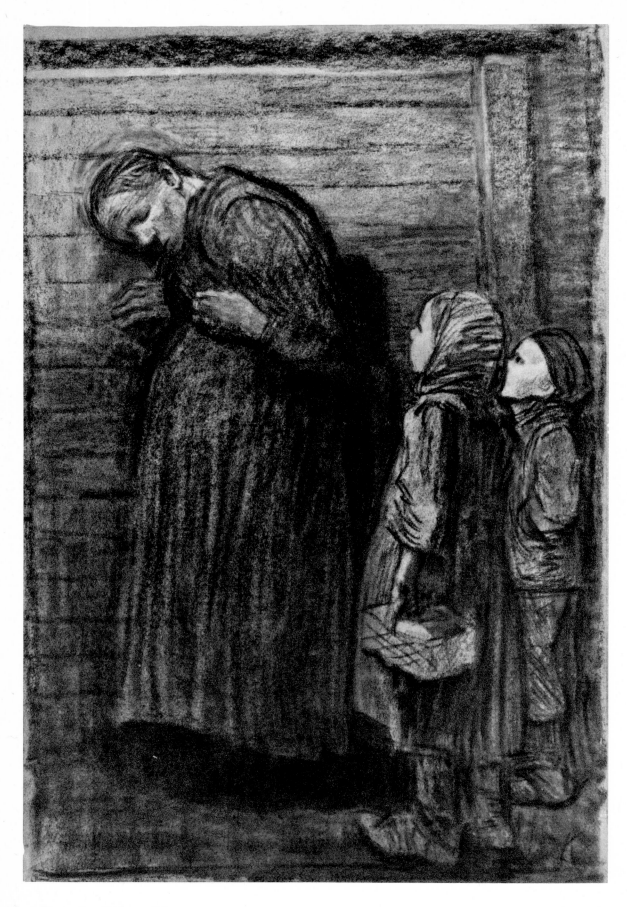

72. Portraits of misery, VI

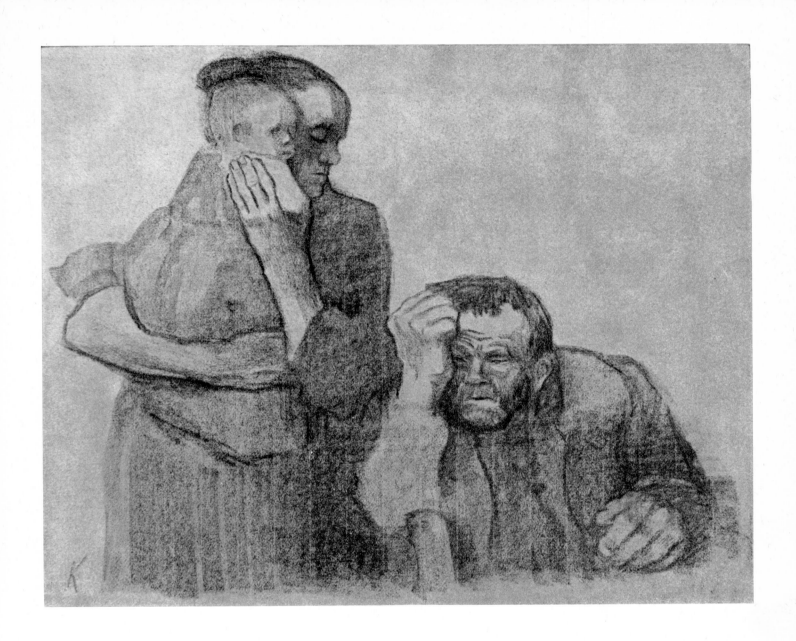

73. At the end of their tether

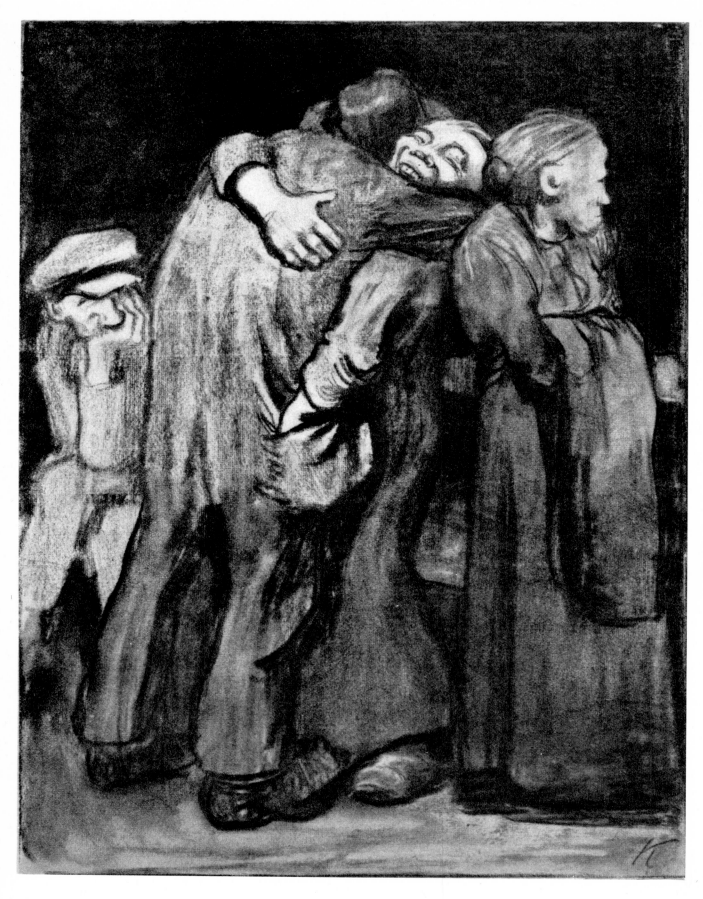

74. Shelter for the night

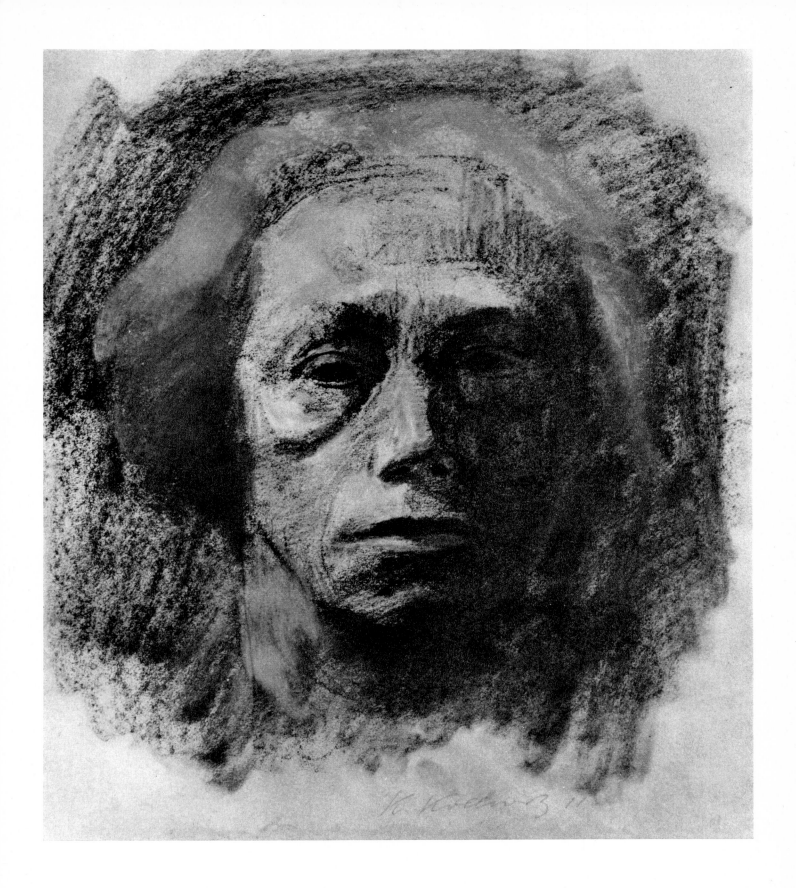

75. Self-portrait, 1911

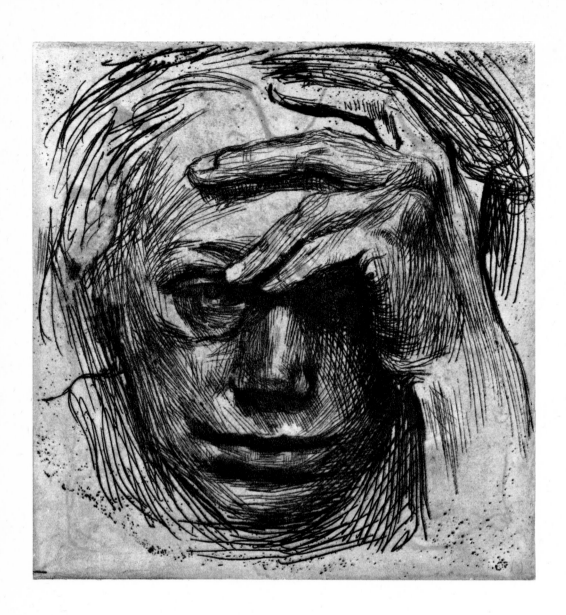

76. Self-portrait, with hand on forehead, 1910

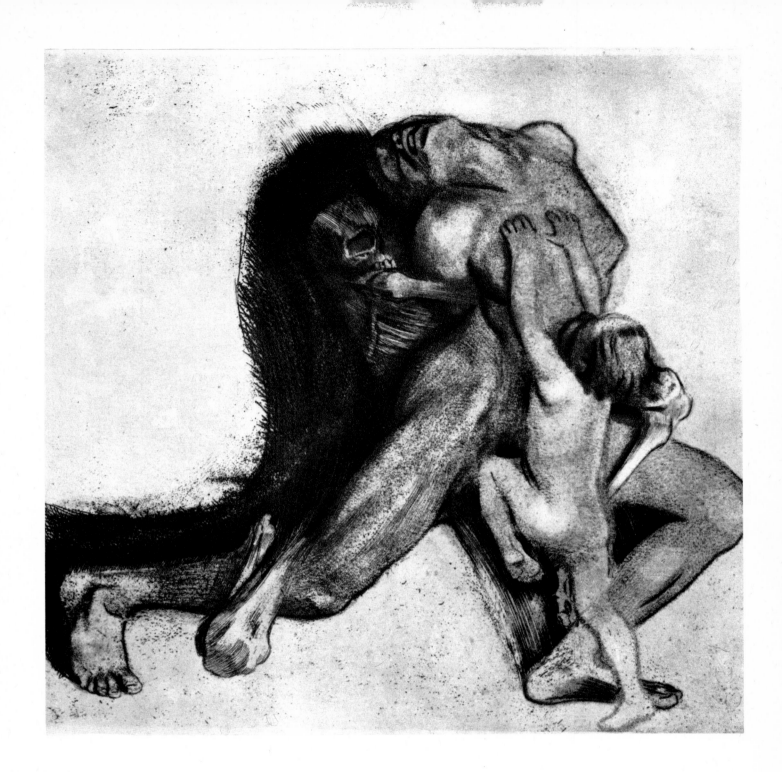

77. Death and the woman, 1910

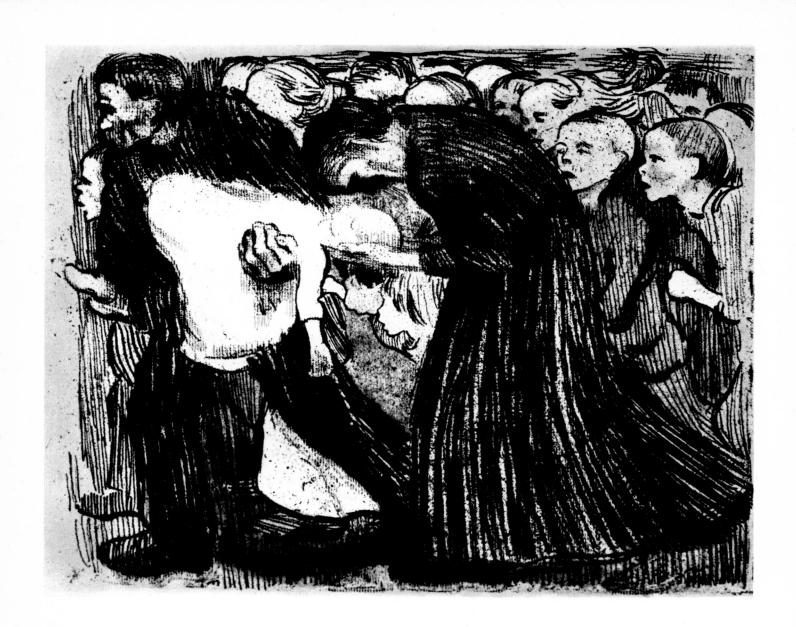

78. Run over, 1910

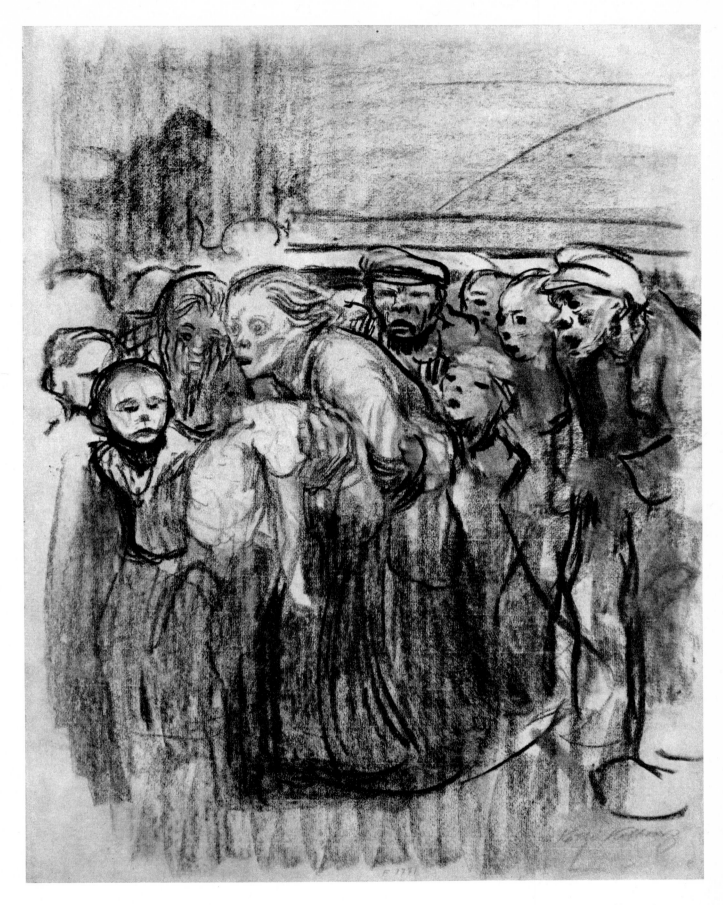

79. Study for Plate 78, c. 1910

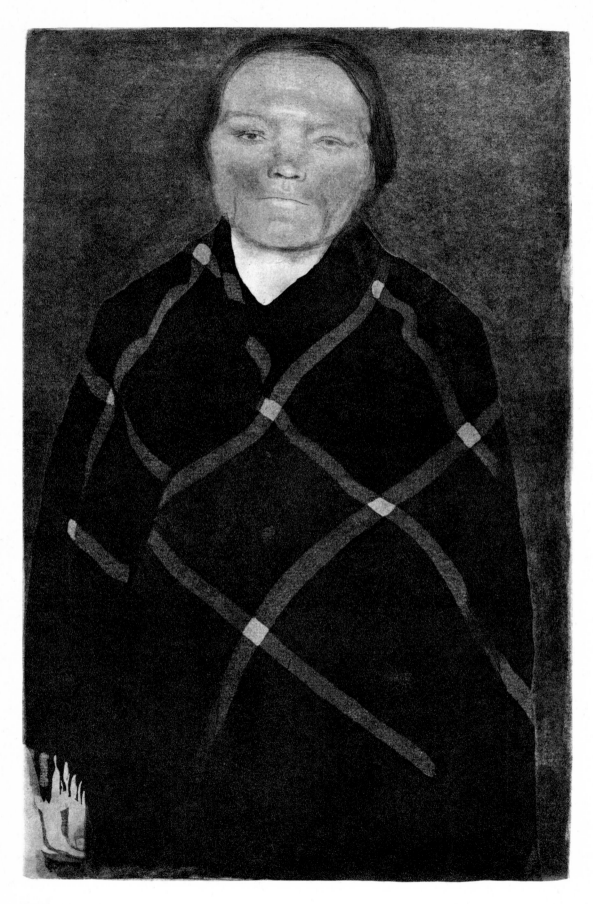

80. Pregnant woman, 1910

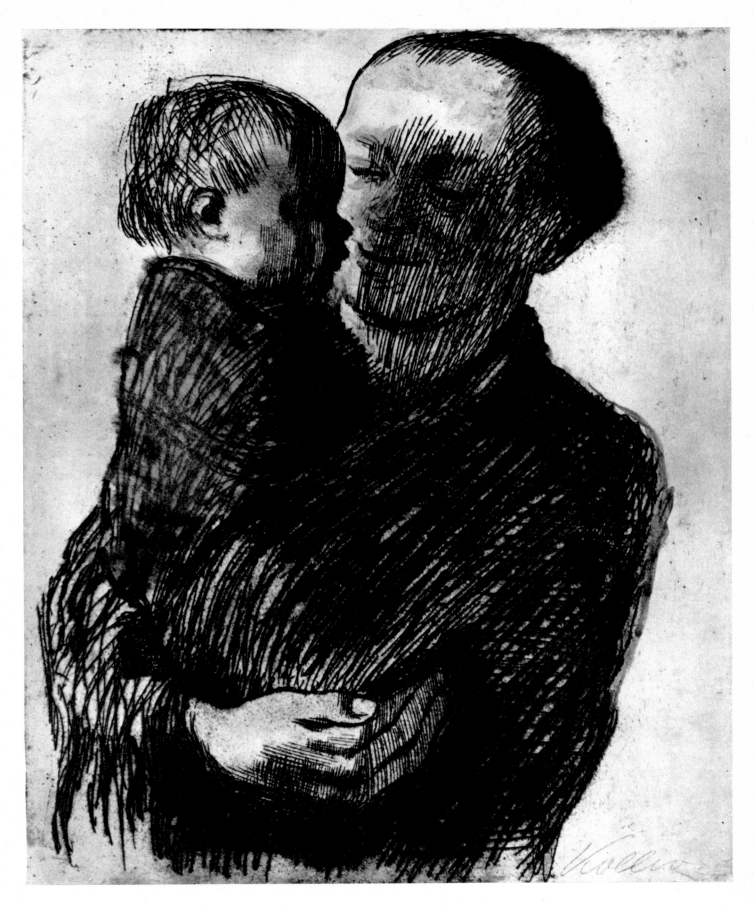

81. Mother holding child, 1910

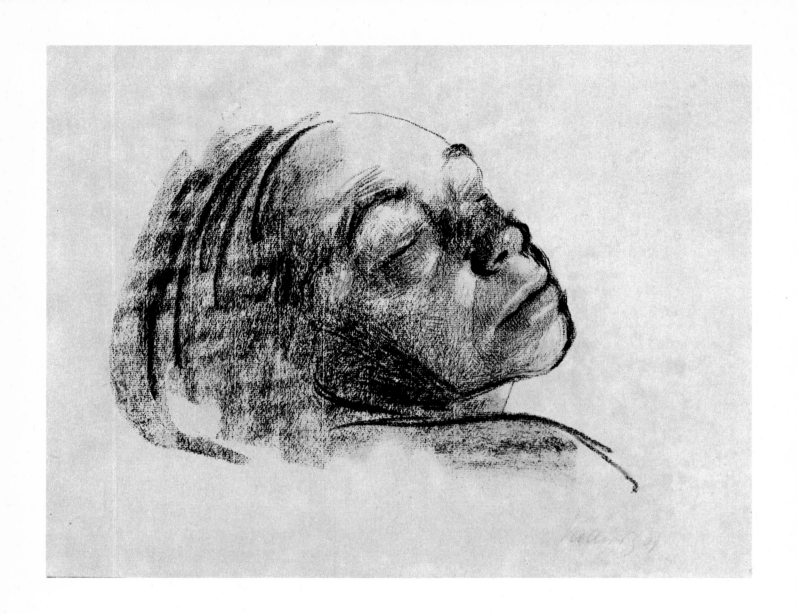

82. Woman asleep, 1909

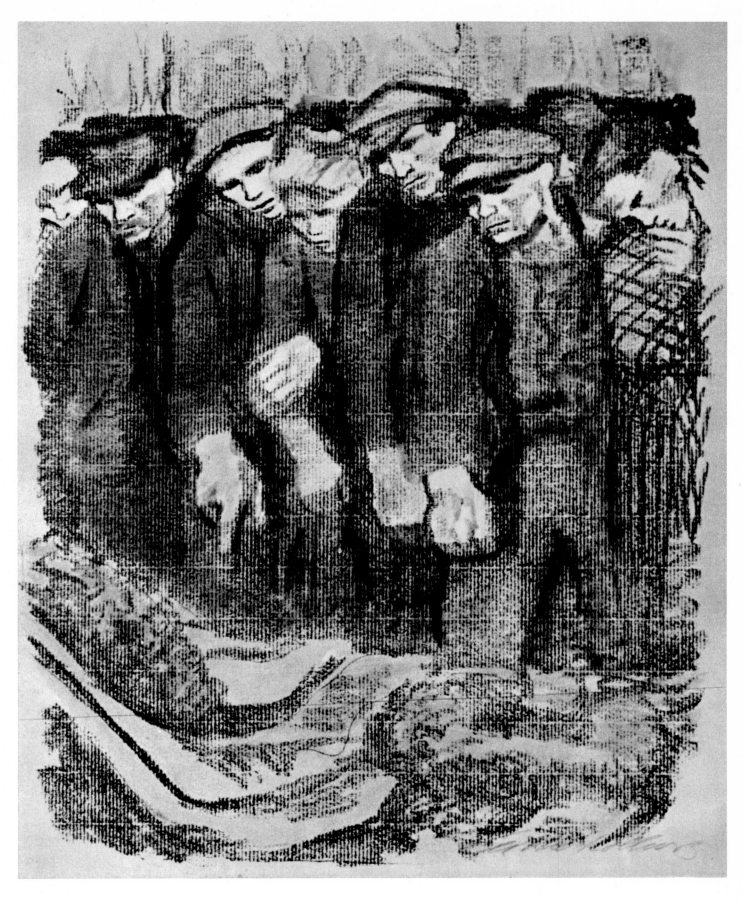

83. Graves of victims of the 1848 Revolution, (The 'March' Cemetery), 1913

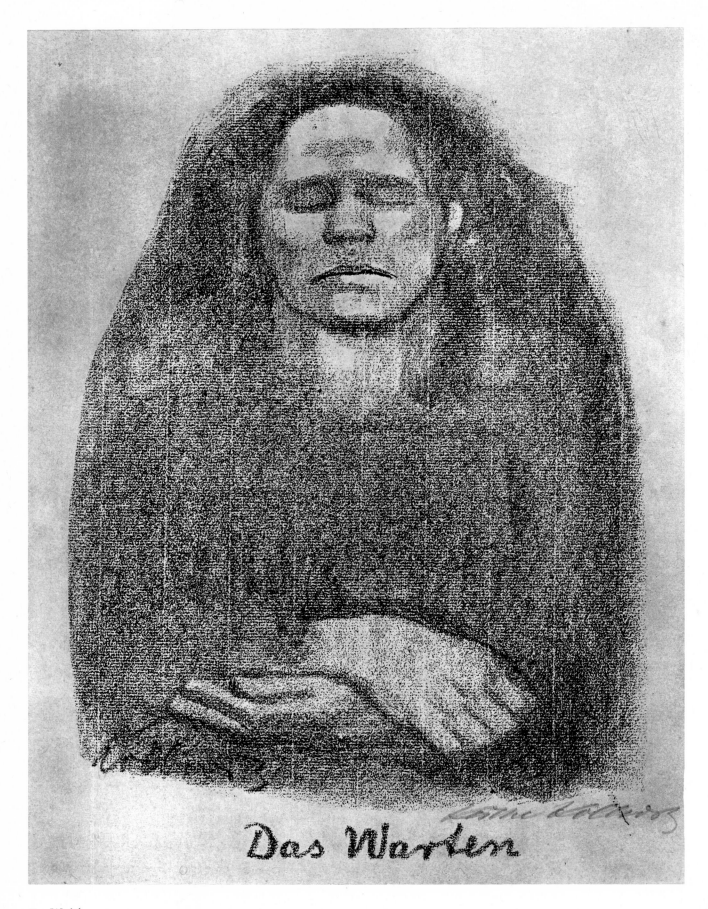

Das Warten

84. Waiting, 1914

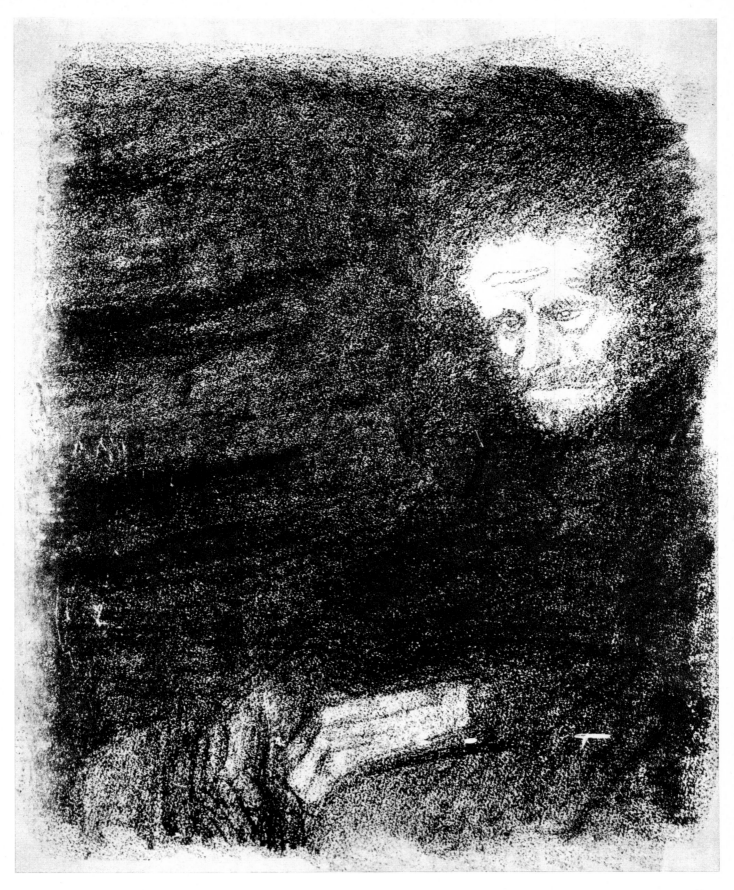

85. A lonely man: the artist's father, 1915

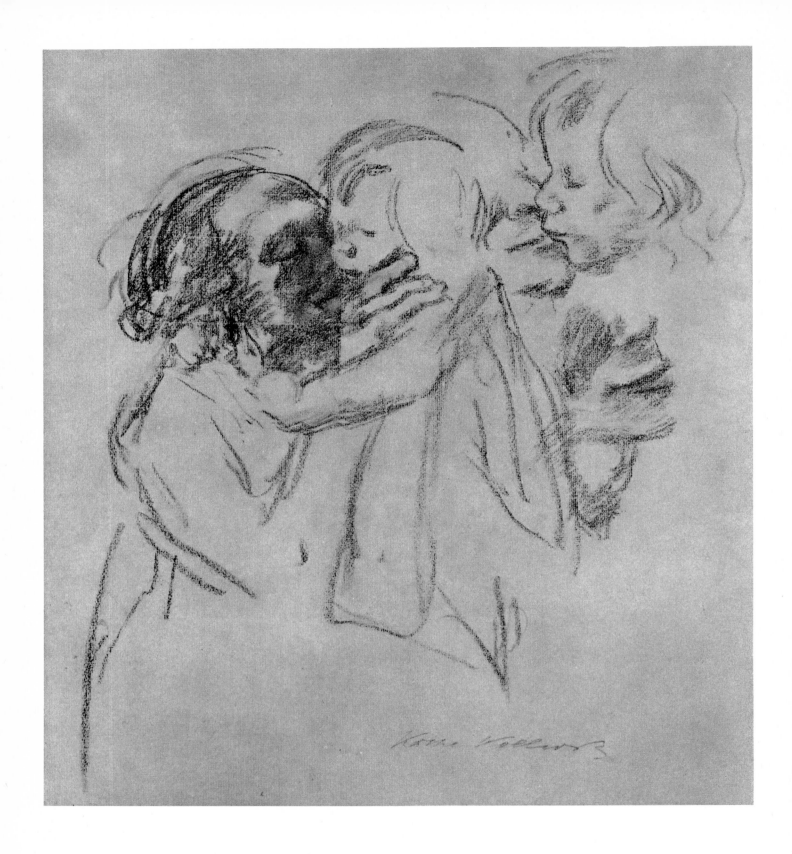

86. Have pity on the children (undated)

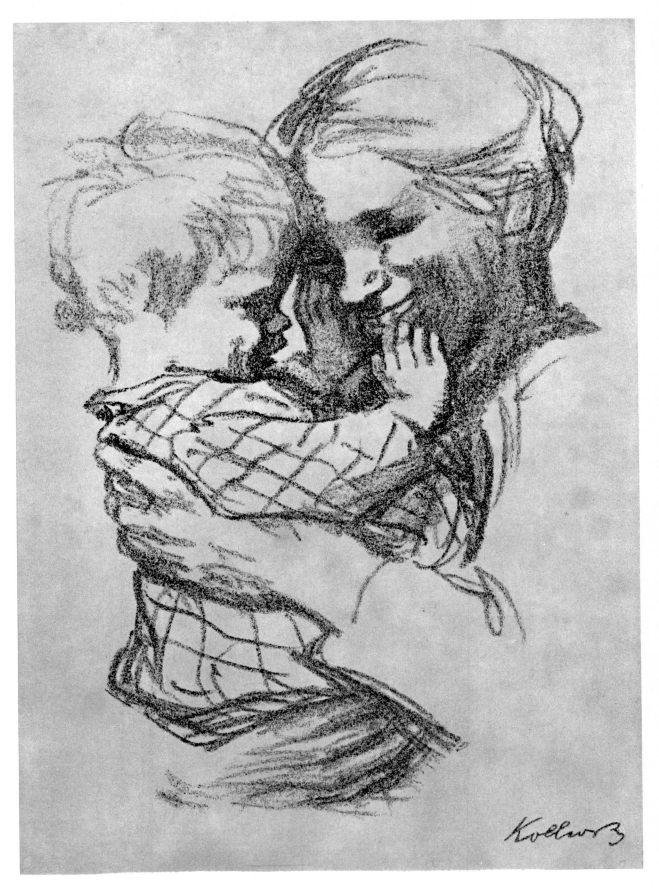

87. Mother holding child, 1916

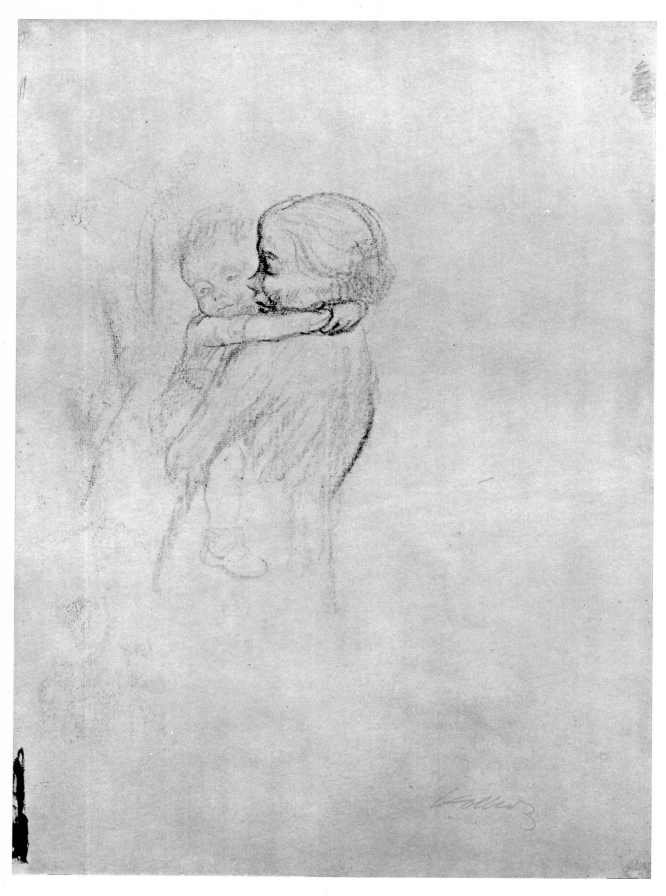

88. Mother holding child, 1916

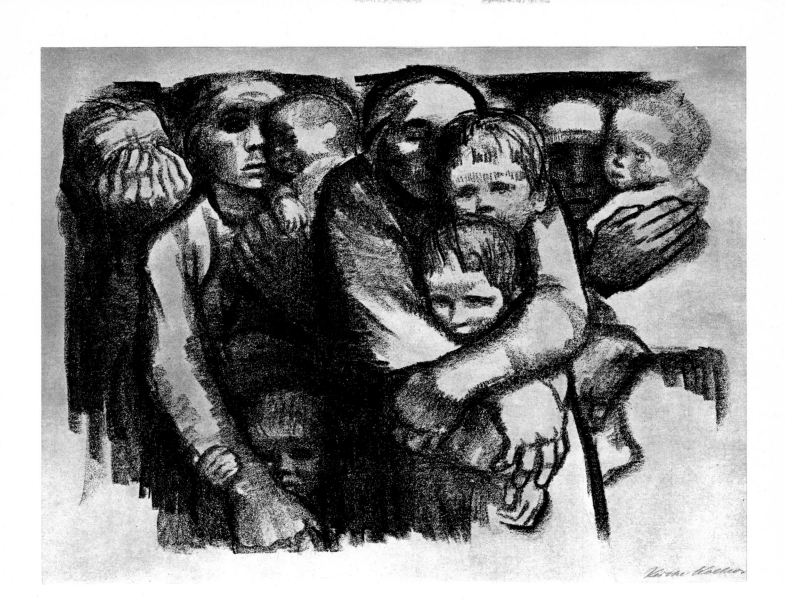

89. Mothers, 1919

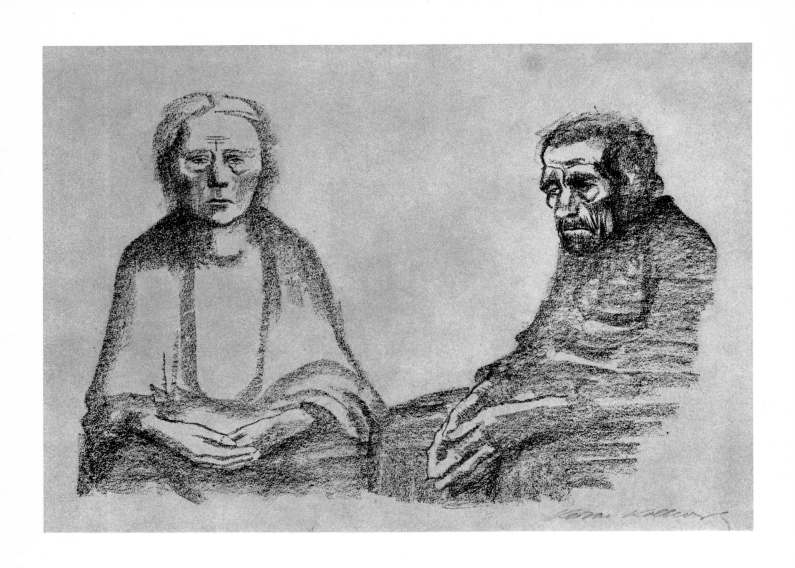

90. The artist's parents, 1919

91. Karl Liebknecht on his deathbed, 1919

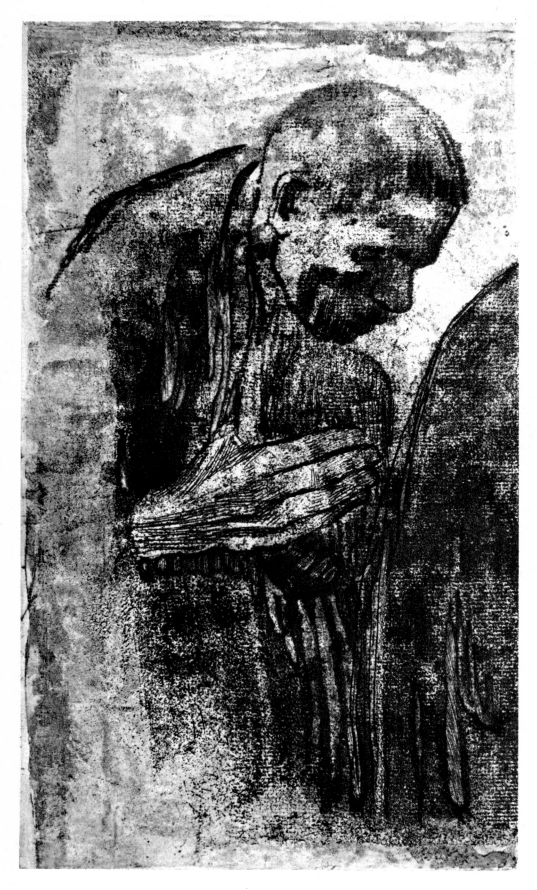

92. In memory of Karl Liebknecht (left section of damaged plate), 1919

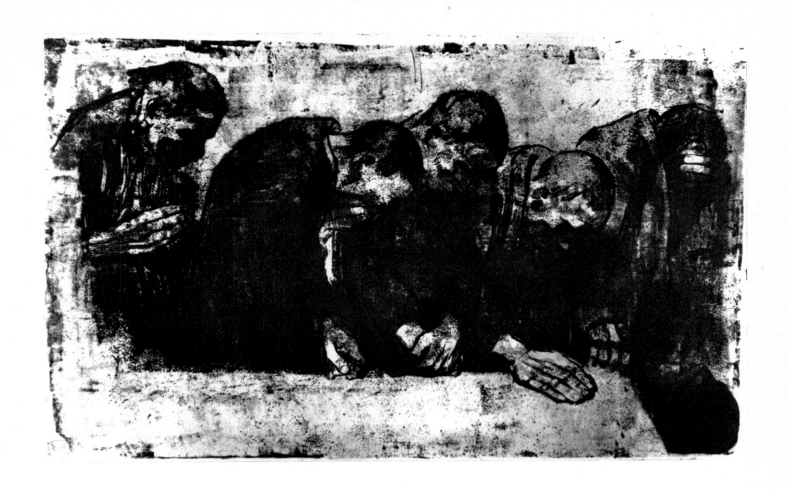

93. In memory of Karl Liebknecht, 1919

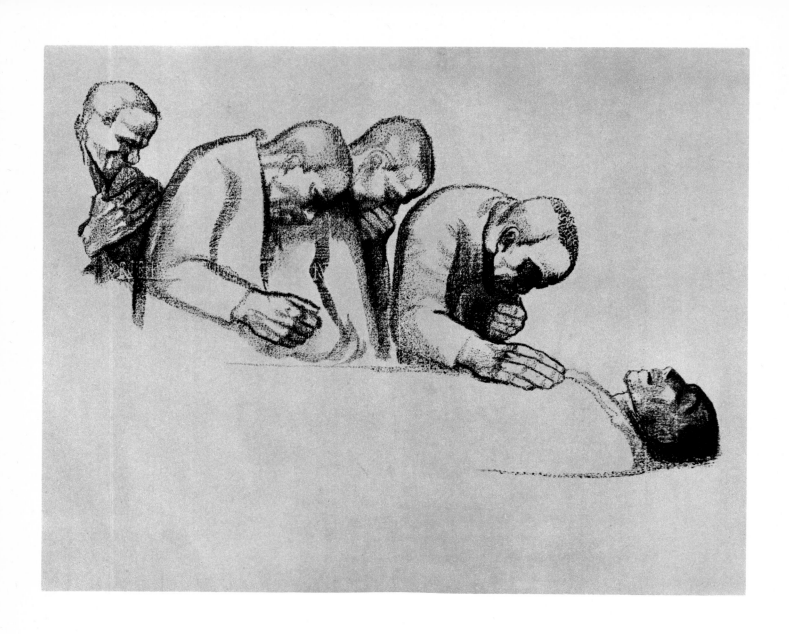

94. In memory of Karl Liebknecht, 1919

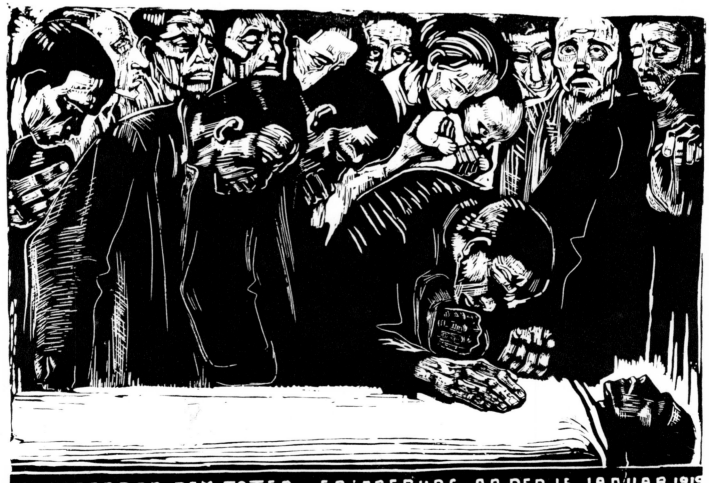

DIE LEBENDEN DEM TOTEN . ERINNERUNG AN DEN 15. JANUAR 1919

95. In memory of Karl Liebknecht, 1919/20

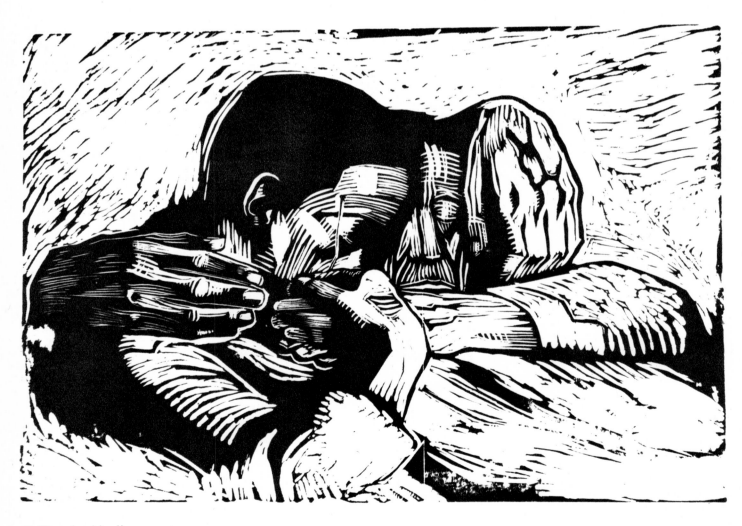

96. Two dead bodies, 1919

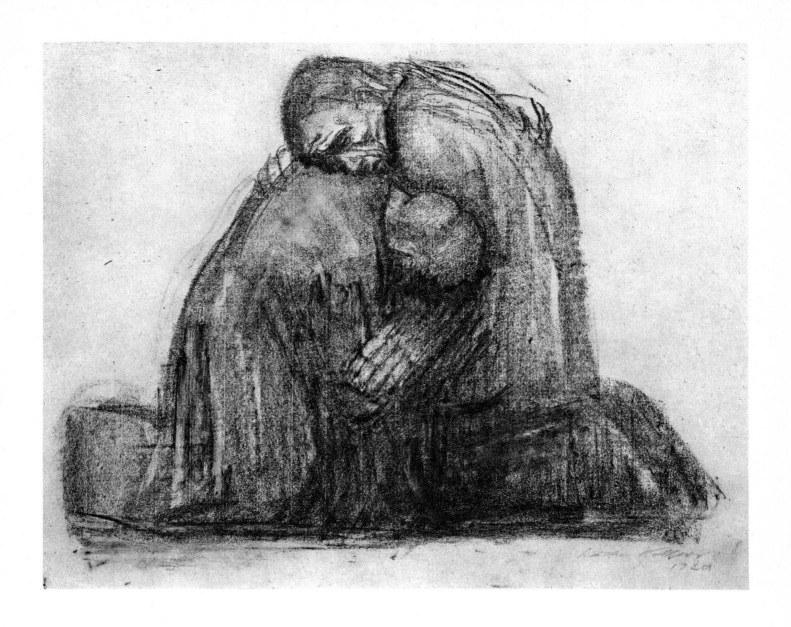

97. The parents, 1920

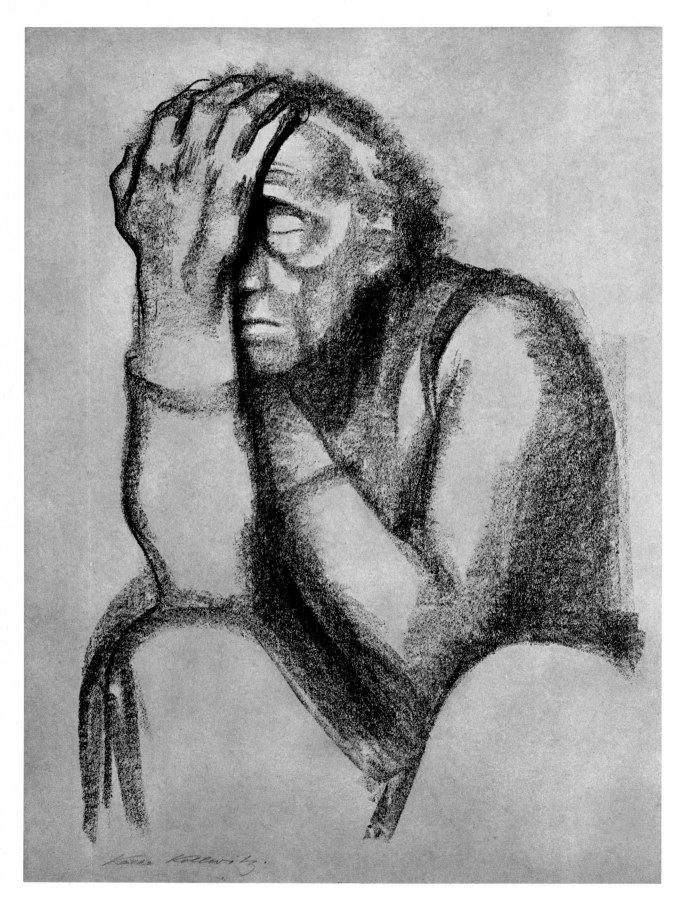

98. Woman lost in thought, 1920

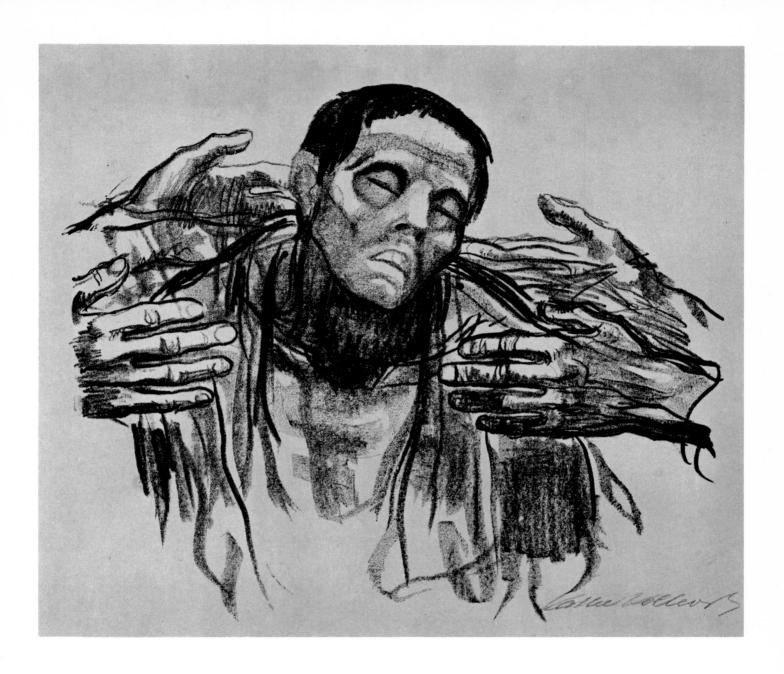

99. 'Help Russia', 1921

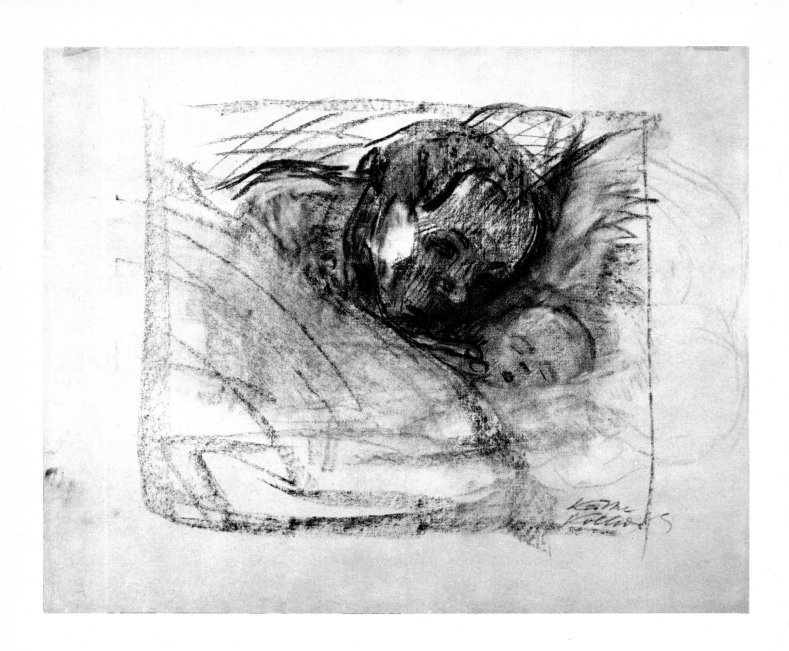

100. Mother at bedside of dead child (undated)

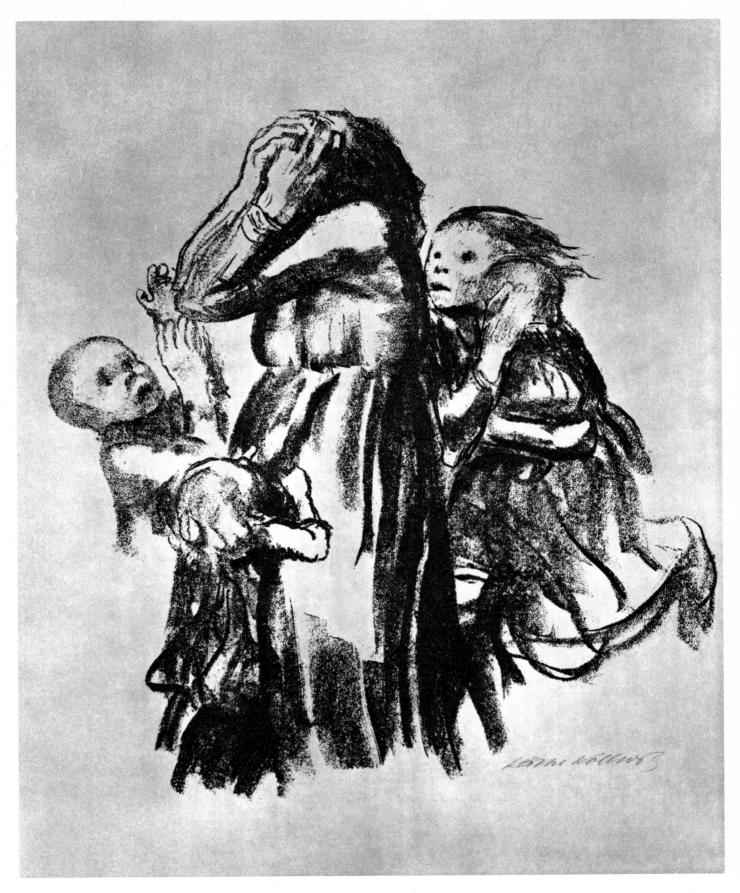

101. Killed in action, 1921

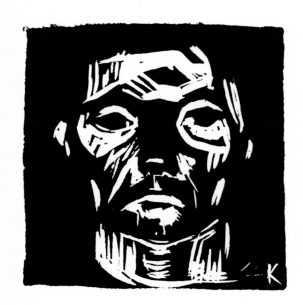

102. Man's head, miniature, 1922

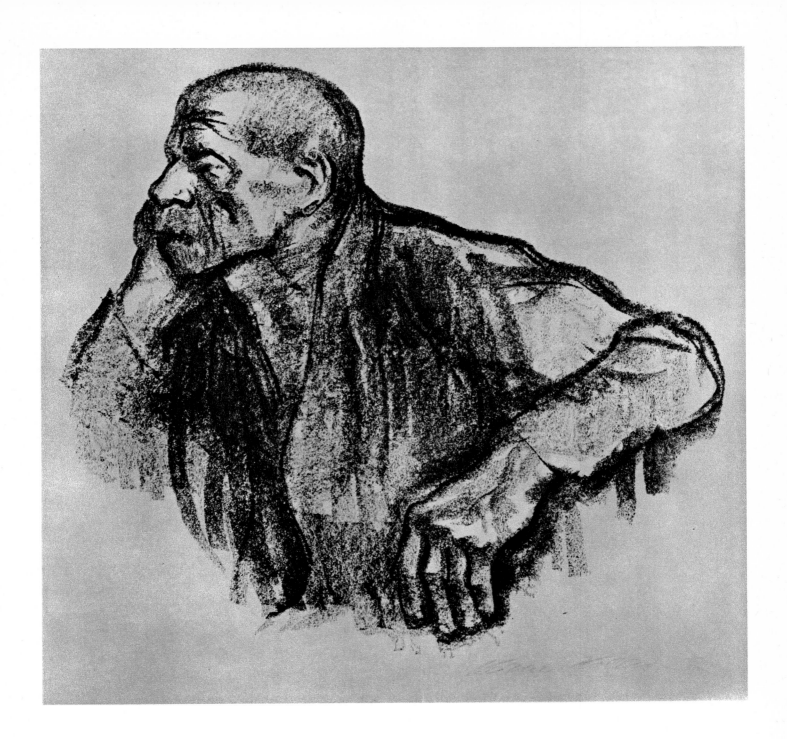

103. Workman, seated, 1923

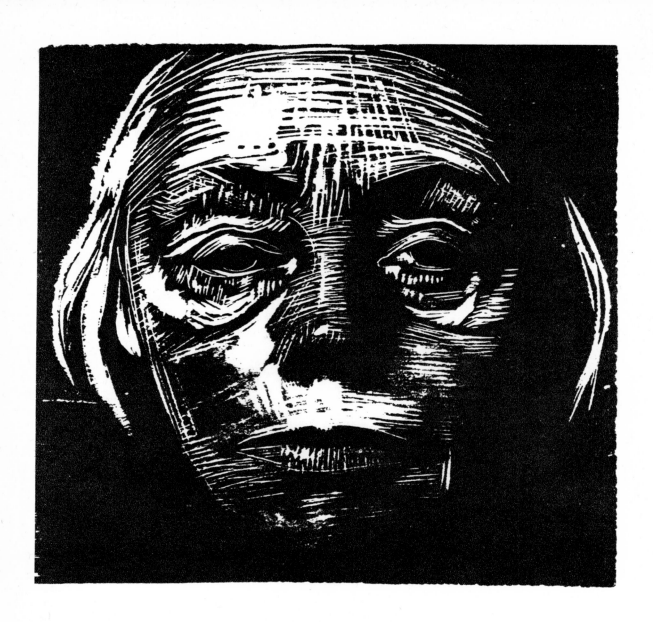

104. Self-portrait, front view, 1923

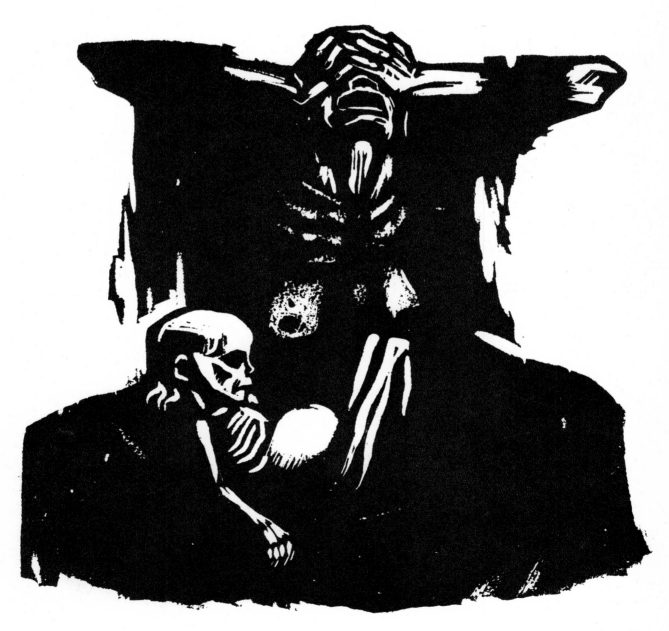

105. Hunger, 1923

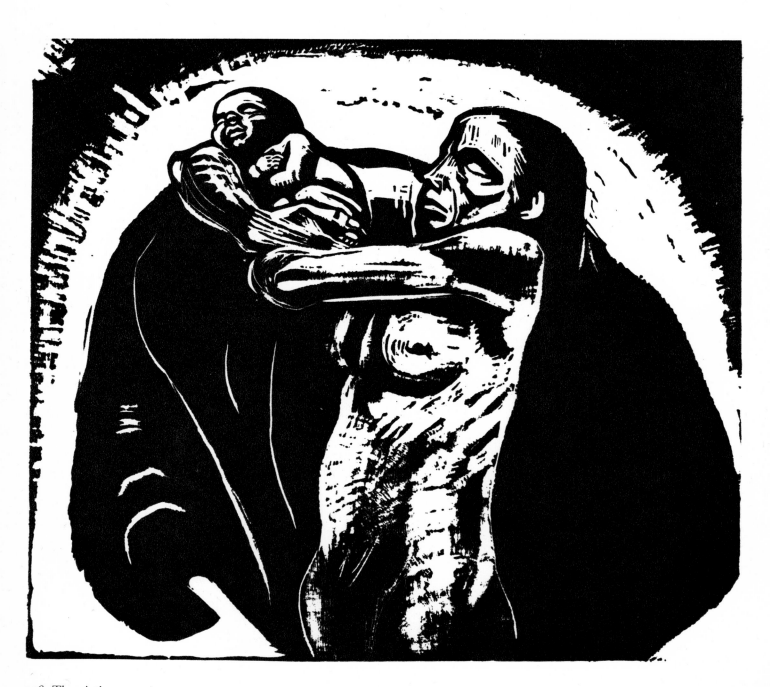

106. The victim, 1922/23

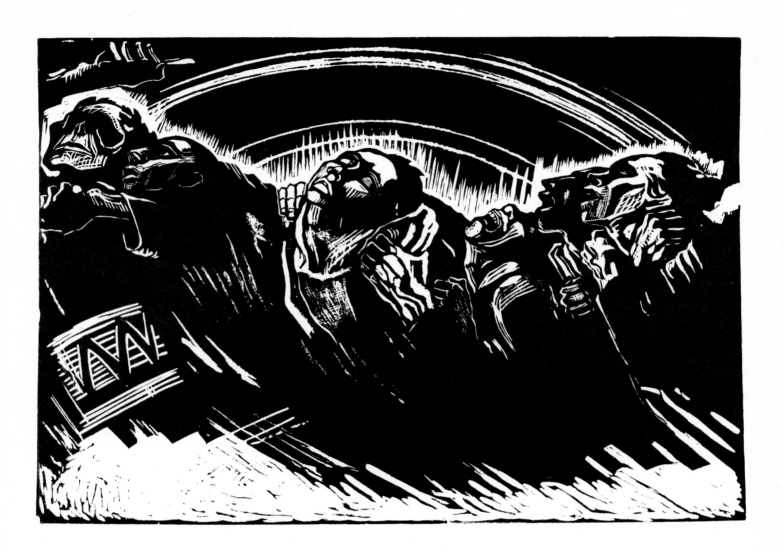

107. The volunteers, 1922/23

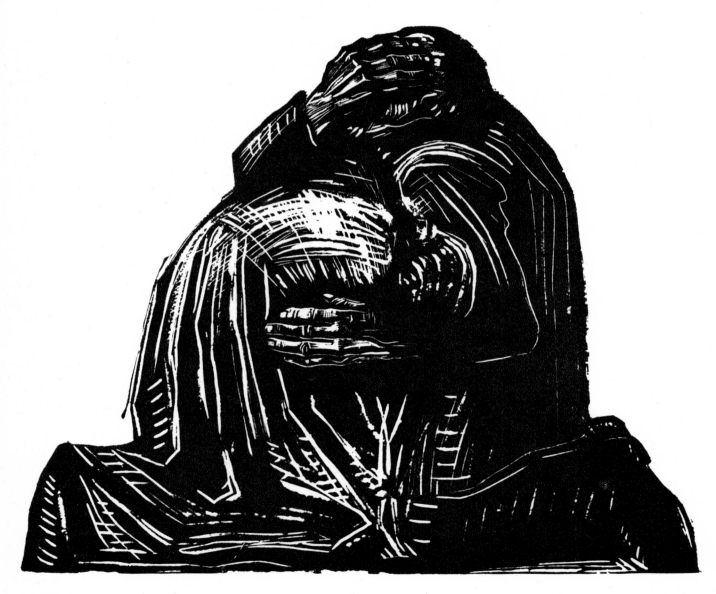

108. The parents, 1922/23

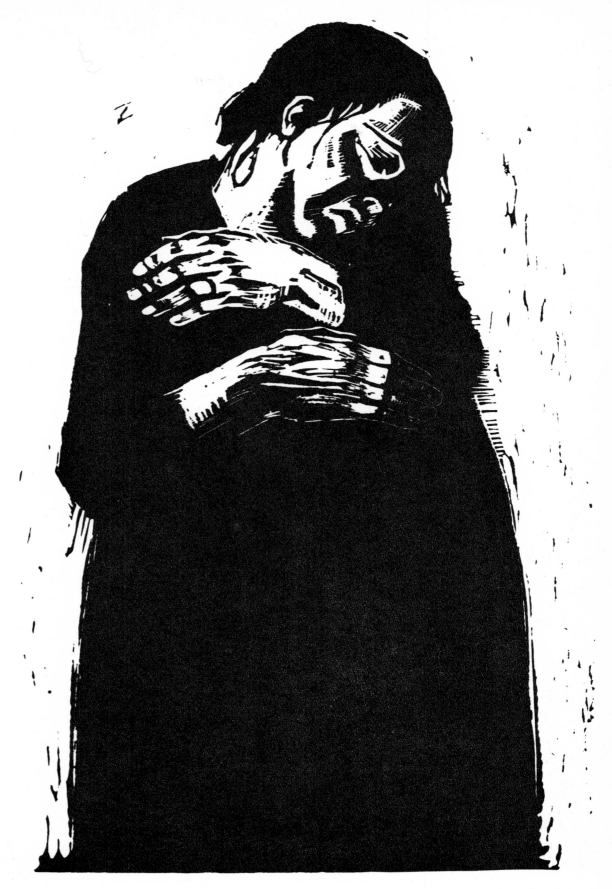

109. The widow I, 1922/23

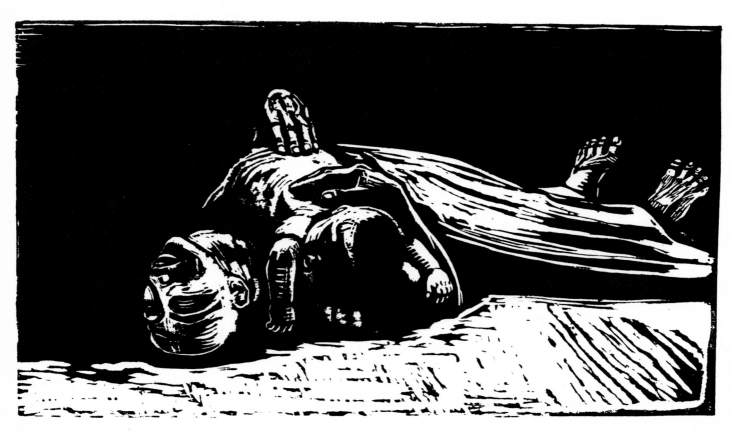

110. The widow II, 1922/23

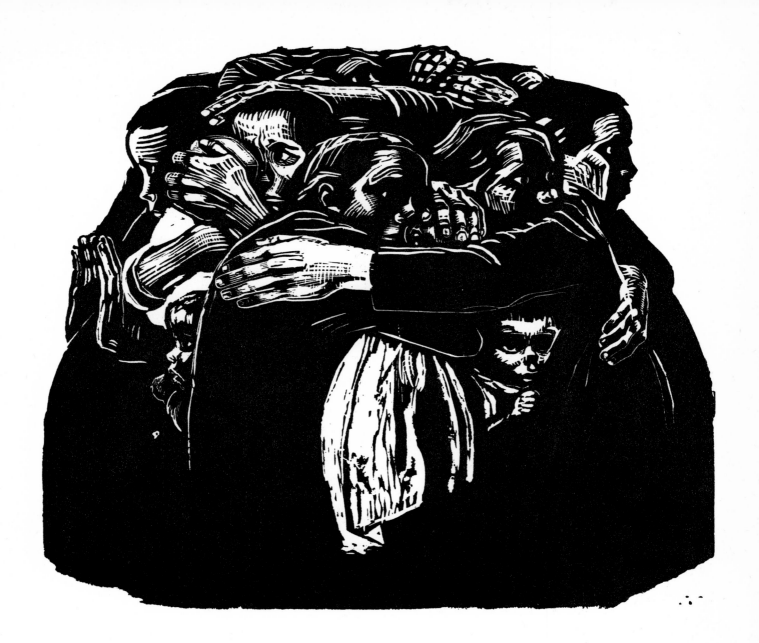

111. The mothers, 1922/23

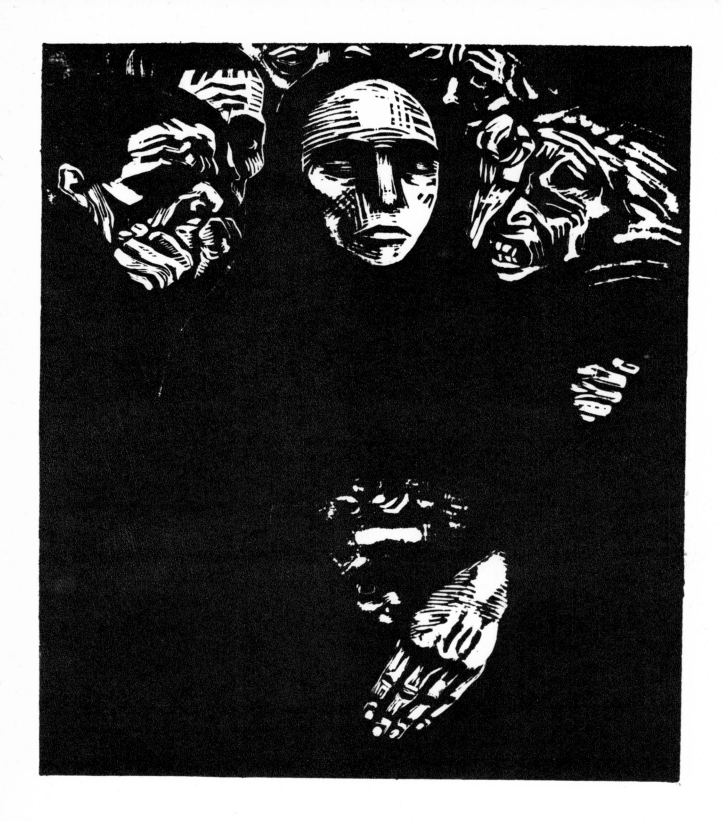

112. The people, 1922/23

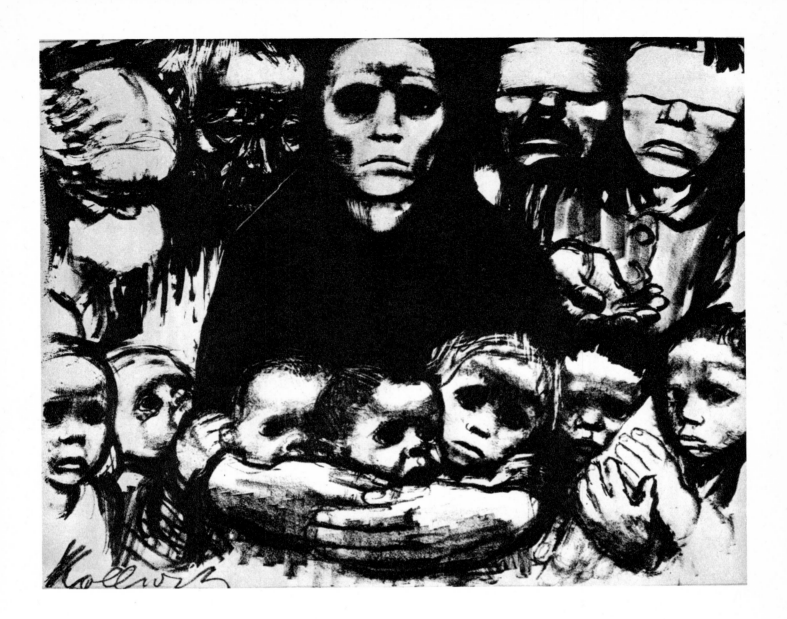

113. The survivors, 1923

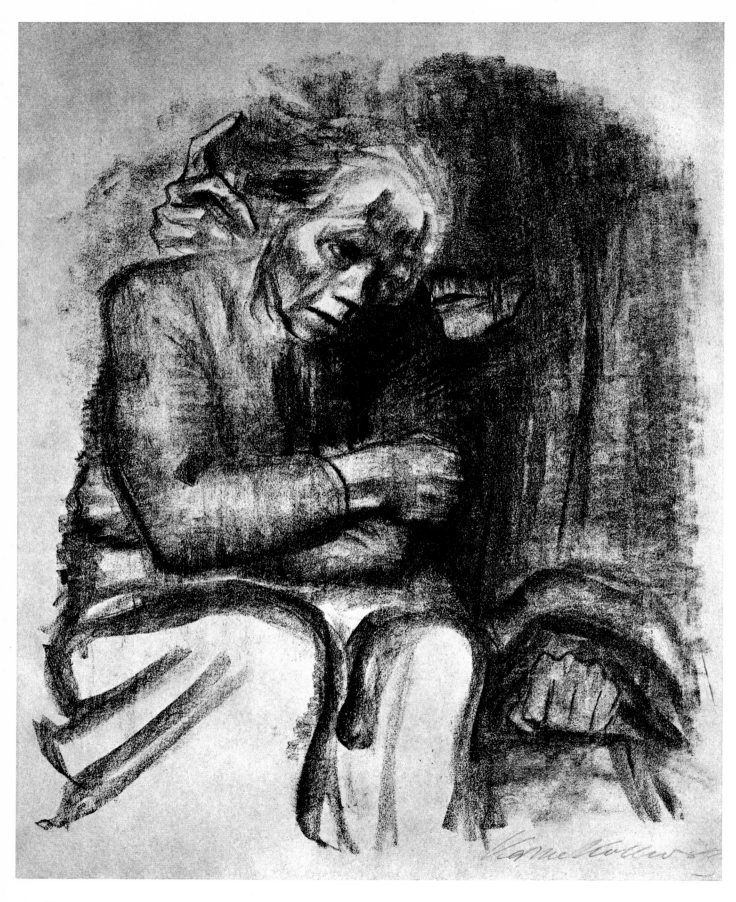

114. Conversation with death, 1923/24

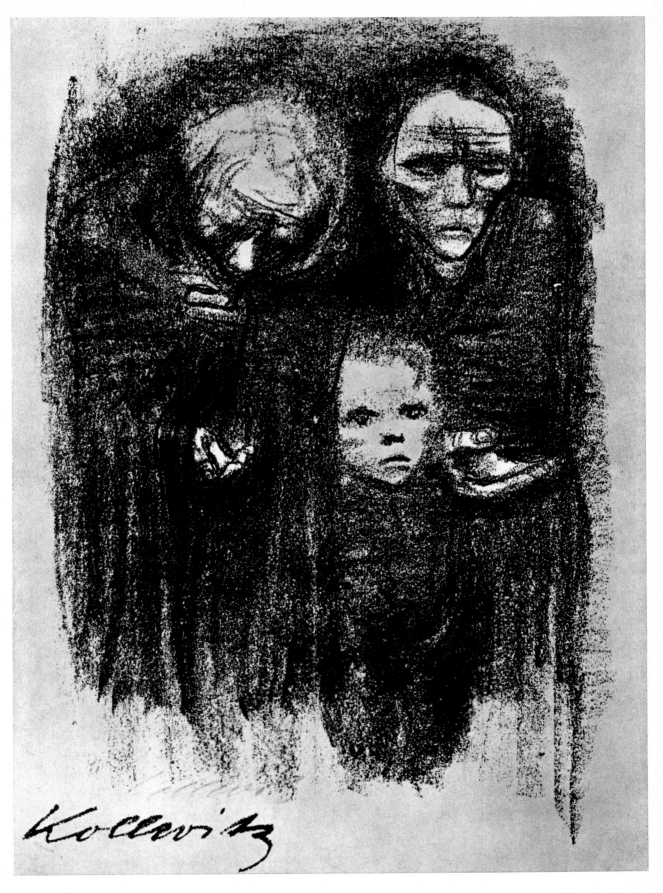

115. Begging, 1924

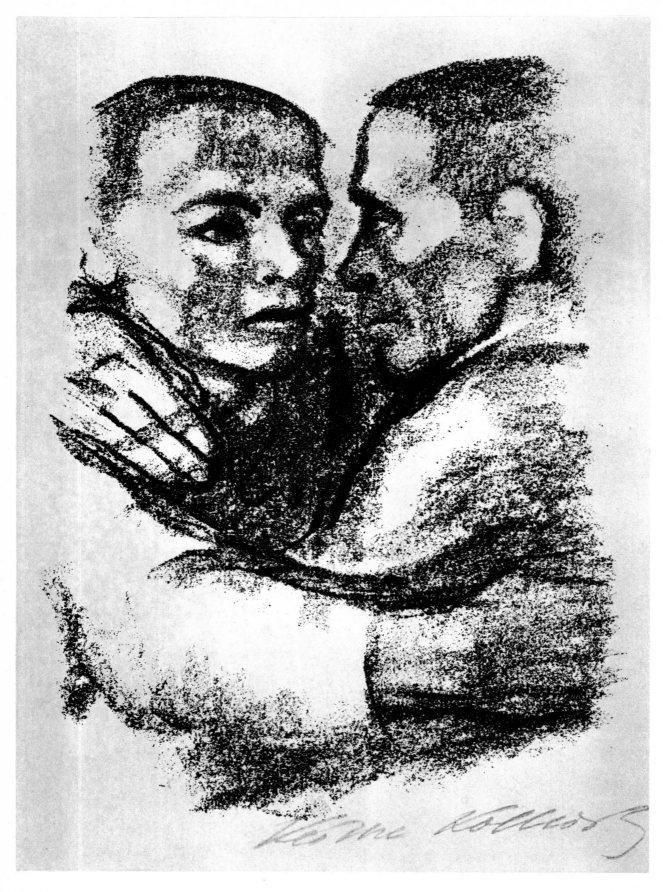

116. Fraternizing, 1924

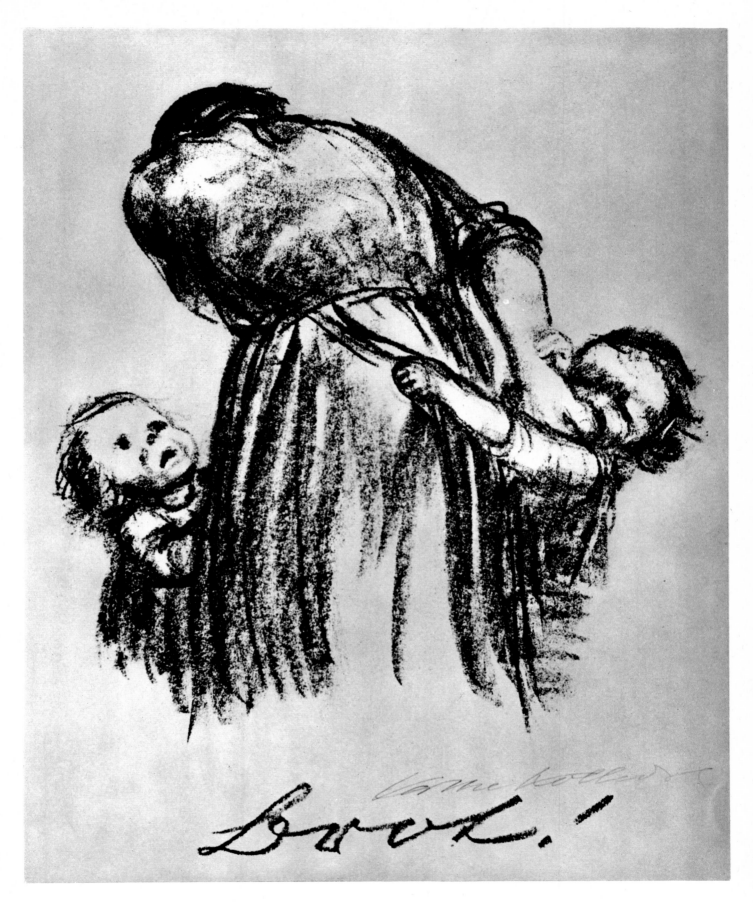

117. Bread, 1924

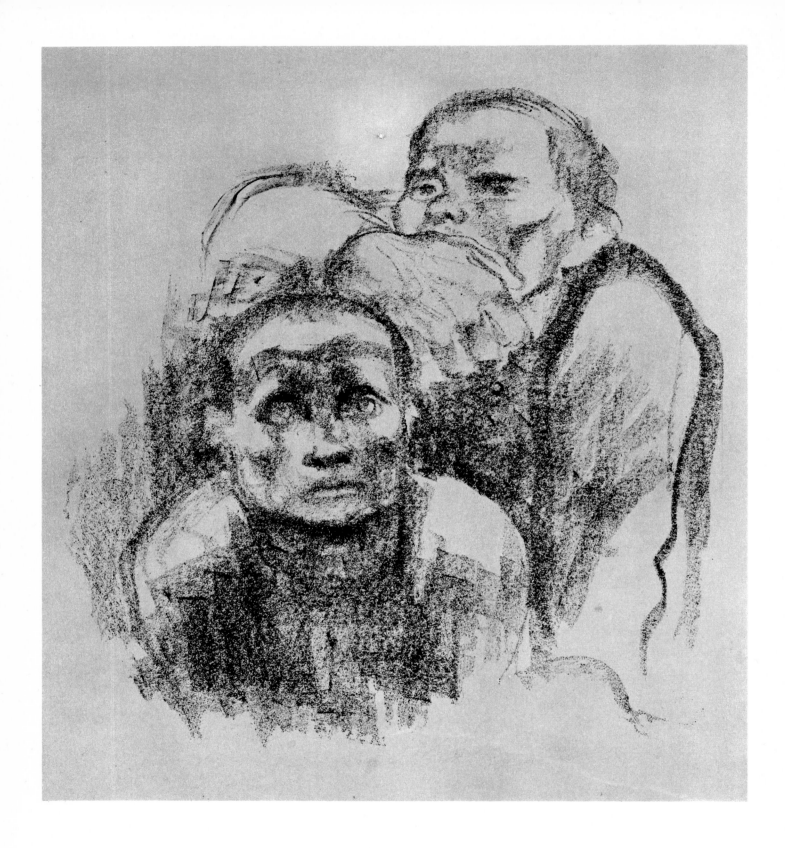

118. Prisoners listening to music, 1925

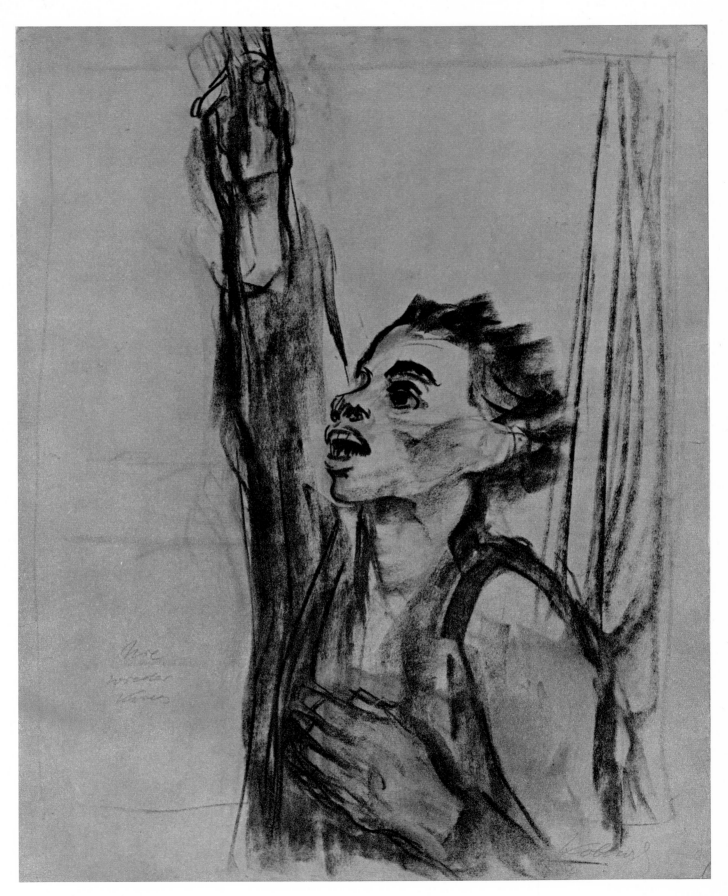

119. Sketch for 'War, never again!', 1924

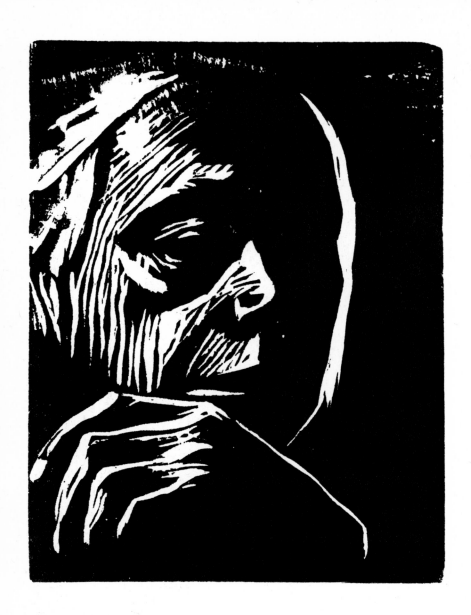

120. Self-portrait, 1924

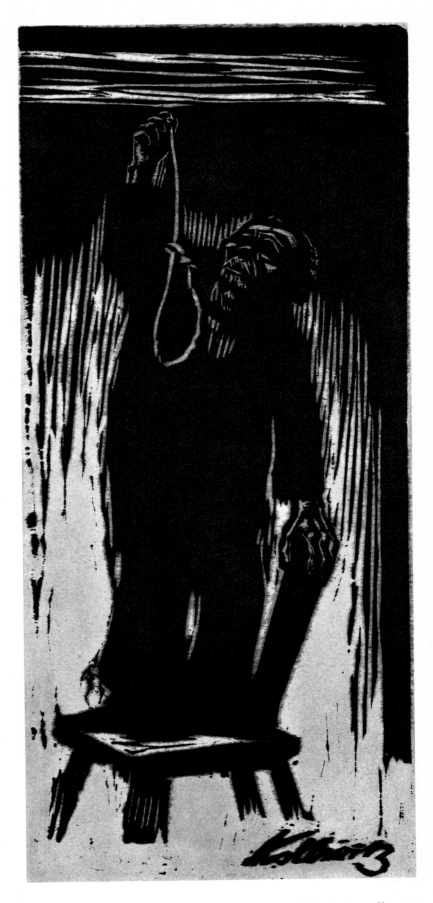

121. 'This is the end', 1925

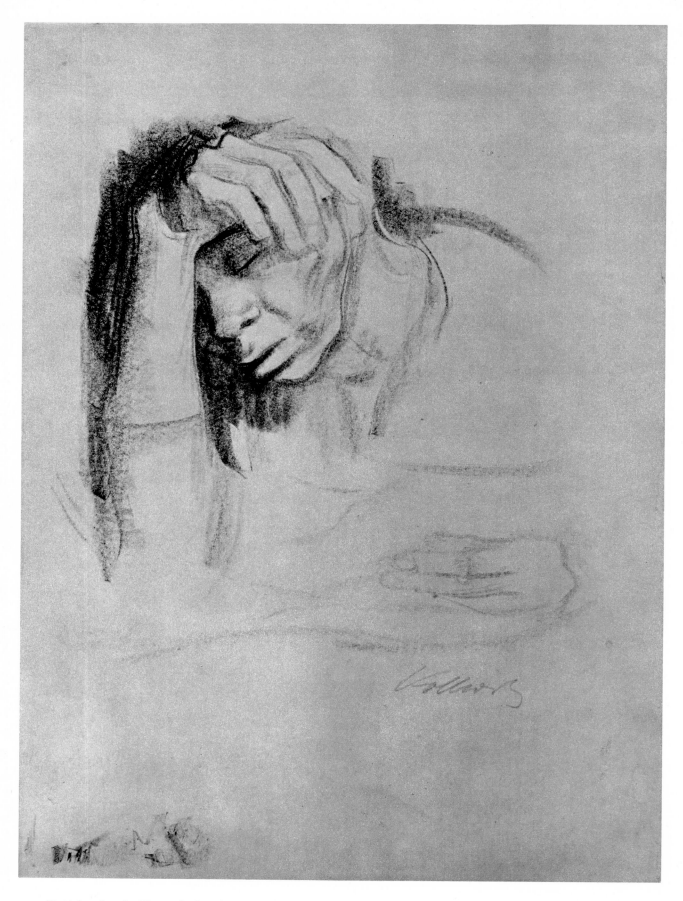

122. Drawing for the Home Industries Exhibition poster, 1925

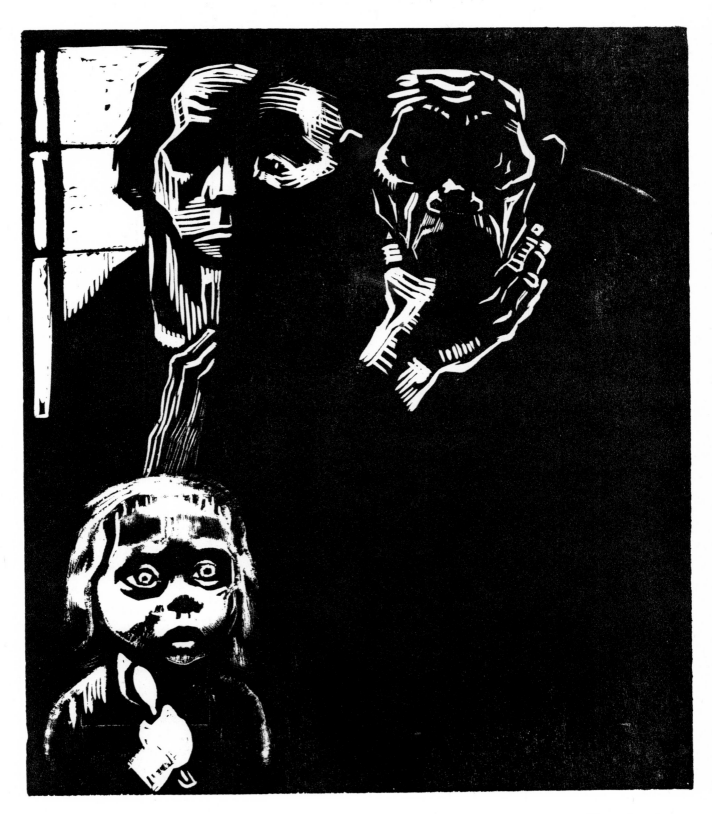

123. Unemployed, 1925

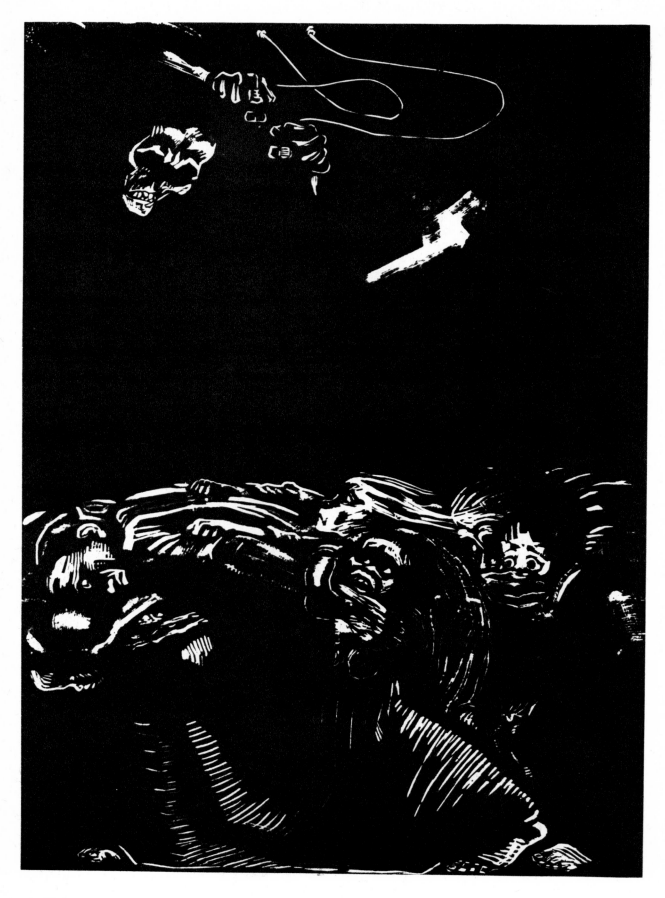

124. Hunger, 1925

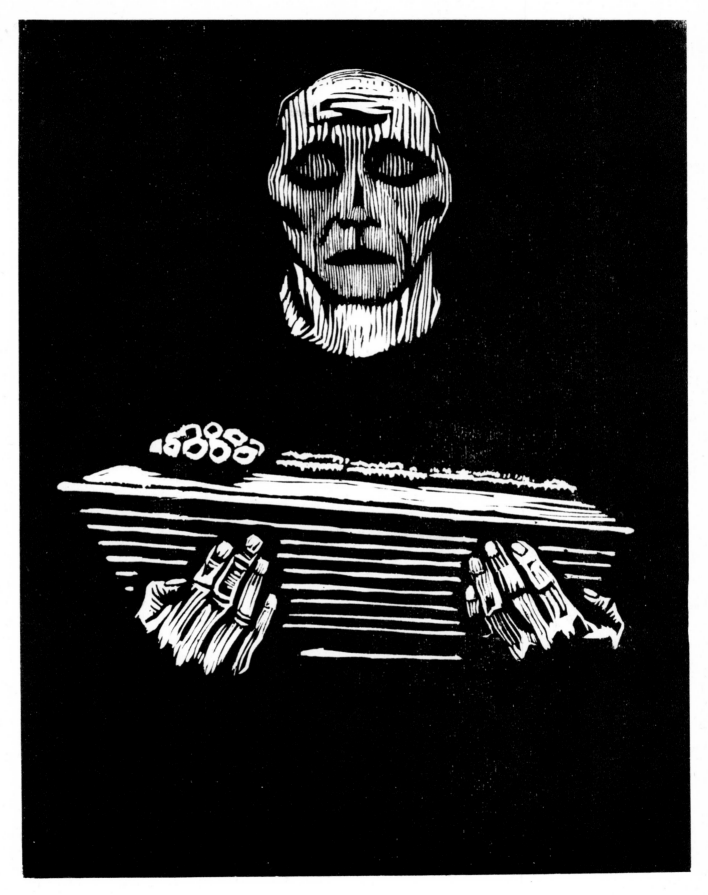

125. The children die, 1925

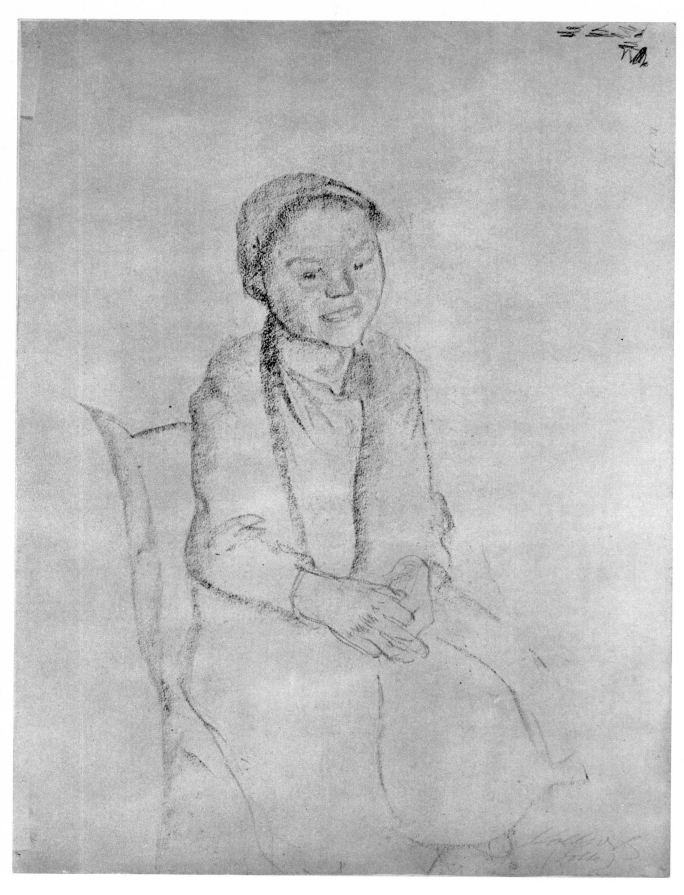

126. Lotte (undated)

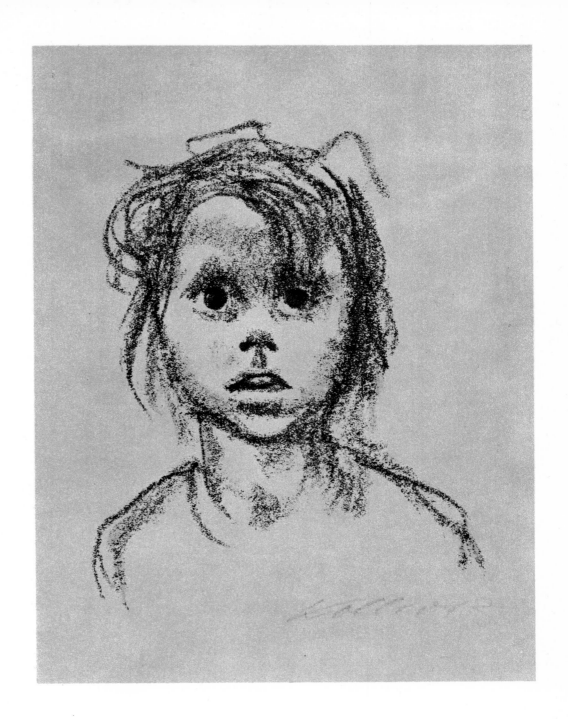

127. Child's head, (Lotte), 1925

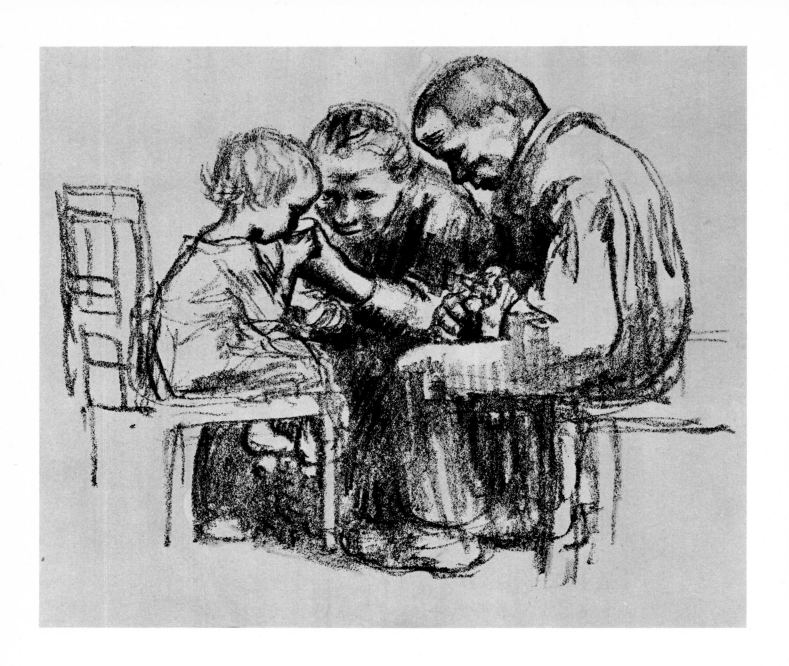

128. Visiting the children's hospital, 1926

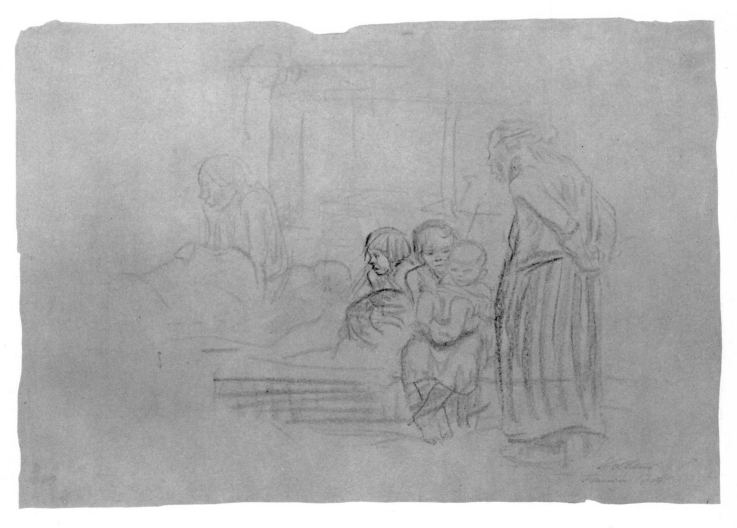

129. Shelter for homeless women, (undated)

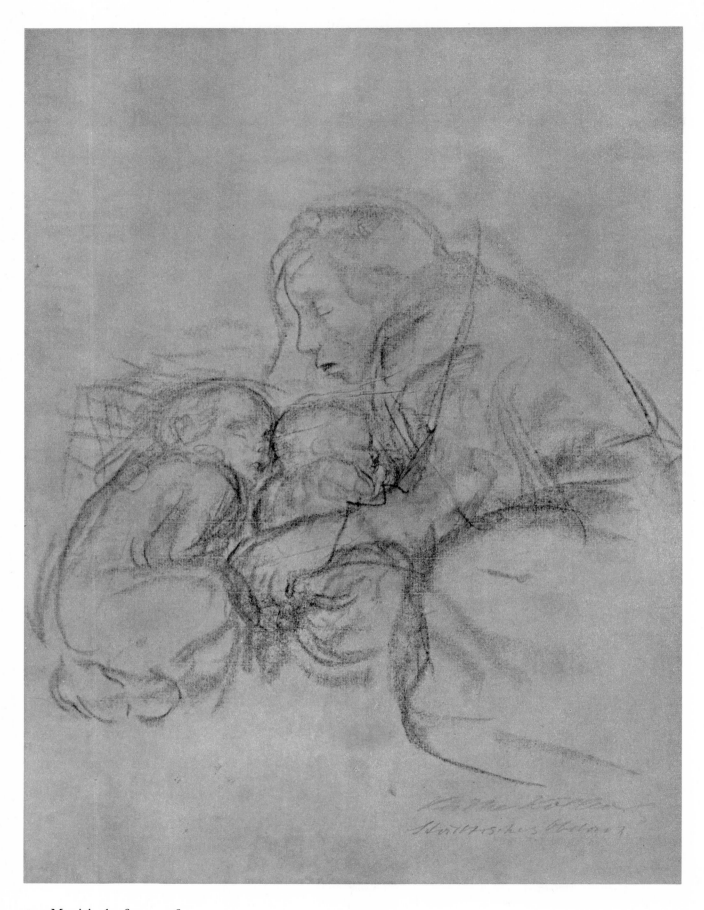

130. Municipal refuge, 1926

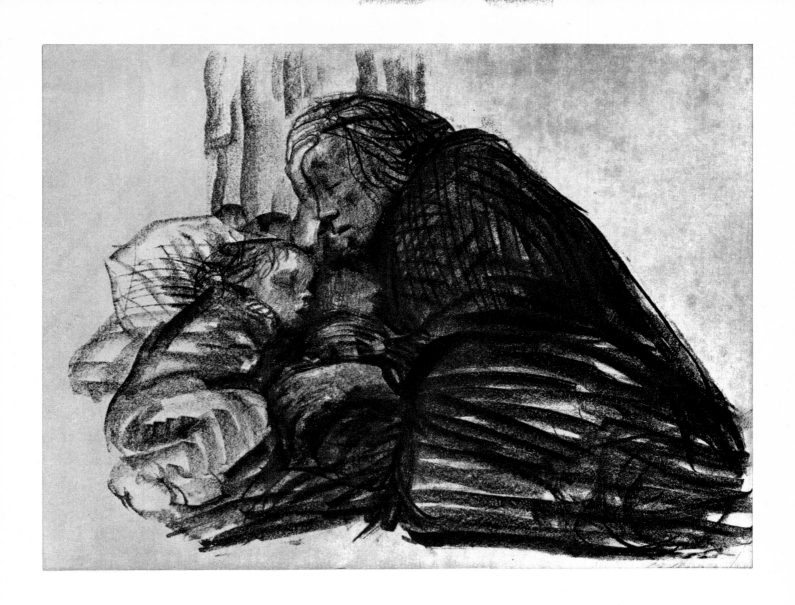

131. Municipal refuge, 1926

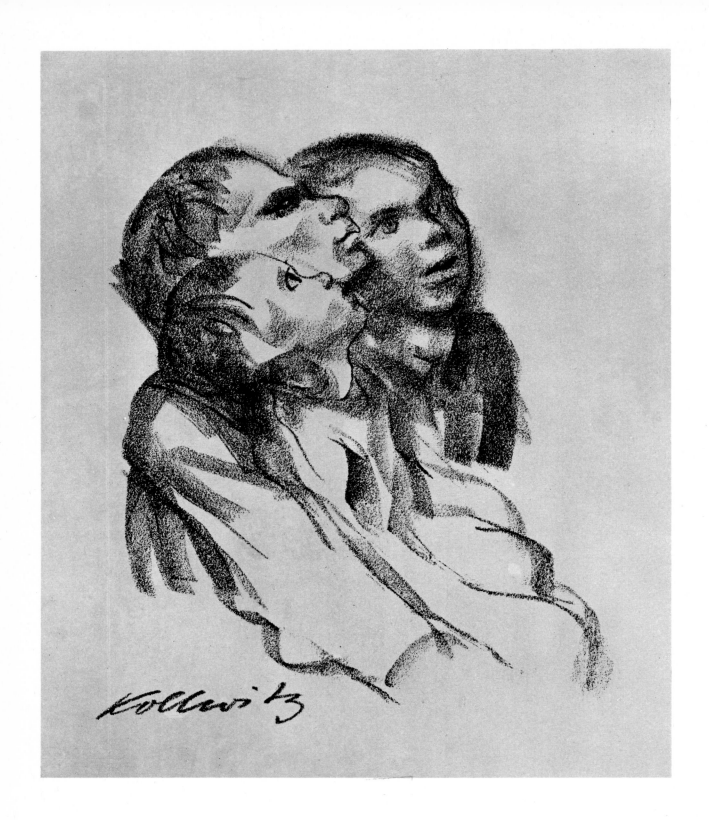

132. Listening, 1927

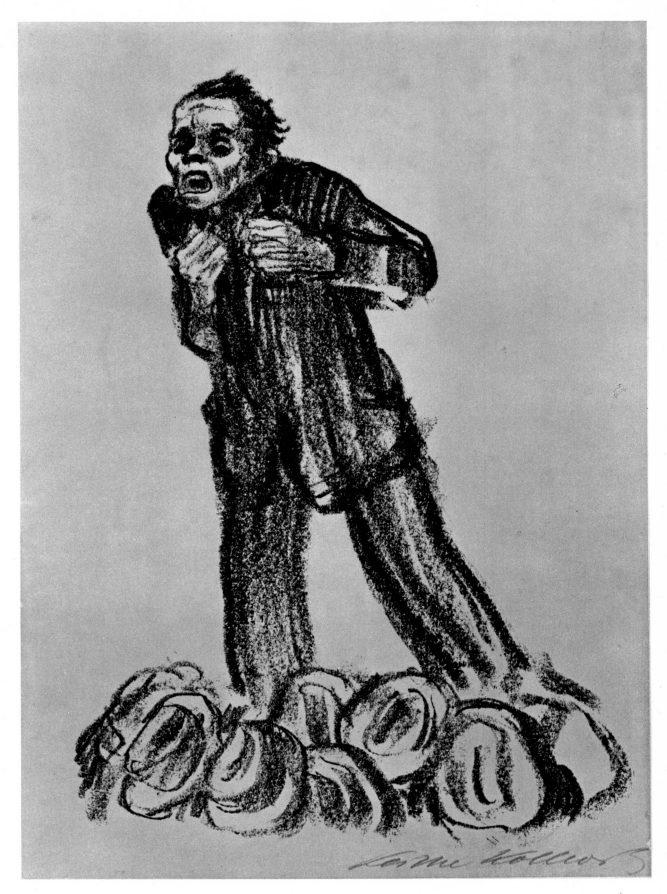

133. The agitator, 1926

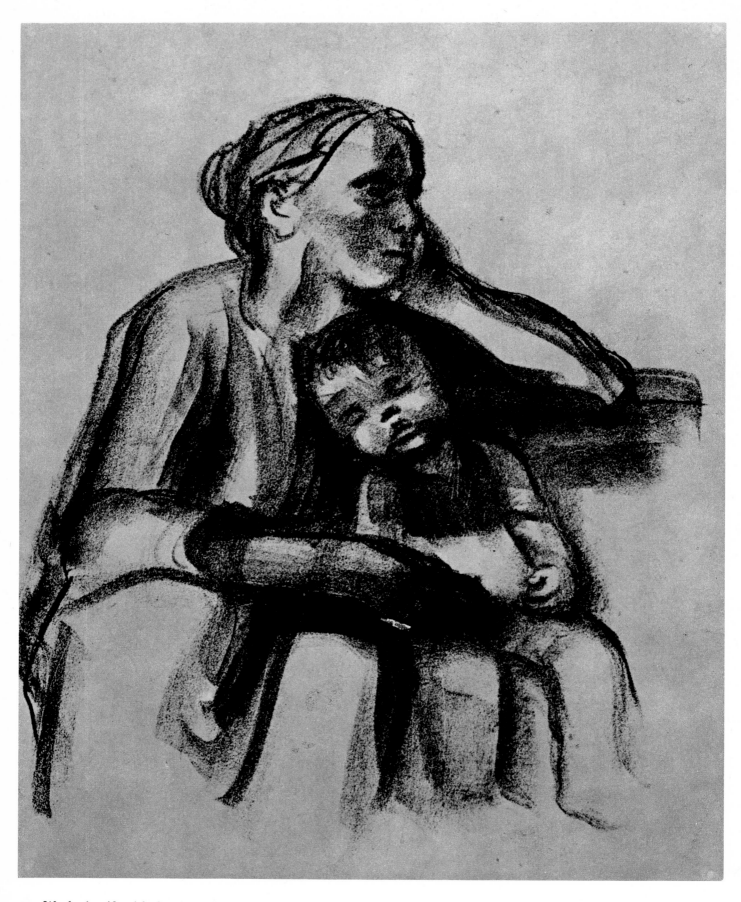

134. Worker's wife with sleeping boy, 1927

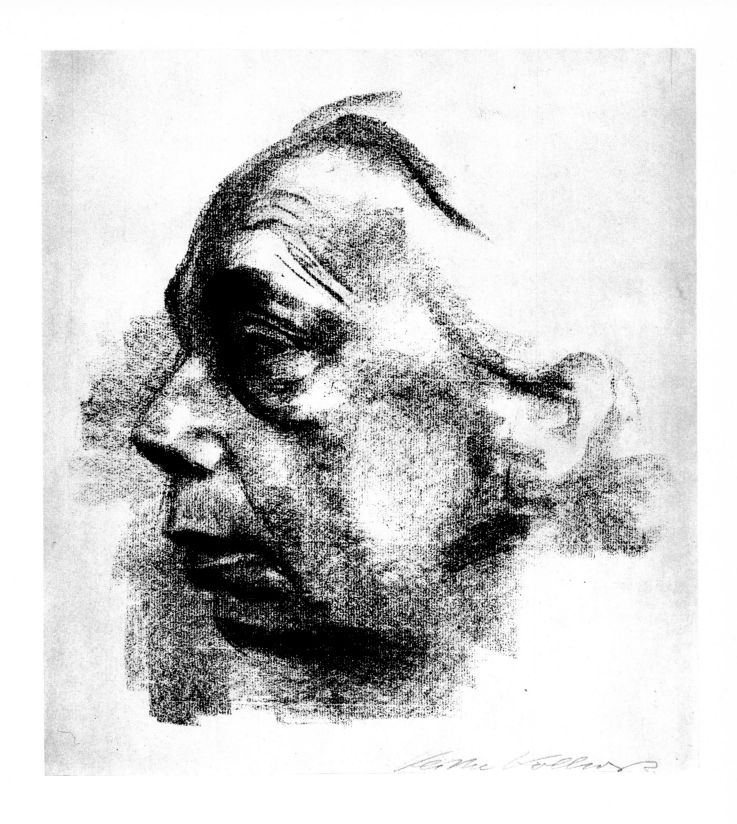

135. Self-portrait, profile, 1927

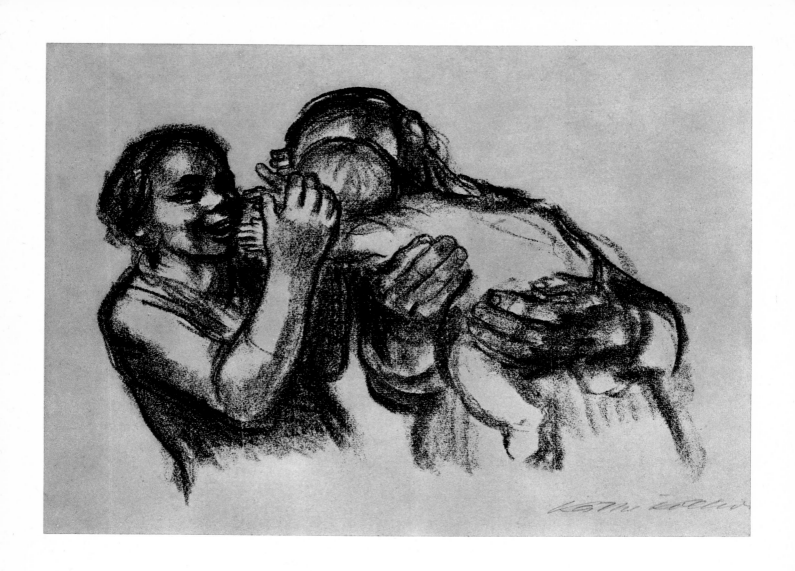

136. A family, 1931

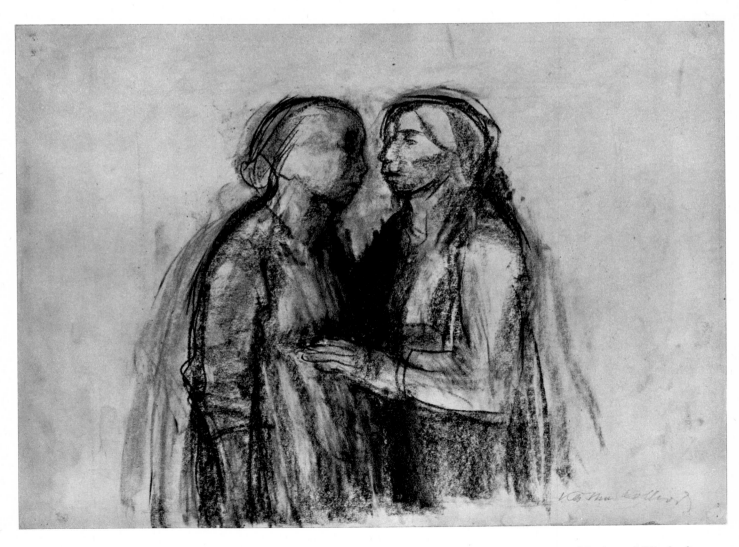

137. Maria and Elisabeth, 1927

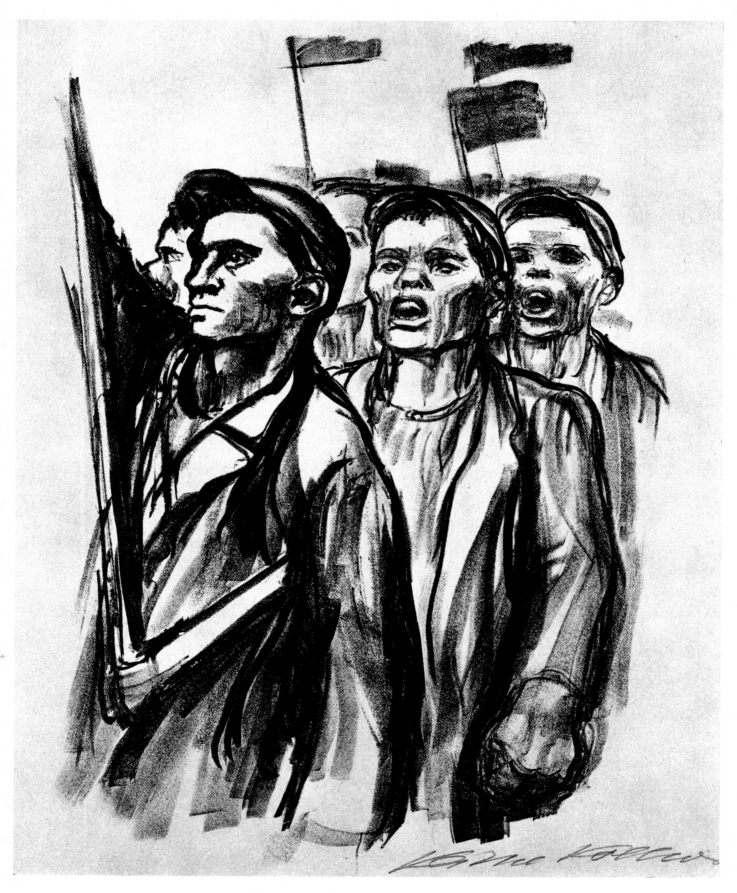

138. Demonstration, 1931

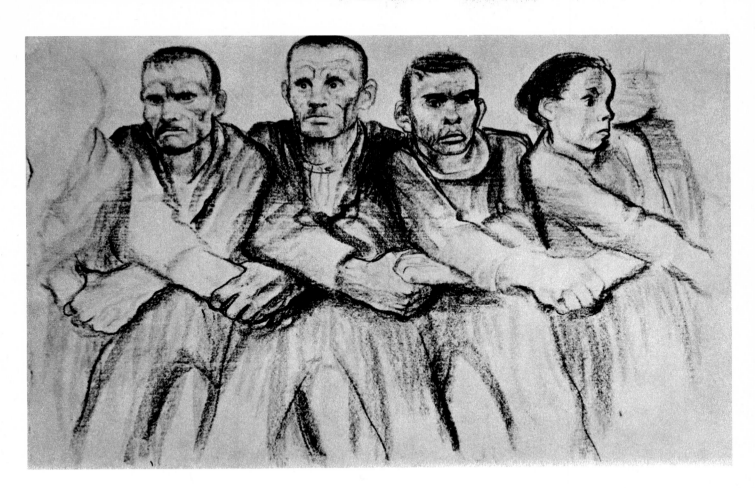

139. 'We protect the Soviet Union!', 1931/32

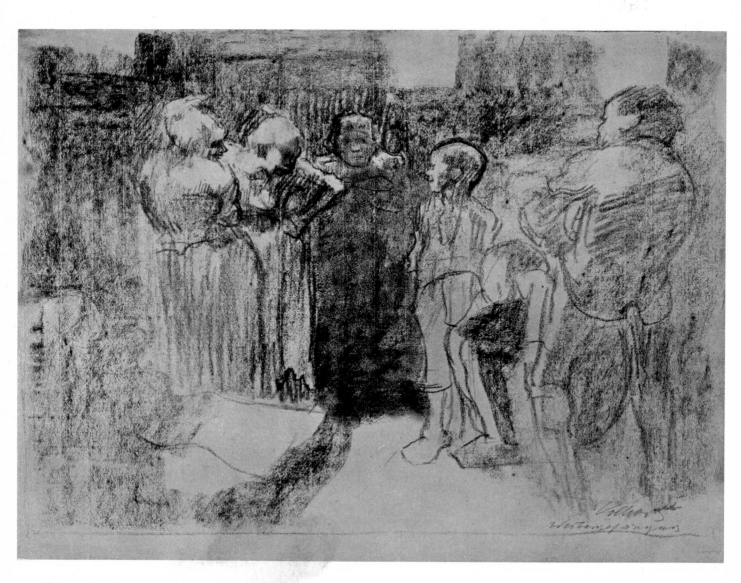

140. Women's prison, c. 1933

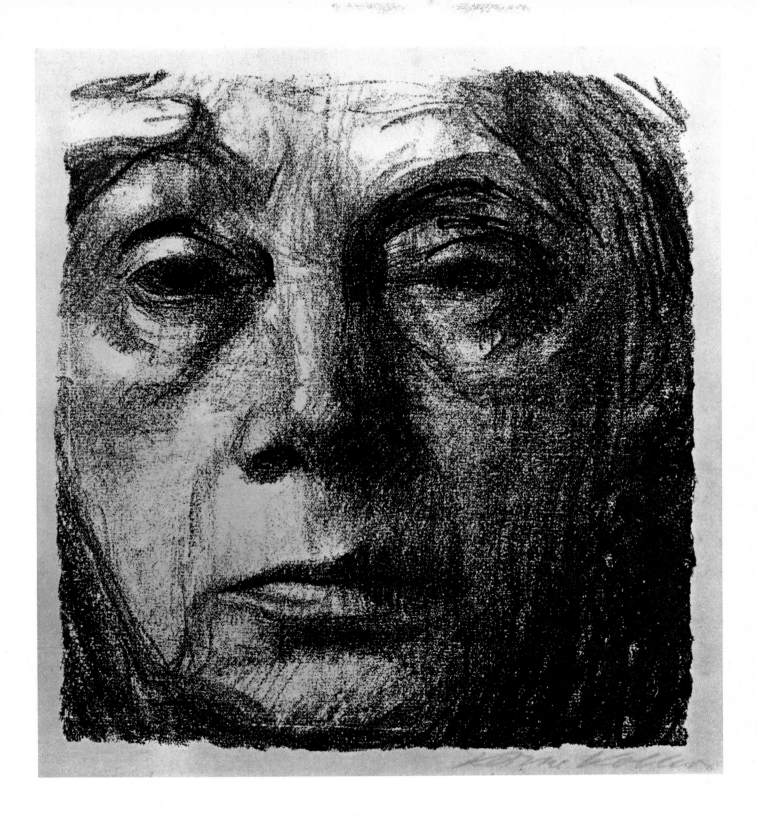

141. Self-portrait, 1934

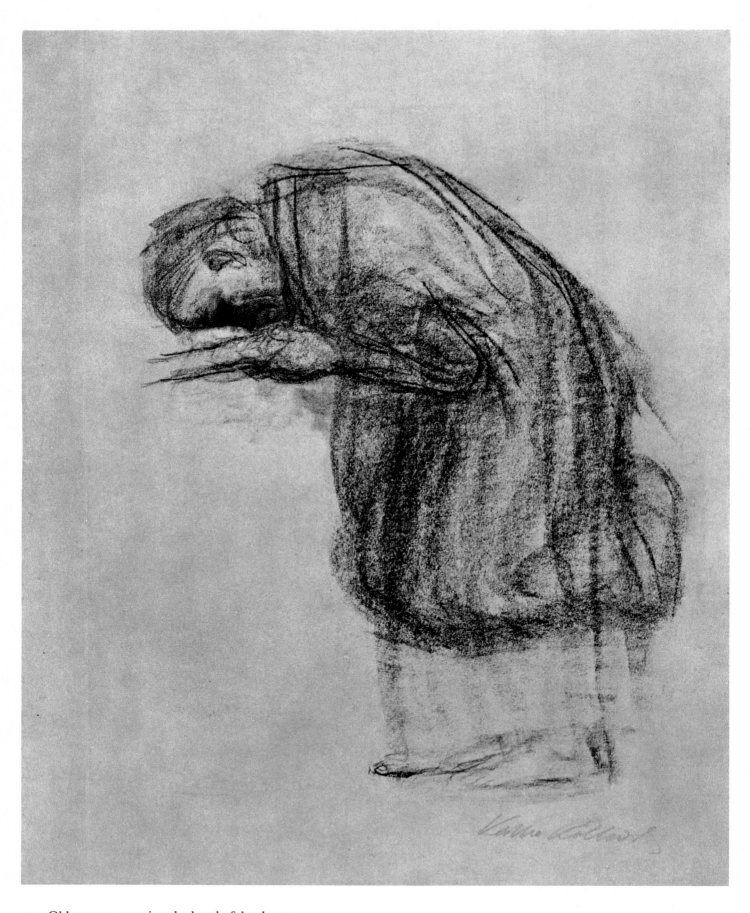

142. Old woman grasping the hand of death, 1934

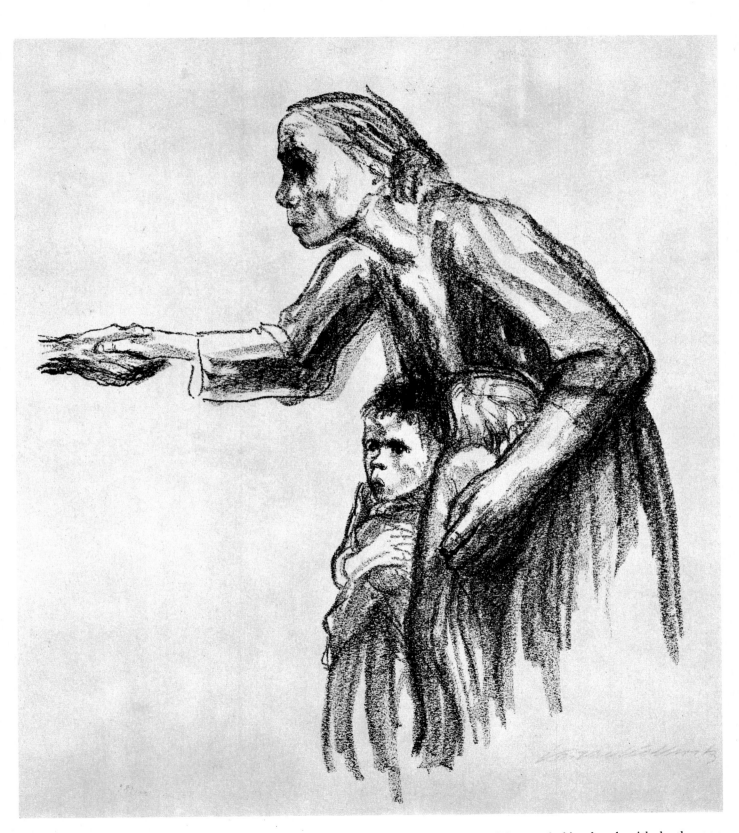

143. Woman shaking hands with death, 1934

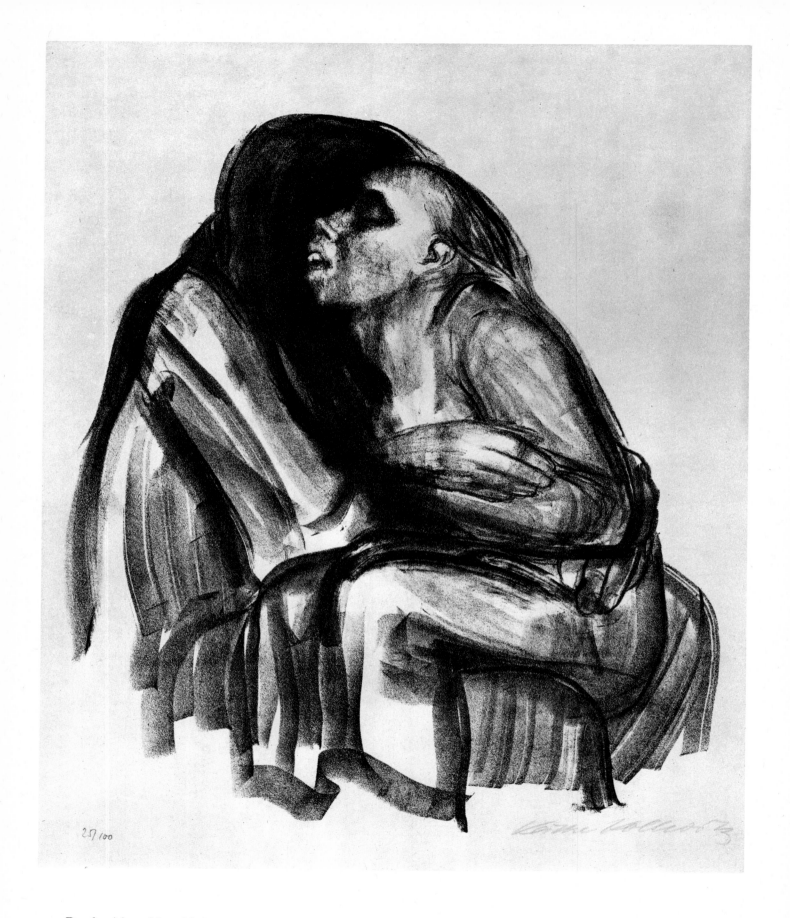

27/100

144. Death with a girl on his knee, 1934

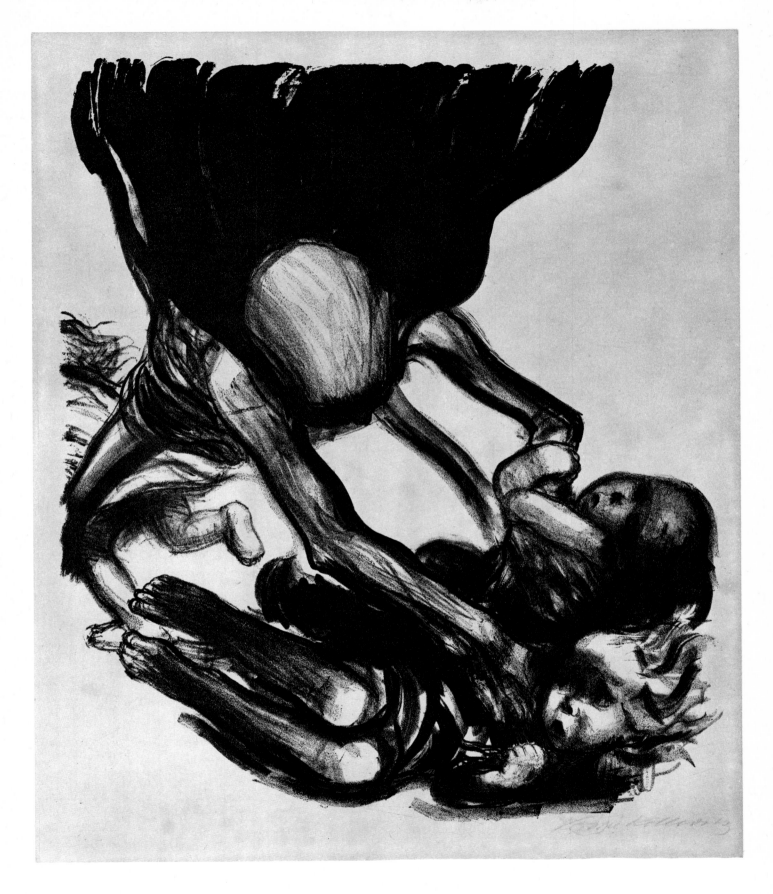

145. Death swoops upon a group of children, 1934

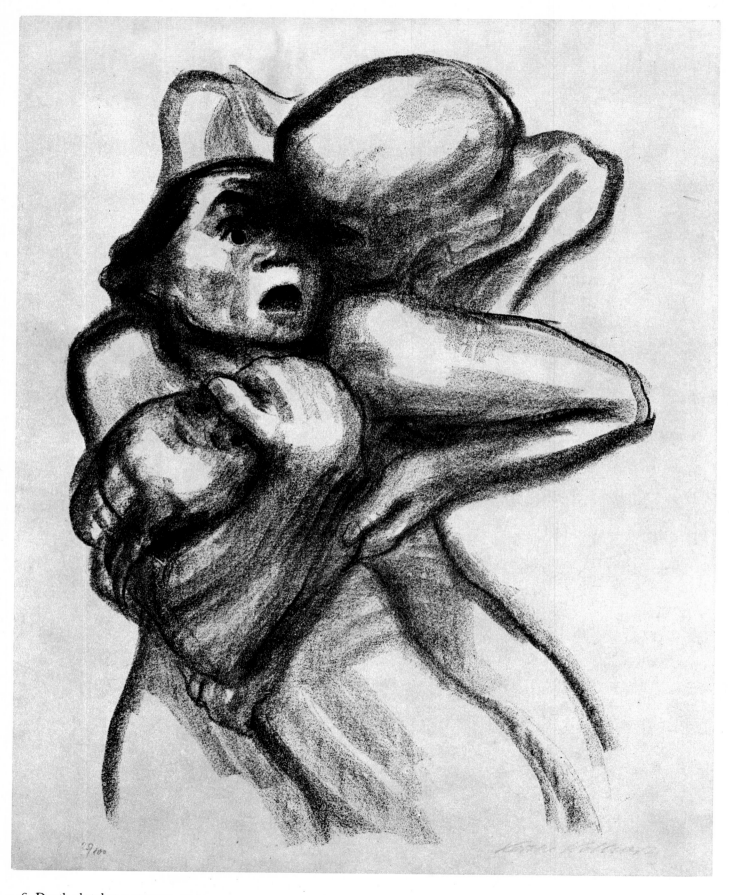

146. Death clutches a woman, 1934

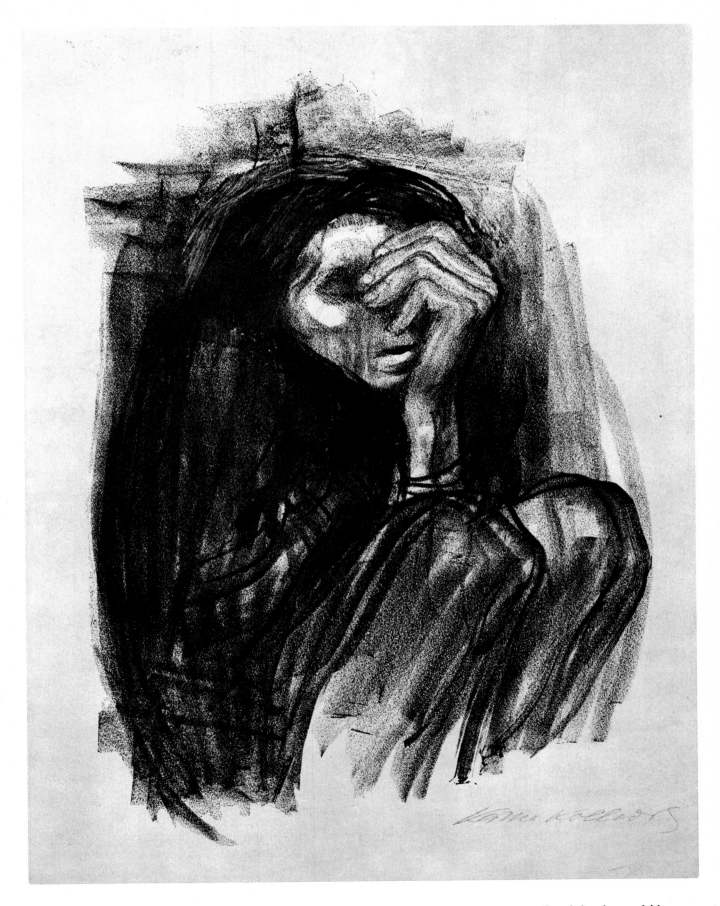

147. Death by the roadside, 1934

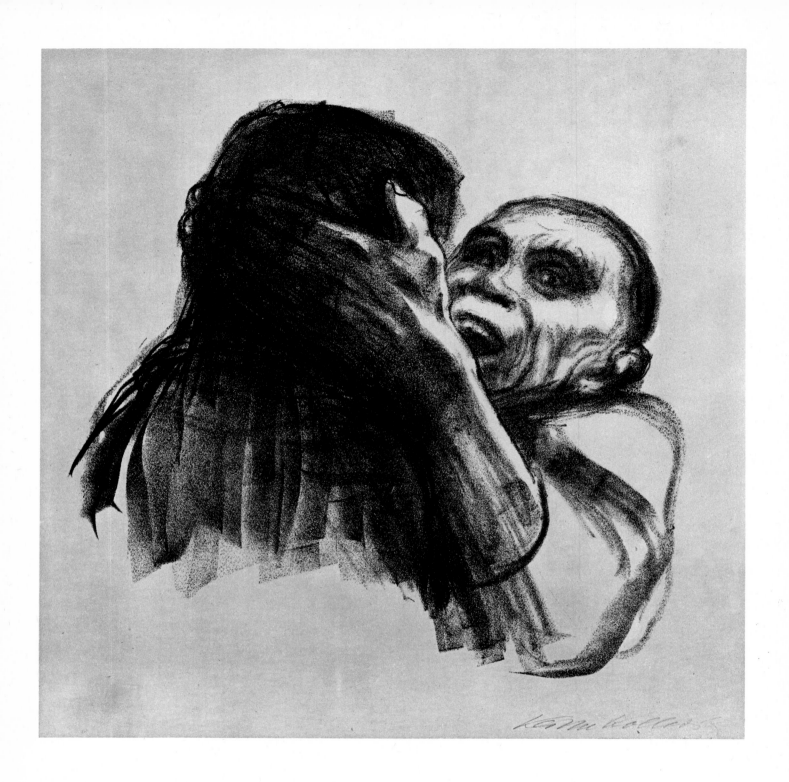

148. Death recognized as a friend, 1934/35

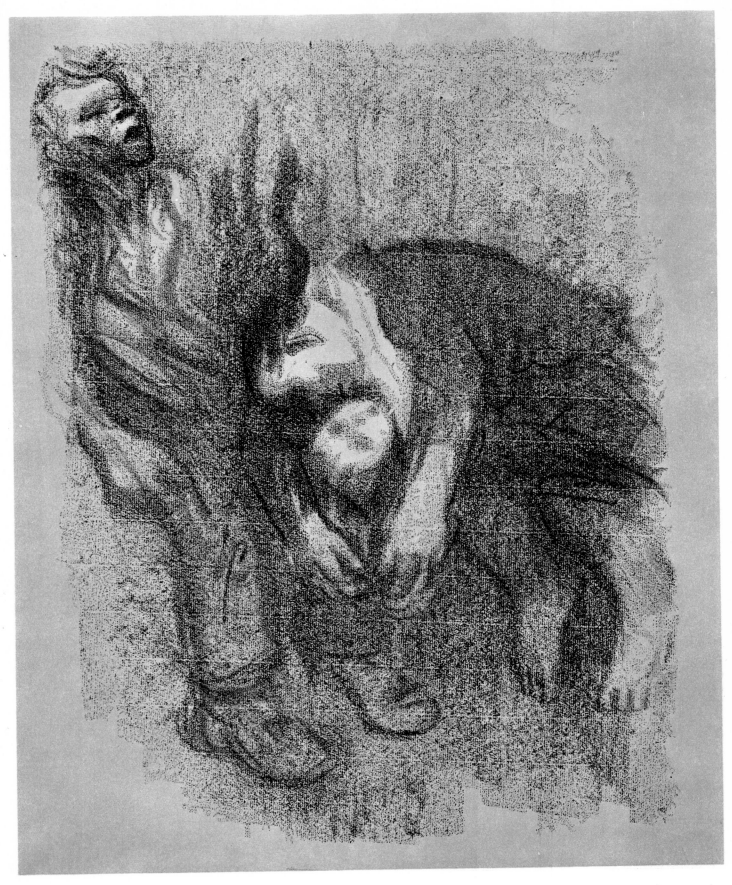

149. Death by drowning, 1934/35

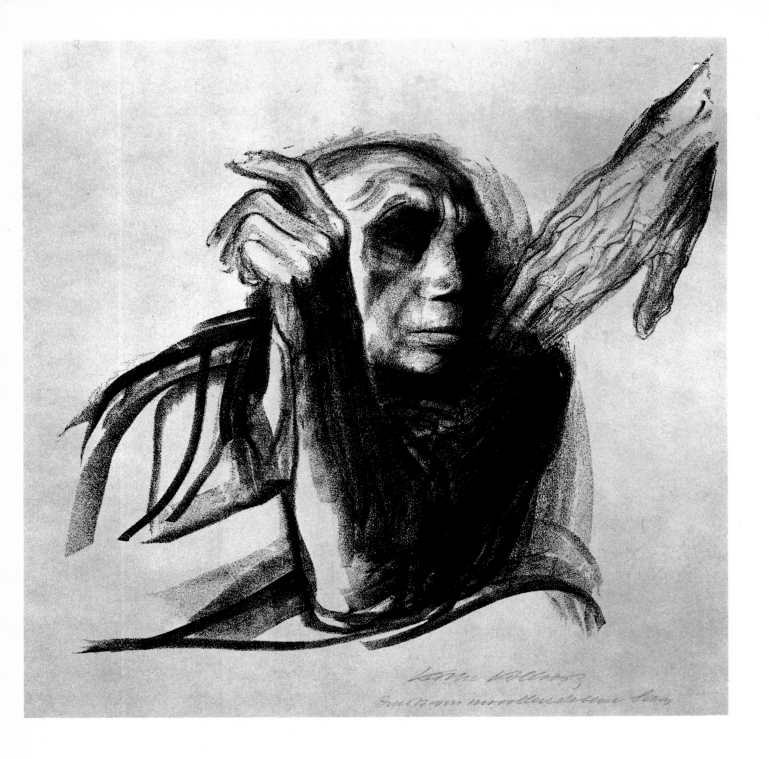

150. The call of death, 1934/35

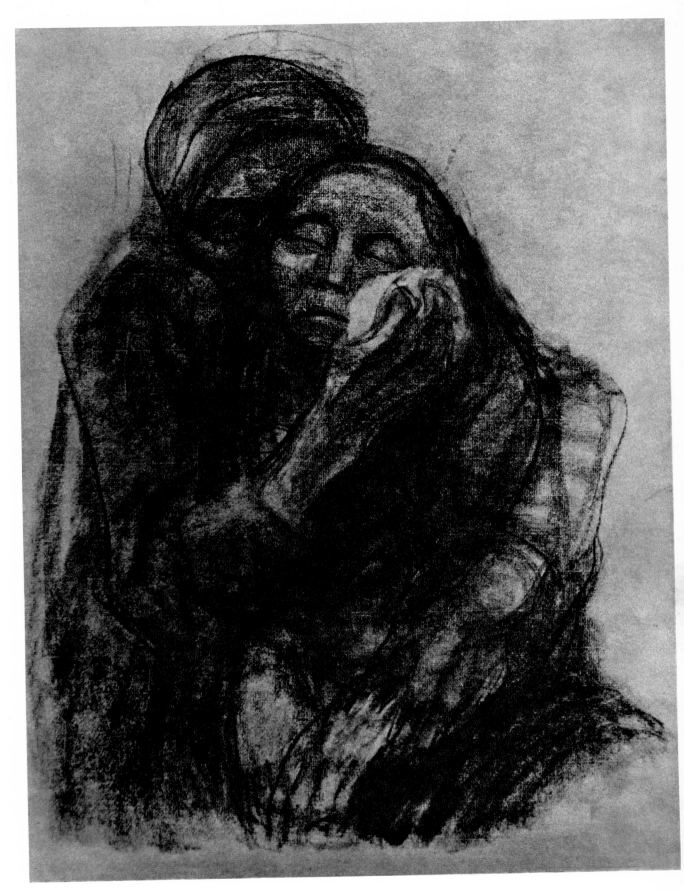

151. Weeping women (undated)

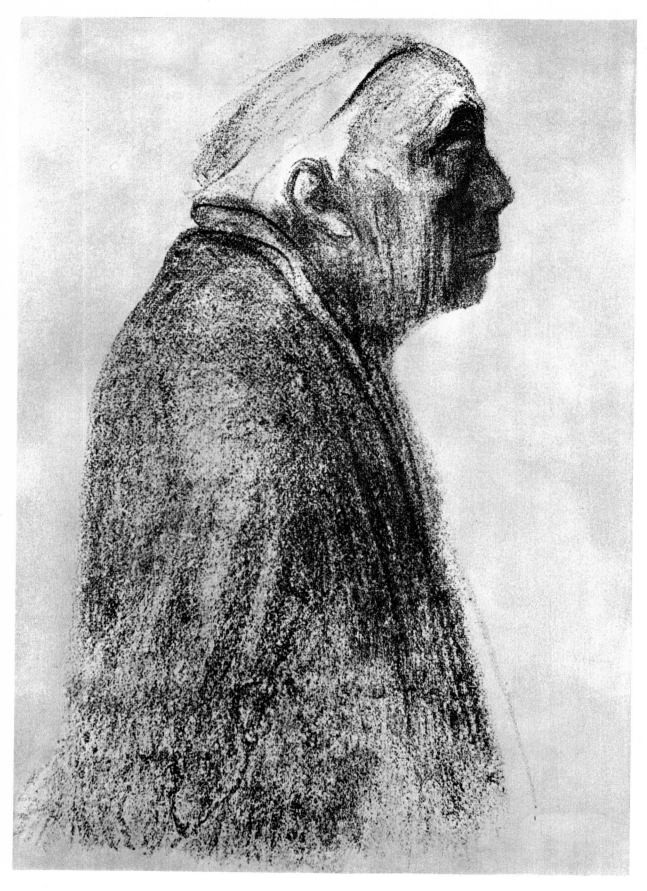

152. Self-portrait, right profile, 1938

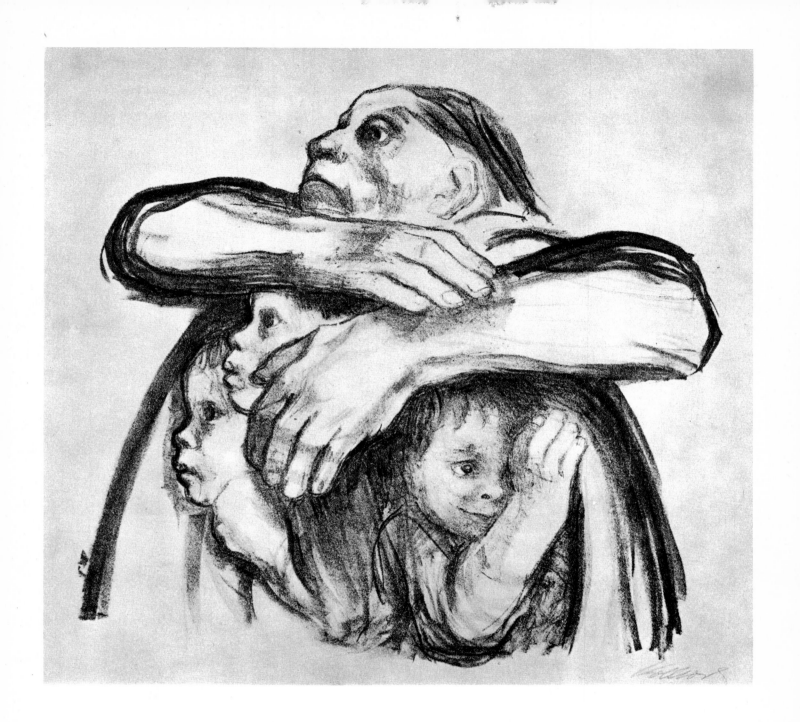

153. 'Thou shalt not grind the seed-corn', 1942

1 Letter to Hans Kollwitz and family, 16 April 1945, from: Käthe Kollwitz — *Tagebuch-blätter und Briefe* (Diaries and Letters) ed. by Hans Kollwitz, publ. Gebr. Mann Verlag, Berlin 1948, p 172

2 Letter to Hans Kollwitz, March 1945, ibid, p 172

3 Letter to Hans Kollwitz and family, 16 April 1945, ibid p 172

4 Letter to Otto Nagel and family, postmark 5 December 1944, ibid, p 170

5 Letter to Mrs Wally Nagel, no date. In possession of addressee

6 Letter from Mrs Erna Vogler to Otto Nagel, 11 March 1955. In possession of addressee

7 Reminiscences. From *Diaries* etc p 17

8 Ibid p 17

9 Ibid p 19

10 Ibid p 20

11 Ibid p 24

12 Ibid p 25f

13 Ibid p 20

14 Ibid p 28

15 cf Karl Stauffer-Bern: *Sein Leben — Seine Briefe — Seine Gedichte* (His life, letters and poems) arranged by Otto Brahm, Deutsche Buchgemeinschaft, Berlin 1926, p 67f

16 cf Werner Noth: *Wesen und Wirkung einer Ausstellung realistischer Kunst* (Nature and effect of an exhibition of realistic art) Publ. Bildende Kunst, Book 7/1958 Dresden

17 cf Otto Nagel: *Heinrich Zille* publ. Deutsche Akademie der Künste (German Academy of the Arts) Henschelverlag, Berlin 1955

18 cf Otto Nagel: *Hans Baluschek*, publ. Deutsche Akademie der Künste, in preparation

19 Emil Neide — German historical, genre and portrait painter, b. 1843, Königsberg; d. 1908, Dresden; 1880—1902, teacher at Königsberg Academy

20 Ludwig Herterich — German figure, portrait and monumental painter, b. 1856, Ansbach; d. 1932, Etzenhausen; c. 1898 professor at Munich Academy

21 Looking back on one's youth. From *Diaries* etc, 1941, p 39

22 Ibid p 39f

23 Ibid p 41

24 Now renamed Käthe Kollwitz Strasse

25 Looking back on one's youth. From *Diaries* etc, p 41

26 Ibid p 41

27 From the diaries, entry for April 1910. From *Diaries* etc p 48

28 Looking back on one's youth. From Diaries etc p 42

29 Martin Brandenburg — German painter and graphic artist, b. 1870, Posen; d. 1919, Stuttgart.

30 From the diaries, entry for September 1909; From *Diaries* etc p 48

31 Looking back on one's youth. From *Diaries* etc p 41

32 From the diaries, entry for September 1909. From *Diaries* etc p 47

33 Ibid 30 November 1909 ibid p 48

34 Ibid 1 August 1919 ibid p 83

35 Ibid 27 August 1914 ibid p 56

36 Ibid 30 September 1914 ibid p 56

37 Ibid 27 August 1916 ibid p 65

38 cf Beate Bonus-Jeep: *Sechzig Jahre Freundschaft mit Käthe Kollwitz* (Sixty years of friendship with Käthe Kollwitz) Karl Rauch Verlag, Boppard, 1948, p 127

39 From the diaries, entry for 1 December 1914, *Diaries* etc p 56f

40 Ibid entry for 19 March 1918, *Diaries* etc p 77

41 Ibid entry for 21 February 1916, *Diaries* etc p 61

42 Ibid entry for 1 October 1918, *Diaries* etc p 78

43 Ibid entry for 30 October 1918, *Diaries* etc p 78f

44 cf Beate Bonus-Jeep: *Sixty years* etc p 162f

45 cf Otto Nagel: *Leben und Werk* (Life and Work) Aufbau-Verlag, Berlin 1952

46 Vogeler, Heinrich—German painter, graphic artist, book illustrator, textile designer, architect and poet; b. 12 December 1872, Bremen; d. 14 June 1942 in a small village in Kazakhstan

47 Letter to Otto Nagel, 31 December 1924. In possession of addressee

48 The 'Hunger'. Portfolio also contained lithographs by Otto Dix, George Grosz, Otto Nagel, Karl Völker, Heinrich Zille and Eric Johansson

49 Letter to Hans Kollwitz and family, 11 June 1926: *Diaries* etc p 144ff

50 Letter to Mrs Wally Nagel, undated. In possession of addressee

51 cf Anatole Lunacharski: *Die Revolution und die Kunst* (The Revolution and Art) VEB Verlag der Kunst, Dresden 1962—Fundus Bücher 6, p 105f

52 From the diaries, entry for New Year's Eve, 1927; *Diaries* etc p 101

53 From the diaries, entry for 16 April 1932; *Diaries* etc p 105f

54 Letter to Otto Nagel, 18 June 1932. In possession of addressee

55 From the diaries, entry for 14 August 1932; *Diaries* etc p 108

56 cf Beate Bonus-Jeep: Sixty years etc p 260

57 Letter to Artur Bonus, 1933; *Diaries* etc p 150

58 Letter to Otto Nagel, 18 June 1932. In possession of addressee

59 cf *Appendix* to Diaries etc p 188

60 Letter to Gertrud Weiberlen, 6 February 1938, from Käthe Kollwitz: *I wish to work in this age*, a selection from the diaries and letters on graphics, drawings and sculpture. Introduction by Friedrich Ahlers-Hestermann. Verlag Gebr. Mann, Berlin 1952

61 cf Richard Hamann: *'Rembrandt' Stichnote*, (Notes on Rembrandt) Potsdam 1948, p 124 and p 128; ill. 90

62 cf *Collected Works* of Goethe, Propyläen-Verlag, Berlin, undated, Vol VIII

63 From the diaries, entry for October 1924; *Diaries* etc. p 114

64 From the diaries, last entry for May 1943; *Diaries* etc p 114

65 Letter to Hans Kollwitz, 17 May 1943. In possession of addressee. Unpublished.

66 The letters. Letter to Otto Nagel and family, dated 13 July 1943 in error, postmark 14 August 1943. *Diaries* etc p 158. In possession of addressee.

67 Letter to Otto Nagel and family, 27 August 1943, hitherto unpublished. In possession of addressee

68 Letter to Otto Nagel and family, 5 October 1943, hitherto unpublished. In possession of addressee

69 Letter to Otto Nagel and family, 4 February 1944. *Diaries* etc p 160

70 Letter from Clara Stern to Otto Nagel and family, 4 February 1944, hitherto unpublished. In possession of addressee

71 An instance of denigrating criticism, long after Rembrandt's death can be found in the *Allgemeinen deutschen Real-Encyclopädie für gebildete Stände* (Conversations-Lexikon) F. A. Brockhaus, Leipzig, 1827: Rembrandt was, in the narrowest sense of the word, a mere painter, that is, he understood in the highest degree everything about handling colour, shading, chiaroscuro, and brushwork, but on the other hand, he was never able to master the other requirements of a true artist, composition, grouping, noble expression, draughtsmanship, perspective, drapery, and above all, good taste. He did indeed draw nudes and other models from life, and he also made his pupils do the same; however, one can easily discern what type of model he used from a study of his works. In his composition and grouping he was content to follow

the crudeness of nature and his own personal caprice, without any selectivity in the choice of models. As a rule, he sought to hide the naked body as much as possible, he seldom allowed even hands and feet to be seen, because he did not know how to treat them, and he depicted them either disproportionately large, or else too small. When he could not conceal nakedness altogether, as in Christ's descent from the cross, the entombment, or in certain pictures of Bathsheba bathing, his work is totally lacking in proportion, is usually repulsive, or at least vulgar. His drapery is extravagant, without discrimination, mainly in poor taste and ridiculous. His heads are eloquent, but are almost invariably distortions, his Marys are common serving women, his Christ is a man of the lowest social class. etc...

72 cf Beate Bonus-Jeep: *Sixty years* etc. p 308 ff

73 Letter (dictated) to Otto Nagel and family, 13 February 1944. Hitherto unpublished. In possession of addressee

74 The letters. Letter to Hans Kollwitz and family, from Nordhausen, 17 February 1944. *Diaries* etc p 161

75 The letters. Letter to Hans Kollwitz and family, from Nordhausen, 21 February 1944. *Diaries* etc p 161 f

76 Letter to Otto Nagel and family, postmark 25 April 1944. Hitherto unpublished. In possession of addressee

77 Letter to Otto Nagel and family, 6 June 1944. Hitherto unpublished. In possession of addressee

78 Letter to Otto Nagel and family, dated 24 November 1924 in error, postmark 26 November 1944. Hitherto unpublished. In possession of addressee

79 Letter to Otto Nagel and family, postmark 5 December 1944. Hitherto unpublished. In possession of addressee

80 Her last days. From Jutta Kollwitz. *Diaries* etc p 191

81 From the diaries. Entry for December 1942. *Diaries* etc p 113

82 The letters. Letter to Hans Kollwitz and family, from Moritzburg, 14 November 1944. *Diaries* etc p 169

83 Letter to Reinhard Schmidhagen, 8 December 1943. From Käthe Kollwitz, *I wish to work in this age*

254

The numbers in brackets refer to the index of the artist's graphic work published by August Klipstein, Berne, 1955. All measurements are in centimetres, height before width

PLATES

256

Drawings from SIMPLICISSIMUS, May 1903—January 1911

64 At an infant's deathbed
65 Their only happiness
66 The Petitioner
67 Portraits of misery, I
68 Portraits of misery, II
69 Portraits of misery, III
70 Portraits of misery, IV
71 Portraits of misery, V
72 Portraits of misery, VI
73 At the end of their tether (undated)
74 Shelter for the night (undated)
75 Self-portrait, 1911, chalk, 35 × 30.9, Dresdener Kupferstichkabinett
76 Self-portrait with hand on forehead, 1910, etching, 15.4 × 13.7 (Kl 106)
77 Death and the woman, 1910, etching and sandpaper soft ground, 44.7 × 44.6 (Kl 103)
78 Run over, 1910, vernis-mou, 24.8 × 31.7 (Kl 104/IV)
79 Study for Plate 78, c. 1910, charcoal drawing, 59 × 45
80 Pregnant woman, 1910, vernis-mou and etching, 37.7 × 23.6 (Kl 108)
81 Mother holding child, 1910, etching, 26.7 × 21.9 (Kl 109)
82 Woman asleep, 1909, charcoal drawing, 35 × 44
83 Graves of victims of the 1848 Revolution (The 'March' Cemetery), 1913, lithograph, 46.5 × 37 (Kl 125)
84 Waiting 1914, lithograph, 33 × 24.5 (Kl 126)
85 A lonely man: the artist's father, 1915, lithograph, 33 × 26.5 (Kl 129)
86 Have pity on the children, (undated) charcoal drawing, 50 × 45.5
87 Mother holding child, 1916, lithograph, 33.4 × 18.9 (Kl 132)
88 Mother holding child, 1916, charcoal drawing, 49 × 36, Staatsgalerie Stuttgart
89 Mothers, 1919, lithograph, 43.5 × 58.5 (Kl 135)
90 The artist's parents, 1919, lithograph, 32 × 48 (Kl 136)
91 Karl Liebknecht on his deathbed, 1919, drawing, Märkisches Museum, Berlin
92 In memory of Karl Liebknecht, (left section of damaged plate), 1919, etching, 27.6 × 15.9 (Kl 137/V)
93 In memory of Karl Liebknecht, 1919, etching 33.5 × 53 (Kl 137)
94 In memory of Karl Liebknecht, 1919. lithograph, 42 × 66 (Kl 138)
95 In memory of Karl Liebknecht, 1919/20, woodcut, 35 × 50 (Kl 139)
96 Two dead bodies, 1919, woodcut, 19 × 27.5 (Kl 140)
97 The parents, 1920, charcoal drawing, 39 × 44
98 Woman lost in thought, 1920, lithograph, 41 × 37.5 (Kl 147)
99 'Help Russia', 1921, lithograph, 42.5 × 47 (Kl 154)
100 Mother at bedside of dead child, charcoal drawing, (undated) 48 × 56 Staatsgalerie Stuttgart
101 Killed in action, 1921, lithograph, 41 × 38.5 (Kl 153)
102 Man's head, miniature, 1922 woodcut, 7.2 × 6.8 (Kl 163)
103 Workman, seated, 1923, lithograph, 32.6 × 35.5 (Kl 164)
104 Self-portrait, front view, 1923, woodcut, 15 × 15.5 (Kl 168)
105 Hunger, 1923, woodcut, 22 × 22.8 (Kl 169)
 WAR
106 The victim, 1922/3, woodcut, 37 × 40 (Kl 177)
107 The volunteers, 1922/3, woodcut, 35 × 49 (Kl 178)
108 The parents, 1922/3, woodcut, 35 × 42 (Kl 179)
109 The widow I, 1922/3, woodcut, 37 × 22 (Kl 180)

110 The widow II, 1922/3, woodcut, 30×40 (Kl 181)

111 The mothers, 1922/3, woodcut, 34×40 (Kl 182)

112 The people, 1922/3, woodcut, 36×30 (Kl 183)

113 The survivors, 1923, lithograph, 56.2×68.5 (Kl 184)

114 Conversation with death, 1923/4, lithograph, 53×43 (Kl 187)

115 Begging, 1924, lithograph, 30×28 (Kl 193)

116 Fraternizing, 1924, lithograph, 23.5×17 (Kl 199)

117 Bread, 1924, lithograph, 30×28 (Kl 196)

118 Prisoners listening to music, 1925, lithograph, 33.5×31.8 (Kl 203/II)

119 Sketch for 'War, never again!' 1924, charcoal drawing, 65×50, Staatsgalerie Stuttgart

120 Self-portrait, 1924, woodcut, 15×11 (Kl 201)

121 'This is the end', 1925, woodcut, 30.4×12.6 (Kl 205)

122 Drawing for the Home Industries Exhibition poster, 1925, 53×99, Staatsgalerie Stuttgart

THE PROLETARIAT

123 Unemployed, 1925, woodcut, 36×30 (Kl 206)

124 Hunger, 1925, woodcut, 59×43 (Kl 207)

125 The children die, 1925, woodcut, 36.5×27.5 (Kl 208)

126 Lotte, (undated) charcoal drawing, 50.5×38.5

127 Child's head (Lotte) 1925, lithograph, 13.5×10.5 (Kl 213)

128 Visiting the children's hospital, 1926, lithograph, 27.5×33 (Kl 218)

129 Shelter for homeless women, (undated) drawing, 52×72, Staatsgalerie Stuttgart

130 Municipal refuge, 1926, drawing, 60×45, Staatsgalerie Stuttgart

131 Municipal refuge, 1926, lithograph, 42×56 (Kl 219)

132 Listening, 1927, lithograph, 22×19.3 (Kl 228)

133 The agitator, 1926, lithograph, 31×21.5 (Kl 224)

134 Worker's wife with sleeping boy, 1927, lithograph, 39×33 (Kl 226)

135 Self-portrait, profile, 1927, lithograph, 32×29 (Kl 227)

136 A family, 1931, lithograph, 22.5×31.5 (Kl 244)

137 Maria and Elizabeth, 1927, drawing, 38.5×50.5, Staatsgalerie Stuttgart

138 Demonstration, 1931, lithograph, 36.9×26.2 (Kl 242)

139 'We protect the Soviet Union!' 1931/2 ('The Propeller Song'), lithograph, 56×83 (Kl 248)

140 Women's prison, c. 1933, drawing, 48×63, Staatsgalerie Stuttgart

141 Self-portrait, 1934, lithograph, 20.8×18.7 (Kl 252)

142 Old woman grasping the hand of death, 1934, charcoal drawing, 62.8×47, Staatsgalerie Stuttgart

DEATH

143 Woman shaking hands with death, 1934, lithograph, 46×39.5 (Kl 256)

144 Death with a girl on his knee, 1934, lithograph, 43.4×37.8 (Kl 257)

145 Death swoops upon a group of children, 1934, lithograph, 50×42 (Kl 258)

146 Death clutches a woman, 1934, lithograph, 51×36.5 (Kl 259)

147 Death by the roadside, 1934, lithograph, 41×29.2 (Kl 260)

148 Death recognized as a friend, 1934/5, lithograph, 31.5×32.8 (Kl 261)

149 Death by drowning, 1934/35, lithograph, 48.5×38.4 (Kl 262)

150 The call of death, 1934/35, lithograph, 38×38.3 (Kl 263)

151 Weeping women, (undated) charcoal drawing, 57.8×42.3

152 Self-portrait, right profile, 1938, lithograph, 47.5×29 (Kl 265)

153 'Thou shalt not grind the seed-corn', 1942, 37×39.5 (Kl 267)

German Text in Illustrations, Facsimiles etc.

Mother: But Doctor, I haven't the money for them. *I can't even buy all the food available on ration cards.*

Doctor: That's the *profiteers'* doing, starving *our children* to death.

Can you stand by and calmly watch this happening? *Everyone* must help in the struggle against the people's worst enemies. Denounce the profiteers *rigorously*. All public prosecutors and police authorities will deal with such denunciations.

(County) Police Headquarters: issued by the Ministry of Food

44 Vienna is dying! Save the children!

45 *Unemployed*

An eight-hour day! Comrade, say:
How many of the gentry indulge their pleasures
Day in, day out, year in, year out. On our wages!
You smiling bourgeois in the street,
Do you know that?
Do you know, that
Hundreds of thousands of workers
Slave away for ten and twelve hours a day,
So that the rest of us cannot breathe
Never eat a decent meal,
And we smell of the gutter?
Oh, if there were but a 'just' law
So that every man need only
(Oh, this Only!)
Torture himself in sickening drudgery for eight hours a day,
So that no one, no one
Need be without a job.

Arno Nadel

50 Germany's CHILDREN *are Starving!*
Contributions received by the International Workers' Help Committee, Berlin W 8
Unter d. Linden 11
Postal Cheque Account Wilhelm Münzenberg Berlin N.W. 87 No. 115185

50 (below) German Home Industries Exhibition

51 WAR, *Never Again!*
Central Germany Youth Day
Leipzig 2—4 August 1924

57 Statement by Käthe Kollwitz in the AIZ Nr 20, 1927

(Workers' International Newspaper)

This is not the place for us to discuss why I am not a Communist. But it is the place for me to state that, as far as I am concerned, what has happened in Russia during the last ten years seems to be an event which both in stature and significance is comparable only with that of the great French Revolution. An old world, sapped by four years of war, and undermined by the work of the revolutionaries, fell to pieces in November 1917. The broad outline of a new world was hammered together. In an essay written during the early days of the Soviet Republic, Gorki speaks of 'flying with one's soles turned upwards'. I believe that I too can sense such flying in the gale inside Russia. For this flying of theirs, for the fervour of their beliefs, I have often envied the Communists.

Thus beg the children of Spain.
The starving children in the villages
Whom hatred has stricken low
Children who have been robbed of laughter
Of love and of childhood.
Children with fear in their eyes,
Left behind as the Red tide retreated
In their misery and pain.

Picture and text have been taken from an appeal to the people distributed by the Nationalist Aid Action (organization) in territory conquered by the Nationalist troops

Acknowledgement is made to the following for supplying photographs:
Klaus G. Beyer, Weimar (1); Deutsche Akademie der Künste, Berlin (35); Deutsche Bücherei, Leipzig (1); Deutsche Fotothek, Dresden (11); Ewald Gnilka, Berlin (14); Märkisches Museum, Berlin (33); Bruno Schuch, Berlin (3); Staatliche Museen zu Berlin (5); Staatsgalerie Stuttgart (15); Foto-Zorn, Dresden (14); the originals by the author and the Deutsche Akademie der Künste, Berlin.

Bibliography

Lehrs, Max: Käthe Kollwitz. Die Graphischen Künste XXVI. Vienna 1903.

Singer, Hans W.: Käthe Kollwitz. Führer zur Kunst. Vol. 15. Esslingen: Paul Neff Verlag (Max Schreiber) 1908.

Stern, Lisbeth: Käthe Kollwitz. Sozialistische Monatshefte. Vol. 23, part 2. 1917. p. 499 ff. (Reprinted in Fritz Schmalenbach: Neue Studien über Malerei des 19. und 20. Jahrhunderts. Bern 1955. p. 36 ff.)

Kollwitz, Käthe: Handzeichnungen in originalgetreuen Wiedergaben. Dresden: Emil Richter Verlag n. d.

Kollwitz, Käthe: Abschied und Tod. Acht Zeichnungen von Käthe Kollwitz. Introd. by Gerhart Hauptmann. Berlin: Propyläen-Verlag 1924.

Bonus, Arthur: Das Käthe Kollwitz-Werk. Dresden: Carl Reissner Verlag 1925. (2. ed. about 1930.)

Müller, J.: Käthe Kollwitz. Thieme-Becker, Allgemeines Lexikon der bildenden Künstler. Vol. 21. Leipzig: Verlag E. A. Seemann 1927. p. 245 ff.

Kollwitz, Käthe: Das Neue Kollwitz-Werk. Dresden: Carl Reissner Verlag 1933.

Kollwitz, Käthe: Tagebuchblätter und Briefe. Ed. by Hans Kollwitz. Berlin: Gebr. Mann Verlag 1948. (Reprint: Aus meinem Leben. Munich: Paul List Verlag 1961.)

Bonus-Jeep, Beate: Sechzig Jahre Freundschaft mit Käthe Kollwitz. Boppard: Karl Rauch Verlag n. d. (Reprint Bremen: Carl Schünemann Verlag 1963.)

Kollwitz, Käthe: Einundzwanzig Zeichnungen der späten Jahre. Introd. by Carl Georg Heise. Berlin: Gebr. Mann Verlag 1948.

Zigrosser, Carl (ed.): Käthe Kollwitz. New York 1951.

Kollwitz, Käthe: Ich will wirken in dieser Zeit. Auswahl aus den Tagebüchern und Briefen, aus Graphik, Zeichnungen und Plastik. Ed. by Hans Kollwitz. Introd. by Friedrich Ahlers-Hestermann. Berlin: Gebr. Mann Verlag 1952. (New edition 1962.)

Schmalenbach, Fritz: Käthe Kollwitz, Einführung in Werk und Leben. Neue Studien über Malerei des 19. und 20. Jahrhunderts. Bern: Rota-Verlag 1955. p. 22 ff.

Klipstein, August: Käthe Kollwitz, Verzeichnis des graphischen Werkes. Bern: Klipstein & Co. 1955.

Kollwitz, Käthe: The diary and letters of Kaethe Kollwitz. Chicago: Regnery 1956.

Fanning, Robert J.: Kaethe Kollwitz, New York: Wittenborn 1956.

Bittner, Herbert: Kaethe Kollwitz, Drawings. 3. ed. New York, London: Thomas Yoseloff 1963.

Schmalenbach, Fritz: Käthe Kollwitz. Königstein im Taunus: Karl Robert Langewiesche Nachfolger Hans Köster 1965.

Nagel, Otto: Die Selbstbildnisse der Käthe Kollwitz. Berlin: Henschelverlag 1965.

Kollwitz, Käthe: Briefe der Freundschaft und Begegnungen. Munich: Paul List Verlag 1966.

Kollwitz, Käthe: Das plastische Werk. Ed. by Hans Kollwitz. Forew. by Leopold Reidemeister. Hamburg: Christian Wegner Verlag 1967.

Meckel, Christoph, Ulrich Weisner and Hans Kollwitz: Käthe Kollwitz. Inter Nationes: Bad Godesberg, 1967.